SEASONS
of the Heartland

Celebrating 20 years of

Midwest Living® name and logo are trademarks of the Meredith Corporation, used under license by Morris Book Publishing, LLC.

BOOK DESIGN Geri Wolfe Boesen, Creative Director

BOOK CONTENT Greg Philby, Executive Editor
Barbara Briggs Morrow, Senior Travel Editor
Trevor Meers, Managing Editor
Kendra L. Williams, Copy Chief

MIDWEST LIVING EDITORIAL STAFF Dan Kaercher, Editor-in-Chief; Diana McMillen, Senior Food Editor; Deb Wiley, Garden Editor; Carol Schalla, Senior Home Editor; Joan Lynch Luckett, Editorial Project Manager; Tara Okerstrom-Bauer, Photography Editor; Faith Berven, Associate Art Director; John Meek, Associate Art Director; Judy Dugger Cordle, Administrative Assistant; Brenda Kienast, Art Administrative Assistant; Merrie Nelson Tatman, Editorial Assistant; Hannah Agran, Assistant Travel Editor; Sara Reimer, Assistant Home Editor; George Hendrix, Contributing Writer-Travel; Joe Warwick, Contributing Designer.

Library of Congress Cataloging-in-Publication Data is available.

ISBN-13: 978-0-7627-4511-1

Printed in China
First Edition/First Printing

CONTENTS

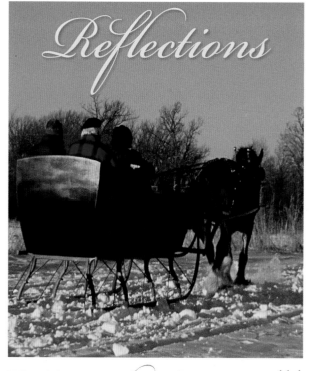

This book seems like the perfect way to commemorate our 20th anniversary. In the mid-1980s, when many media were ignoring the Midwest as "flyover country," Des Moines-based Meredith Corp. decided to embrace and celebrate the Heartland with a new magazine. *Midwest Living®* was born. From the first issue in April 1987, we've featured the places, people, foods and gardens of the central states: Ohio to the east; North and South Dakota, Nebraska and Kansas to the west; Minnesota, Wisconsin and Michigan to the north; and Iowa, Missouri, Illinois and Indiana in the middle of it all. Readers responded immediately, making it one of the most successful new magazines in recent decades. Now, some 4 million people read every issue. Everyone has favorites—weekend getaways to drivable Midwest destinations; recipes for traditional dishes and new twists on classics; homes that reflect the region's style and character; and gardening ideas and planting tips for our specific climate and soils. Most readers have one particular love in common—the changing seasons. Even if we have a favorite season, what we look forward to most is the variety itself. We appreciate the unique character of each part of the year—snowy winter landscapes, spring blossoms, long summer days and changing fall leaves. In words and photos, our stories capture the best of our seasons and who we are as a region. Photographers, writers and editors logged thousands of miles to produce those pieces, and our archives bulge with beautiful work. How to choose a sampling for this book? We pored over hundreds of shots, weighed in with favorites and fitted them together in various ways until the jigsaw puzzle at last came together as a picture of the Midwest that we're proud to present. We think the result is as captivating as our seasons. We hope you agree!

Sometimes it's the simple pleasures, such as a vintage boat and a quiet lake, that define us.

SPRING *in the* HEARTLAND

Begin

n i n g s

Moody springtime mist wanders through the valleys of Shawnee National Forest in southern Illinois.

reen is one of the hardest colors to capture, a Brown County, Indiana, painter reflected in an article about the area's art heritage. As forests leaf out and March's timid lime becomes May's lush blue-green, it's easy to see why. It's also easy to see why we watch so closely as the season's signs unfold. In Missouri and Illinois, we check daffodils poking through patches of snow and hope they'll continue to bloom through still-icy rain and sunny, almost-warm days. On Michigan's Upper Peninsula, everyone studies the walls of snow standing as tall as the mailboxes for signs of melting. Even when it snows again, we check the bikes and riding gear, just to be sure they're ready for that first warmer weekend.

Spring has to be the Midwest's most anticipated season, and not just because it's so elusive or because winter has worn us out. By this point in the year, we long for much more than warmer days and summer pastimes. We're eager to begin—plant a new garden, try that grilling recipe or follow those back roads to where orchards are in full bloom. We're more than ready for our annual fresh start—another chance to grow the flowers that fizzled in last year's scorching heat or take the vacation that didn't happen because everyone got too busy. Maybe this year, it won't rain too much or too little, or get too hot or stay too cold. Maybe this year, we'll run that 5K we've been thinking about or build that dreamed-of screen porch.

More than any other, this season represents the region's natural optimism. It's nature's affirmation for the farmer to plant anew, the small-resort owner to open the doors for the season to come, the town to get that Main Street revitalization going again. It's all new and possible. It's spring!

A flower-lined trail meanders through the grounds of The Clearing, a folk school perched on a rocky cliff above Green Bay in Door County, Wisconsin. The laid-back school, founded in 1935, offers classes in photography, local geology, quilting, yoga, poetry and a dozen other topics. It's the perfect place to relax, refresh the mind and savor the new season. The subject chosen doesn't matter as much as the atmosphere, which one student likened to a summer camp for adults.

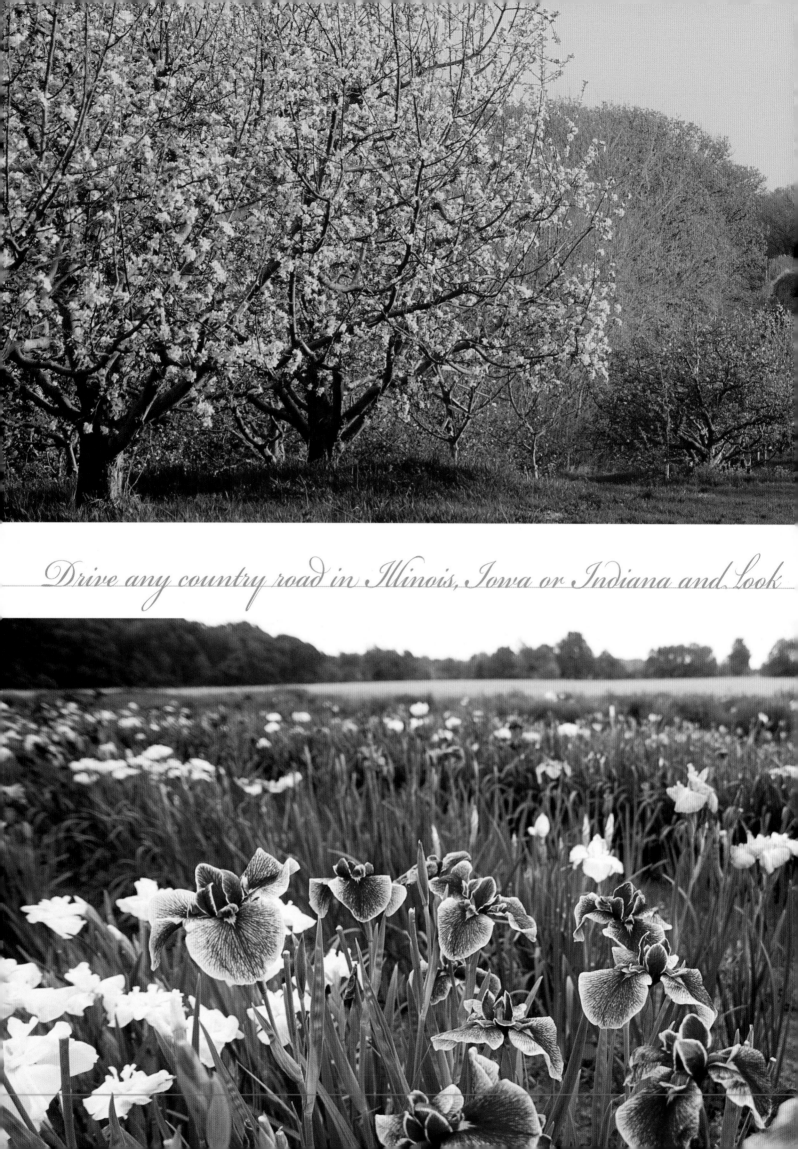

Drive any country road in Illinois, Iowa or Indiana and look

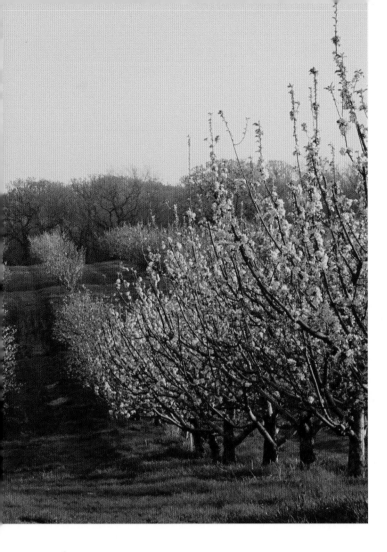

AMONG THE MIDWEST'S JOYS IS AMAZING VARIETY—in all things, but particularly its spring flowers. Along the fringes of still-dormant forests, redbuds and dogwoods invisible most of the year burst into cotton-candy puffs of pink and white. While tiny, blue, false indigo blossoms open amid the emerald prairiegrasses of central Kansas' Flint Hills, scarlet splashes mark Indian paintbrush flowering among the blue-green sagebrush flats of western South Dakota. Delicate, white Dutchman's breeches dance on the breeze riffling a Michigan pine forest, and spikey blue larkspurs arc toward light filtering through the tall oaks of southern Missouri's Ozarks.

We do our best to enhance this natural display. We always have. You can see it in our roots. Drive any country road through Indiana, Iowa, North Dakota or Ohio and look for

for BLOOMING APPLE TREES *and clusters of irises.*

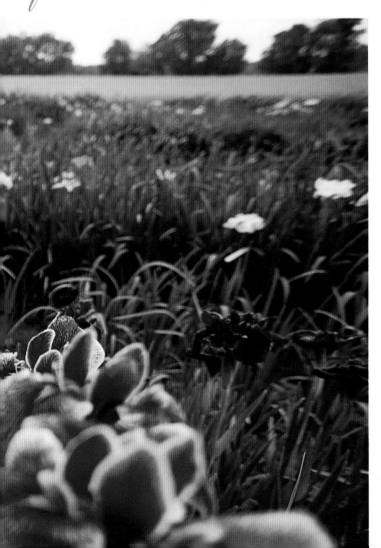

blooming apple trees, fragrant lilac bushes and clusters of irises and tiger lilies marking forgotten homesteads.

Where we've flourished, flowers have, too. The Chicago Botanic Garden and Missouri Botanical Garden in St. Louis are among the world's great public gardens. It seems that just about every available inch of Cincinnati is devoted to wisteria, roses, dahlias and honeysuckle. And along downtown streets in every Midwest community, you can expect window boxes of pansies, dangling baskets of petunias or lines of sweetly blooming crabapples and Bradford pears.

We've become more sophisticated gardeners at home. Waterfalls, statuary and precise riots of exotic perennials and flowering shrubs decorate today's home gardens. But make no mistake: What's at work is the same old Midwestern urge to celebrate spring's renewal with color and perfume.

(Top) White flowering crabapples herald spring across the region. *(Bottom)* Japanese irises come later, leading the parade of late-spring and summer bloomers.

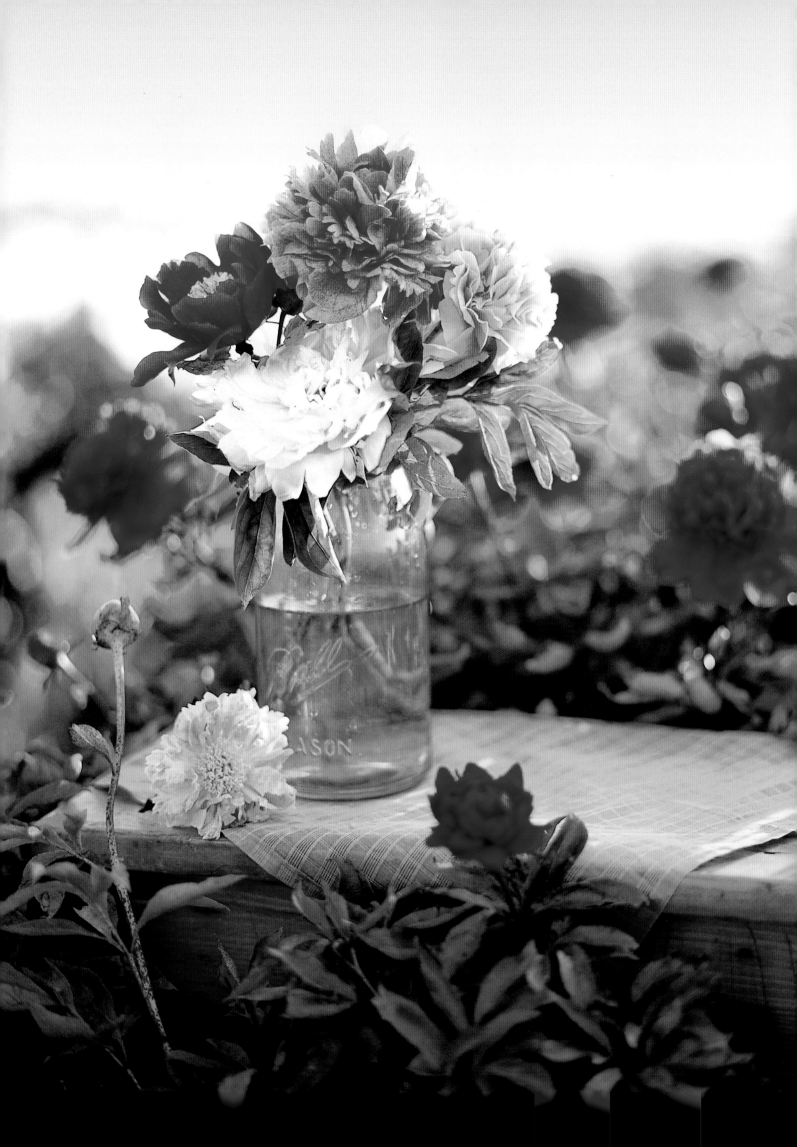

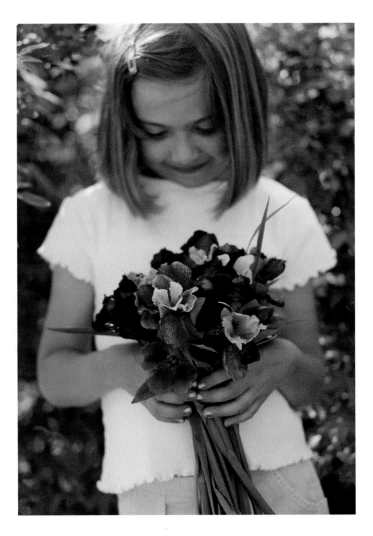

EARLY-SEASON GARDENS

The change of seasons is part of the beauty of a Midwest garden. Though we miss our gardens during winter, many of our favorite plants, including lilacs and peonies, actually need a cold, dormant period to flourish. It also makes spring all the more joyous when the colors and scents emerge from the last of the winter pall. We cherish the spiritual and physical sustenance we get from our gardens. Statistics show Midwesterners nurture more flowers, vegetables and lawns than people in other regions. As spring buds out, it's easy to understand why. It's hard to resist holding flowers in your hands or bringing them indoors. Though some flowers, such as lilacs and bleeding hearts, do not last long when cut, colorful bouquets await with bloomers like daffodils, irises or peonies. Your cut flowers will last longer if you clip them in early morning or late in the day, and have a container of lukewarm water with you so you can set the stems into it immediately. Once inside, recut the stems at an angle and strip off any leaves that will be below the water level. The best tip: Put the flowers where you'll see them often so you can fully appreciate the beauty of the garden in spring.

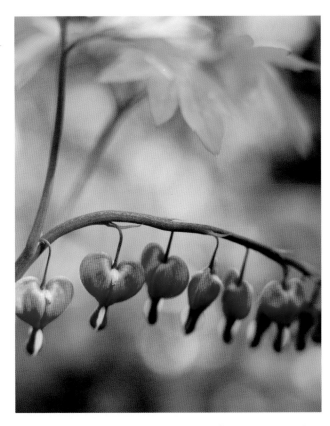

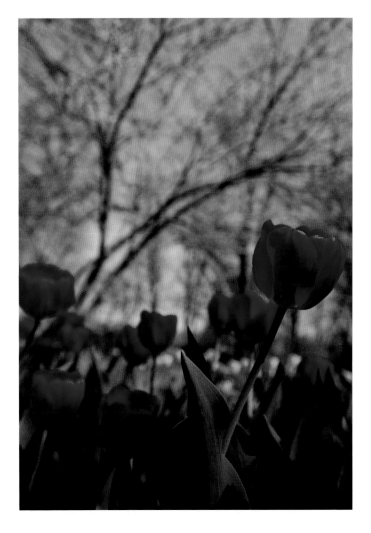

(Opposite) To many gardeners, spring officially arrives when the peonies bloom. (Clockwise, from above) Delicate bleeding hearts beckon from dappled shade. Cutting flowers, irises in this case, is one of spring's greatest pleasures. Tulips are the stars of spring, and of many festivals across the Midwest.

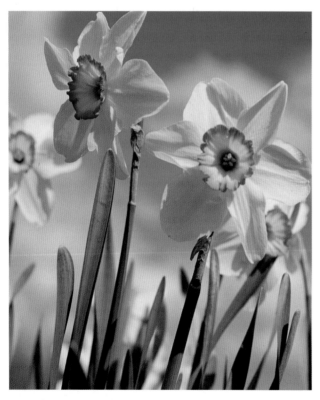

(Top row, from left) North Dakota's International Peace Garden stages one of the Midwest's most striking displays. Trilliums are native to Michigan. (Bottom row, from left) Daffodils are among the hardiest, most reliable early bloomers. Wildflowers signal spring on the Kansas prairie. Gardens are meant to be "lived in" during the region's warmer months.

PUBLIC GARDENS

In some ways, the name of its website says it all: www. ohwow.org. The Midwest has many exceptional public gardens, but the **CHICAGO BOTANIC GARDEN** in Glencoe, Illinois, rises above the rest, stunning visitors with 23 display gardens and 9,400 varieties of plants, all set on 385 acres. An English garden, sweeping native prairie, rushing water-falls and a model-train railroad garden are just some of the experiences awaiting visitors of all ages and interests. We also love the **MISSOURI BOTANICAL GARDEN** in St. Louis. Founded in 1859, this National Historic Landmark is not only one of the nation's oldest gardens, but also one of the world's best, with a signature, 14-acre Japanese strolling garden, complete with waterfalls, streams, stone lanterns and cherry blossoms. And the **MINNESOTA LANDSCAPE ARBORETUM** in Chanhassen has captured our attention and never let go. These 1,000 acres southwest of Minneapolis are filled with woodland, wetland and prairie plants, and 12.5 miles of trails. During the growing season, stop in the visitors center and take advantage of tram tours and guided walks.

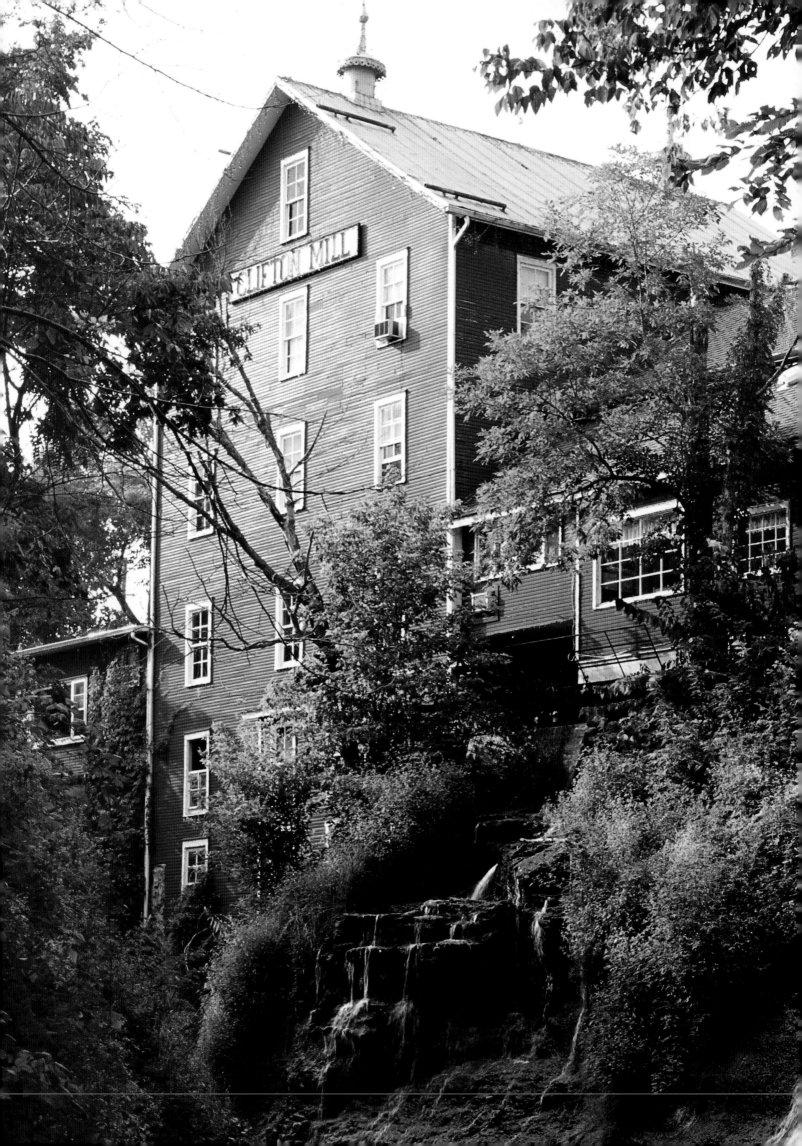

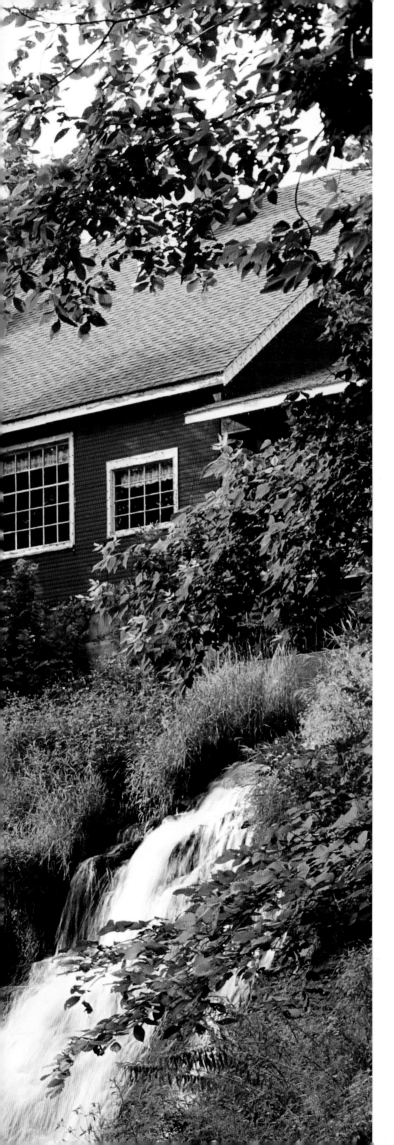

MARCH AND APRIL POUR COLD, CLEAR SNOWMELT and then spring rain into the waterways that are the region's life force. Creeks swell into rushing streams, streams become rivers, and waterfalls that trickled or froze in winter roar to life again. Early settlers harnessed this power with mills, some of which still stand and even grind grain. We revere these monuments to pioneer struggles and make pilgrimages to watch them work. Usually that means a trip down country roads, framed in spring by greening leaves and blushing redbuds. The journeys become affirmations of the season itself.

More than a dozen mills survive in Missouri alone, most hidden away in Ozark mountains. At Alley Spring Mill near Eminence, preserved as part of a state park, interpreters in old-time dress operate the thundering machines, and visitors buy the mill's flour, which everyone swears somehow tastes better than the supermarket variety. Clifton Mill, once one of five mills along southwestern Ohio's Little Miami River, also produces flour that bakers say is worth the drive.

We also marvel at the waterways themselves, especially the ones we never quite managed to tame. The Ozark National Scenic Riverways, the first designated in the country, courses through southern Missouri. Spring is the time for fast, breezy canoe trips on the Current and Jacks Fork rivers, intersecting streams framed by limestone bluffs and towering oaks and cottonwoods. High water usually covers the sandbars that make tempting swimming beaches later in the year. On Michigan's Upper Peninsula, rivers rushing toward the Great Lakes tumble over more than 200 waterfalls. In Porcupine Mountains Wilderness State Park, trails lead to five cascades on the Presque Isle River. Seeing just one isn't enough. Each inspires its own kind of awe. We're fascinated by the rushing waters and the majesty of places that remain wild and free.

Clifton Mill, which was built in 1802, presides over a gorge along the Little Miami River in southwestern Ohio. The impressive six-level mill still grinds white and buckwheat flour, for sale in the country store. The Millrace Restaurant, open for breakfast and lunch, serves pies and breads made with the mill's flour. An annual display with more than 3 million holiday lights brings visitors, too.

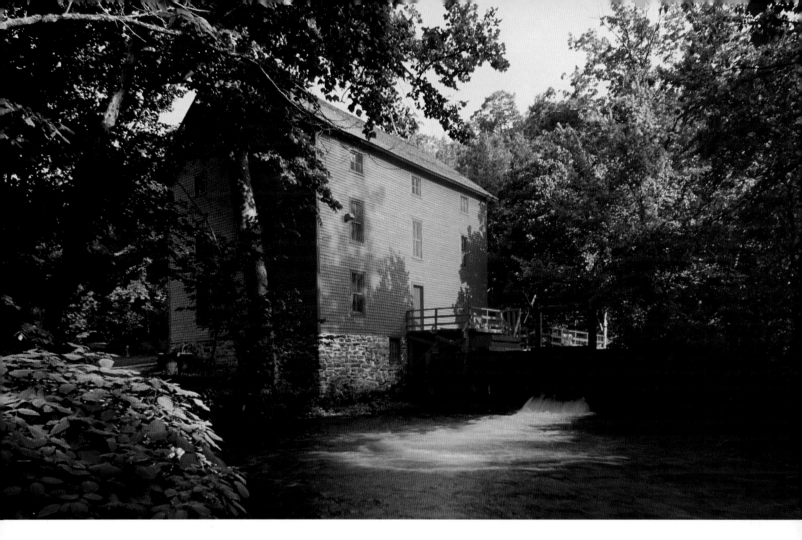

"The GURGLE OF THE WORTER *round the drift jest below*

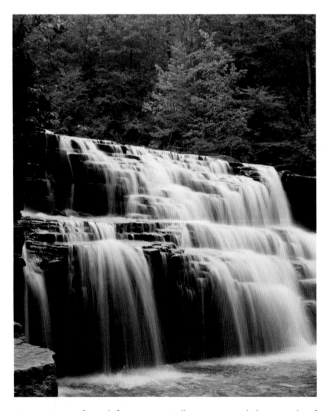

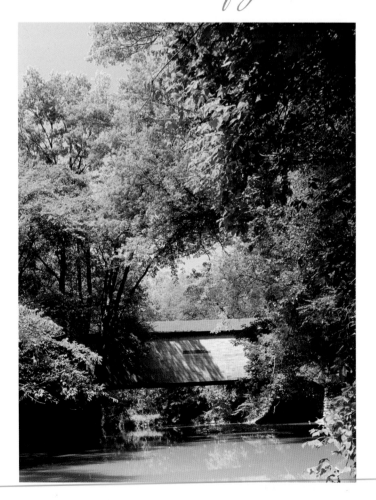

(Bottom row, from left) Canyon Falls roars amid the woods of northern Michigan's Keweenaw Peninsula. A covered bridge still carries traffic in Brown County, Indiana. The Ohio River invites traffic large and small.

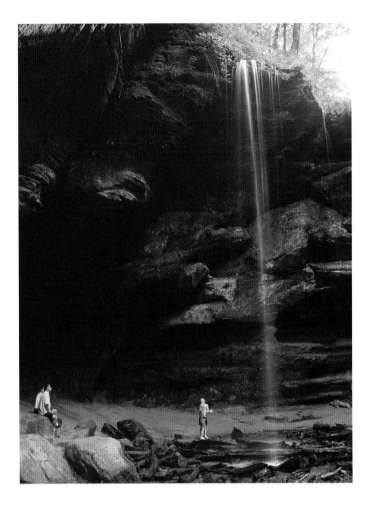

(Top row, from left) Now part of a state park, Alley Spring Mill still grinds flour next to a chilly pool in southern Missouri's Ozarks. Lyons Falls spills over a ledge in Ohio's Mohican State Park. The same family has owned Hodgson Mill in southern Missouri for more than a century.

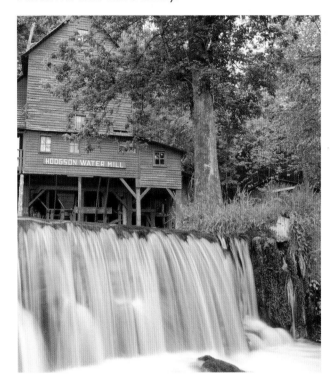

sounded like the laugh of something we onc't ust to know.
FROM INDIANA POET JAMES WHITCOMB RILEY'S "THE OLD SWIMMIN' HOLE"

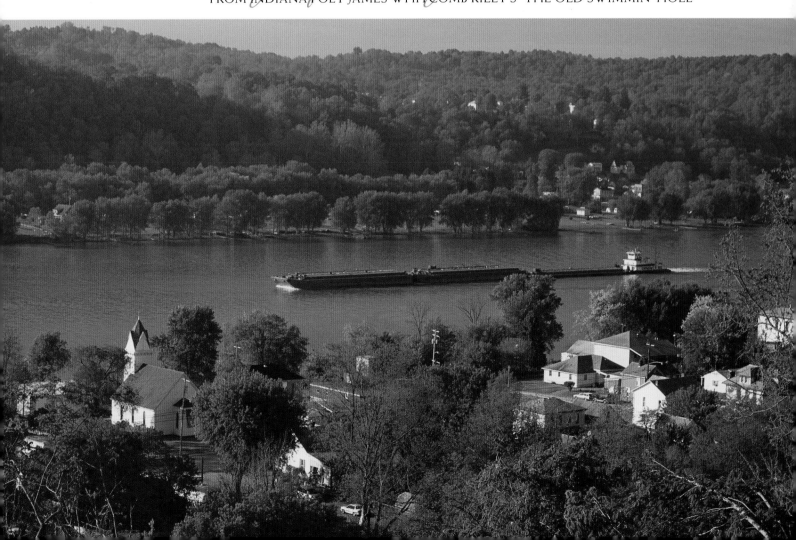

In the laid-back, V-shape foot of the Prairie State, where rugged Illinois Ozarks, longtime residents have a saying: "There's

farmlands begin to roll and then fracture into the foothills of the *time and then* THERE'S SOUTHERN ILLINOIS TIME."

Southern Illinois'
Garden of the Gods.

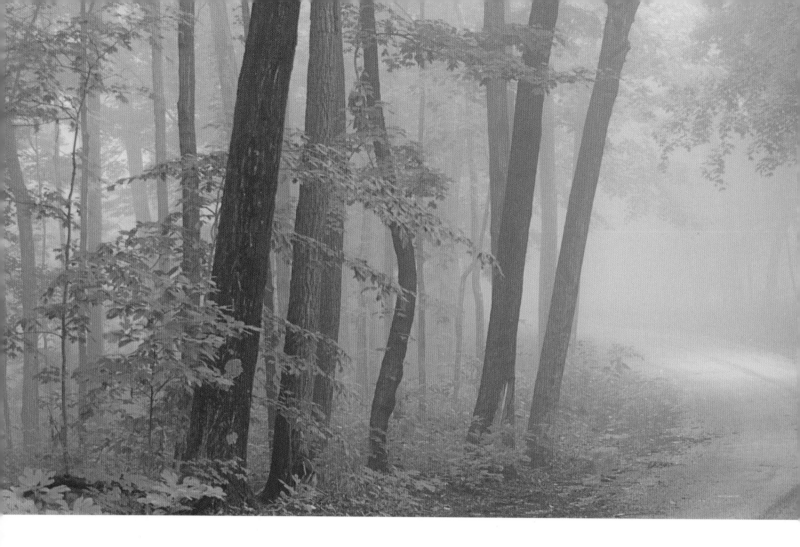

SUNDAY DRIVES *were a weekly appointment to savor*

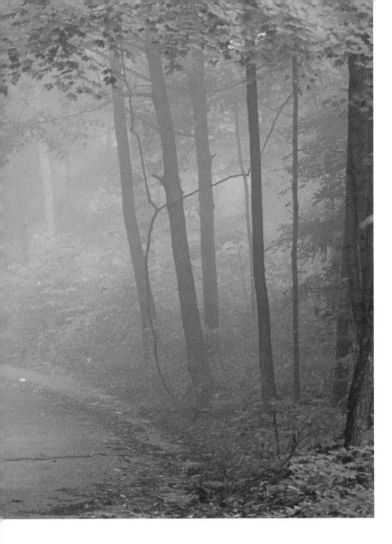

SUNDAY DRIVES HOLD A SPECIAL PLACE in American culture, right beside laundry on clotheslines and home-delivered milk. They're one of those quaint institutions that seem always to be dying, but never quite do.

Back when America's car culture was young, Sunday drives were a weekly appointment to savor fresh air and the newfound freedom of motoring mile after mile with serendipity as a tour guide. Today, those of us trapped in traffic every day wonder why anyone gets in a car for fun.

The answer is that leisurely cruises are as different from commuting as scanning the financial news is from reading a novel on a winter night. It's all in the getting there, the miles aimlessly unspooling like a long ribbon slipping from your hand. Take a map, if you must, but leave it in the glove box until dusk finds you hopelessly, joyously lost.

fresh air and the newfound freedom of motoring mile after mile.

If country is your taste, there are plenty of excuses to go wander two-lane roads. The rise of visitor-friendly farming presents tasty excursions throughout the Midwest. In Wisconsin's cheese country southwest of Madison, seemingly every other lush farm has a tasting room where you can try local varieties. In antiquing hot spots such as the Irish Hills southwest of Ann Arbor, Michigan, you can visit dozens of dealers in an afternoon.

Cities provided another option in the old motoring days, with families rolling down shady streets lined with magnates' stately homes. You can still enjoy those kinds of drives on streets like Saint Paul's Summit Avenue, which retains the air of the novels written by local son F. Scott Fitzgerald.

In the end, your drive's route matters less than your mindset. Destinations are never more splendidly lacking than on Sunday drives.

(Top) A route known as Skyline Drive cuts through Indiana's Jackson-Washington State Forest. *(Bottom)* Woods seem to stretch forever across southern Missouri.

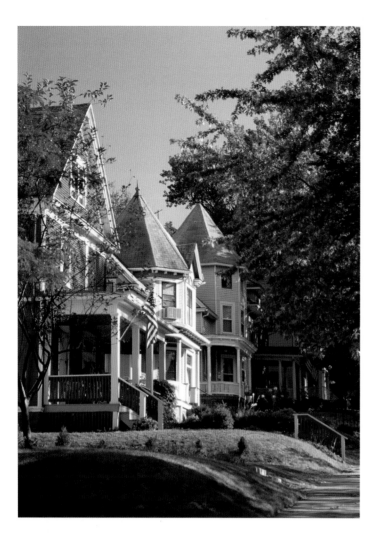

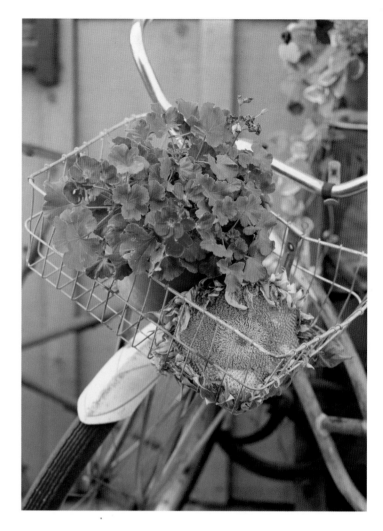

(Bottom row, from left) Hand-lettered signs advertising wares for sale along country roads are sure signs of spring across the region. The season arrives earliest in southern towns, such as Madison, Indiana, where this cast-iron fountain is a local landmark. A piece of Chocolate-Pecan Pie from Ohio's Clifton Mill is the reward for a spring trek over country roads. Driving among the orchards is a spring tradition in southwest Michigan.

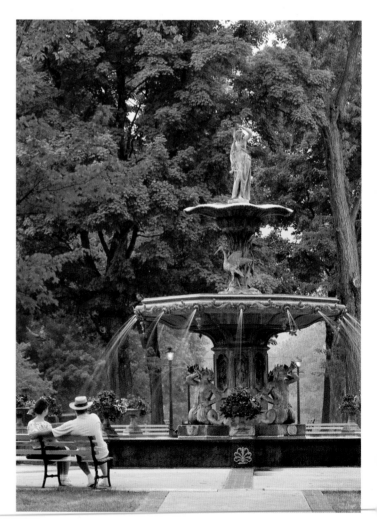

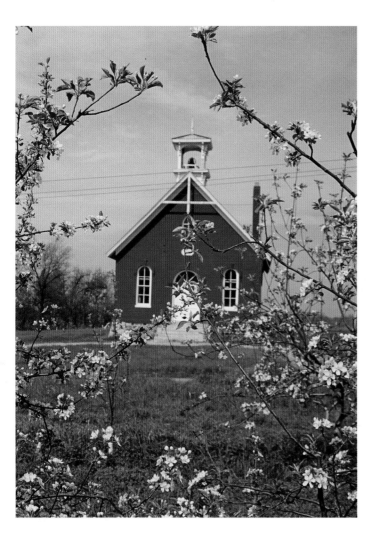

The moments I've cherished most as editor-in-chief of Midwest Living® have been spent driving down winding country lanes on sunny days, far from any interstate highway, feeling half lost and half found, without another person or car in sight. I love the sense of adventure, yet I always know I am somehow home. It confirms to me each time that there's no better place to be than right here in the Heartland.

DAN KAERCHER
EDITOR-IN-CHIEF

(Top row, from left) Rock Island, Illinois', Victorian homes are at their prettiest in spring. A vintage bike does double duty, displaying flowers. Southwestern Michigan orchards frame an old schoolhouse.

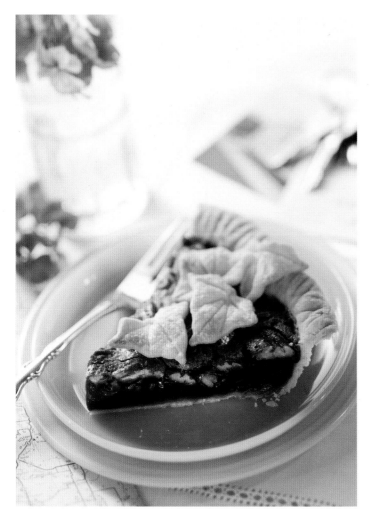

It's hard to VISUALIZE SPRING *without thinking of*

GO AHEAD: TRY TO THINK OF SPRING
without picturing a farm. No thoughts of plowing allowed.
No sprouting plants. No fuzzy little ducks. No Wisconsin
dairy calves bucking and snorting across green pastures
with white faces so bright they look like someone scrubbed
them for a trip to Sunday school.

Spring is, more than any other season, a concept we can
hardly visualize without farms. That's still true even though

our farms, even though few of us still work the land.

few of us still work the land: only about 1.9 percent of
Americans, compared to 40 percent a century ago.

But even if trips to Grandma's farm largely have given way
to visits to her townhome, the farm comes to mind with the
return of the growing season. And when we feel an urge to
go see things sprouting, the Midwest is definitely the place
to be. Six of the top 10 agricultural states are here, including
the top 10 corn states, nine of the top 10 soybean states
and the second- and third-most productive beef states.
Together, the 12 Midwest states annually produce $90
billion worth of agricultural products.

In Michigan, spring brings orchards exploding with color
and natural perfume. In Iowa, it's corn and soybean fields
sprouting green stripes. And in Kansas, winter wheat usually
provides a farm's earliest push into spring. While other
crops are still seeds waiting in the machine shed, the wheat
(planted in fall) is already growing in vast Great Plains fields.
Its green shoots look like a sparse lawn, shimmering even in
the face of harsh winds that still feel more connected to
March's February side than its April end.

Soon, it's warmer, with baby animals peeking through
fence lines and farmers plowing the black ground in earnest.
Their work releases the rich smell of earth. It's the scent
of promise. The scent of the land awakening. It is the scent
of spring.

Dairy cattle graze in a lush Wisconsin pasture.

One of my favorite images of the Midwest is the topography. While some may not consider the flat farmlands of Illinois where I grew up to be particularly attractive, I've always loved their symmetry and order and, of course, the bounty they produce. I moved to Connecticut after college, and on airplane trips, I would know instantly from 25,000 feet up that we were flying over the Midwest because of the patchwork quality of the fields and farms. And I still feel that rolling farmland is one of the prettiest sights when I'm driving through the countryside.

ELLEN BROTHERS
PRESIDENT OF WISCONSIN-BASED
AMERICAN GIRL

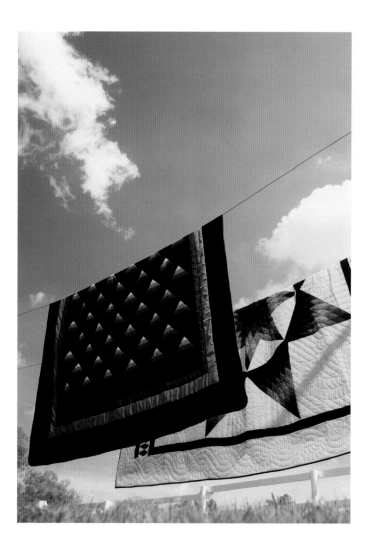

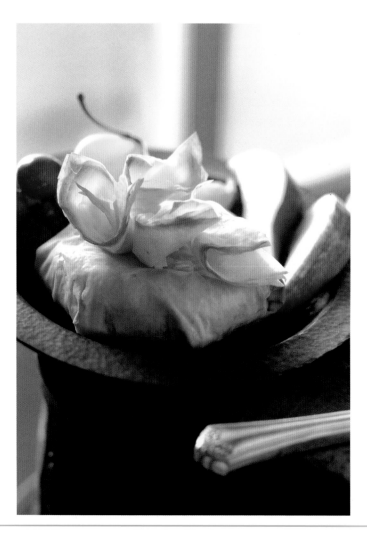

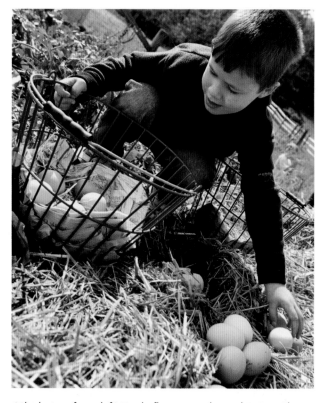

(Clockwise, from left) Fresh flavors, such as this Big Cheese Appetizer made with Gouda, are a fringe benefit of farming. Quilts get a spring airing on an Amish farm. Egg gathering often falls to the youngest member of a farm family. (Opposite) Iowa boasts some of the Midwest's richest farmland.

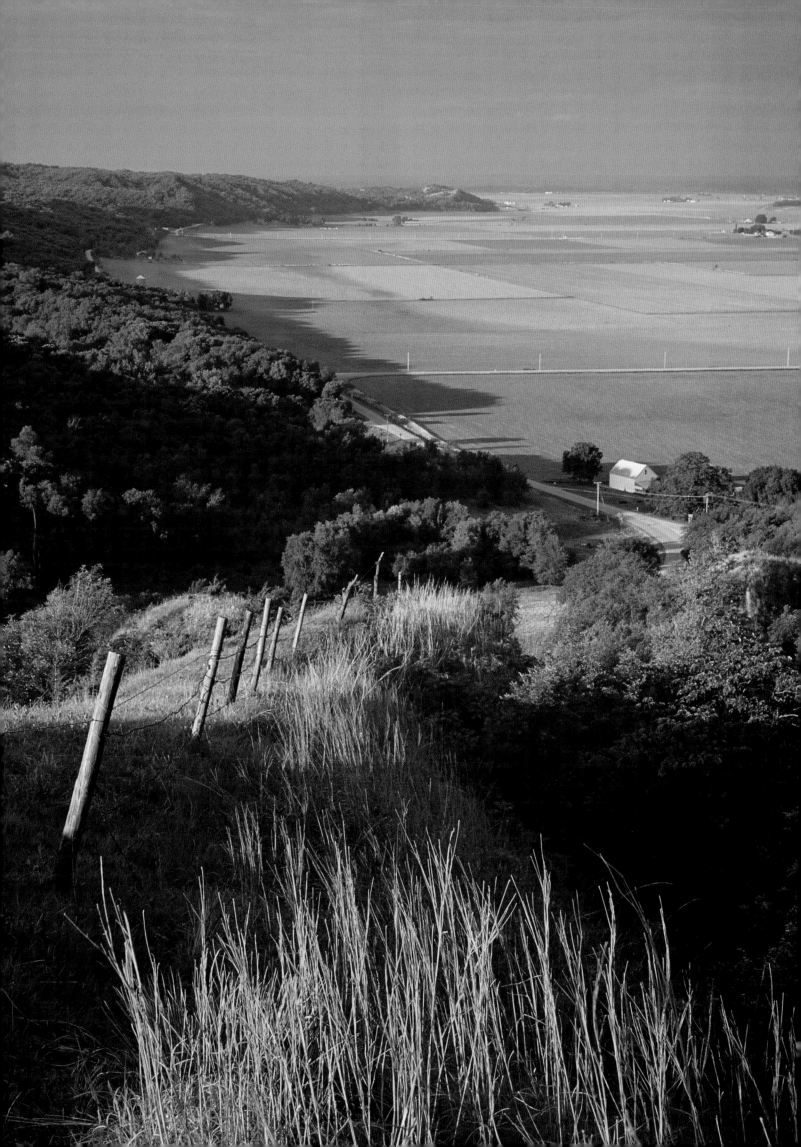

Other holidays repose on the past; ARBOR DAY PROPOSES

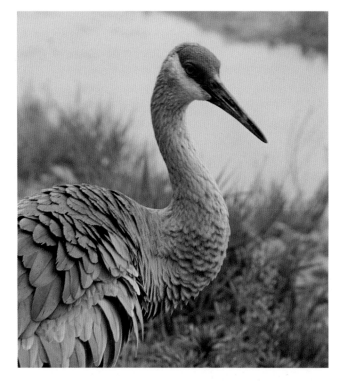

(Top row, from left) A family outing. A light breakfast of Eggs Flo. Planting a tree on Arbor Day in Nebraska. (Bottom row, from left) A sandhill crane in Nebraska. The lush, bayoulike Cache River State Natural Area in southern Illinois. A fresh and easy 24-Hour Tex-Mex Salad. Contemplation in Door County, Wisconsin.

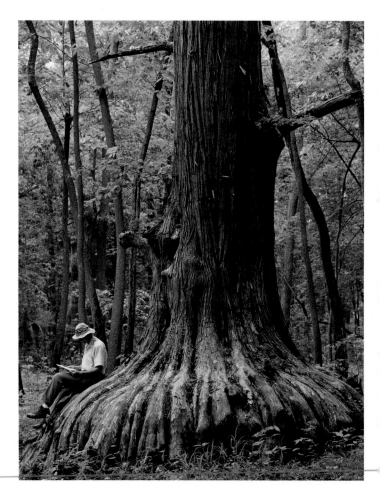

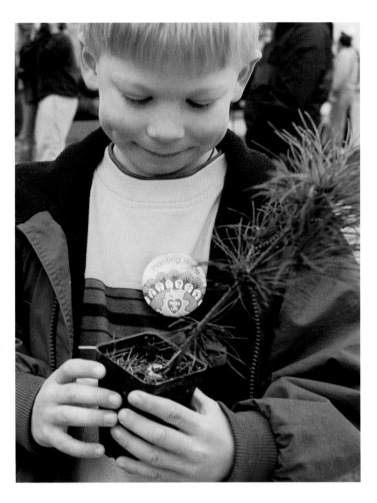

PLANTING A PASSION

It may sound like the height of irony: Arbor Day—the April holiday devoted to planting trees—sprouted on the open canvas of the Nebraska prairie. And why not? Where else would settlers find themselves in greater need of the shade, erosion control and beauty that trees provide? It started when J. Sterling Morton and his wife moved to southeastern Nebraska from Detroit in 1854. The couple missed Michigan's comforting foliage, so they went to work planting trees. Eventually, a forest grew up around their stately home, Arbor Lodge in Nebraska City, but Morton had a vision for something bigger. His platform as a newspaper editor helped him spread his idea, and the first Arbor Day took place on April 10, 1872, when Nebraskans planted more than 1 million trees. The holiday soon spread nationwide and now is observed in most states on the last Friday in April. Today, the National Arbor Day Foundation still gives away more than 6 million trees annually, driven by the passion captured in Morton's words inscribed in stone at the Lied Conference Center near Arbor Lodge: "Other holidays repose on the past; Arbor Day proposes for the future."

FOR THE FUTURE. ARBOR DAY FOUNDER AND NEBRASKA RESIDENT J. STERLING MORTON

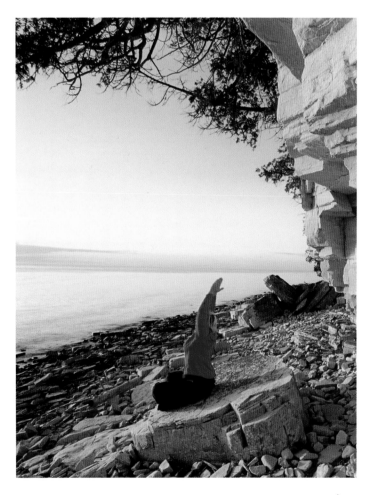

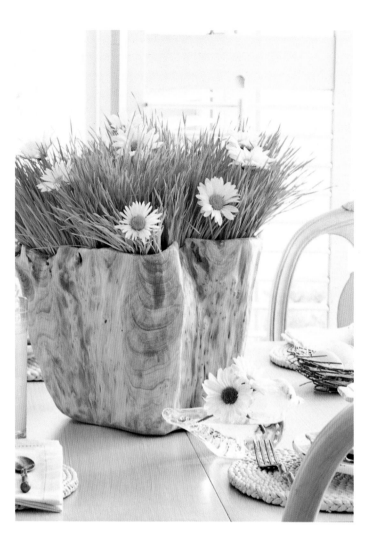

The season's first warm breezes inspire us to throw open windows and refresh our winter-bound homes. As nature reawakens, I renew my home's decor with a few small but noticeable changes: Hanging sheer curtains in gauze or voile. Making my bed with cool, silky, high-thread-count cotton sheets. Lightening up my sofa with white canvas slipcovers. I also like to delight guests with natural tabletop accents, like arranging grasses and daisies in a wood-root centerpiece bowl (right). And I replace the wreath on my front door with, say, a basket planted with sweet potato vine and petunias. These ideas infuse my home with a fresh, organic calm.

CAROL SCHALLA
SENIOR HOME EDITOR

(Clockwise, from above) Spring thoughts turn to concoctions such as this Gougére Salad with tender leaves and sprouts. Refreshing our homes for spring is an annual ritual. Cut lilacs are a chance to bring the season inside. *(Opposite)* A fly fisherman casts in a northeast Iowa stream, another rite of spring repeated across the Heartland.

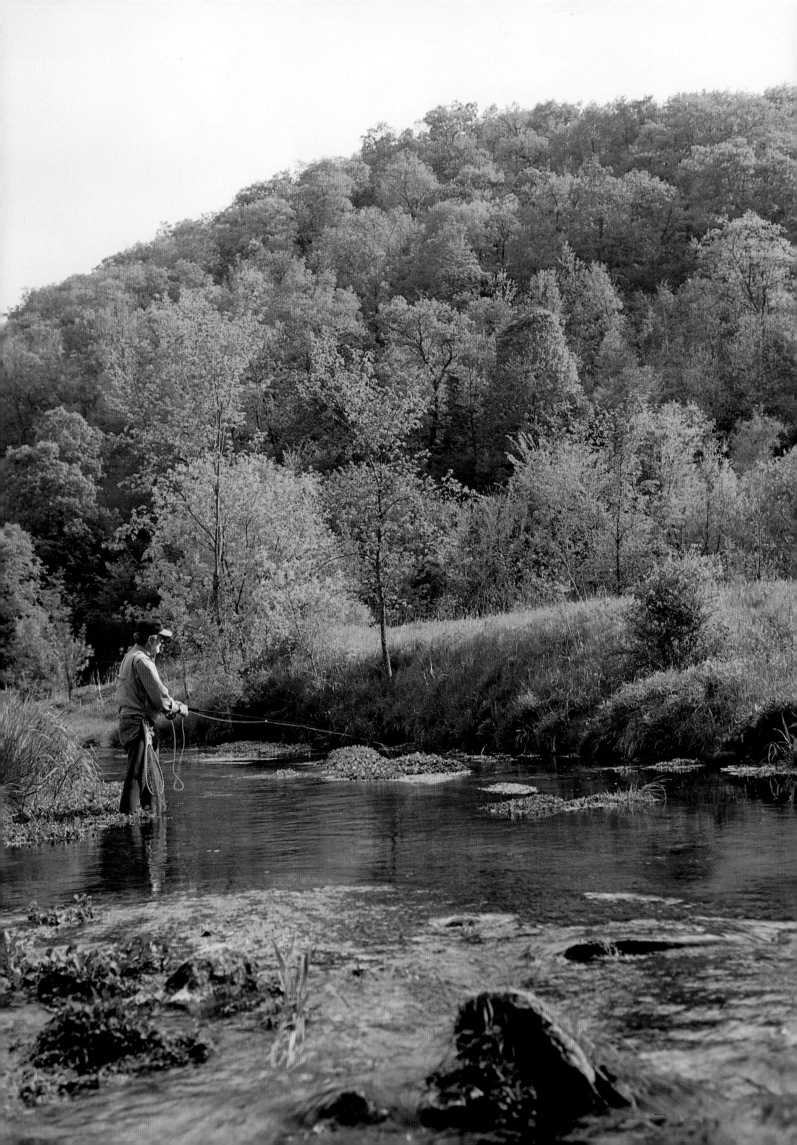

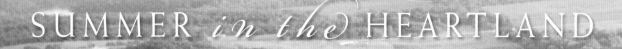

Explor

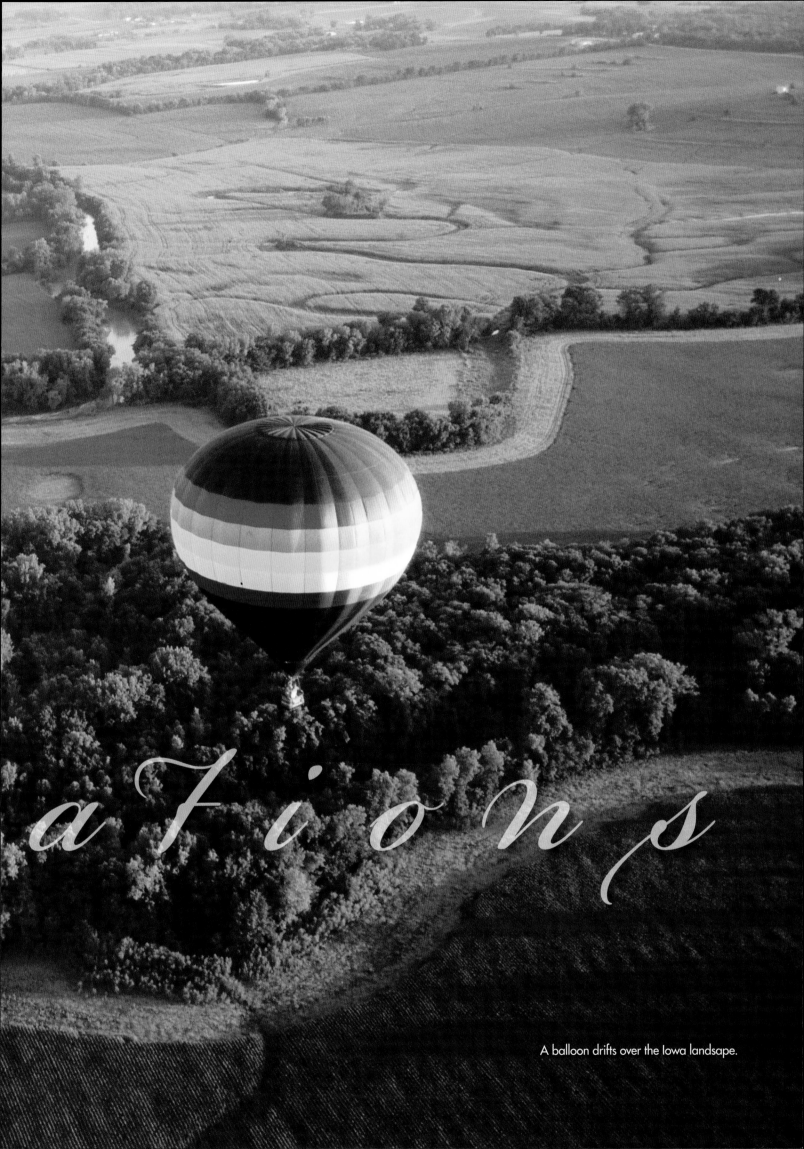

ations

A balloon drifts over the Iowa landsape.

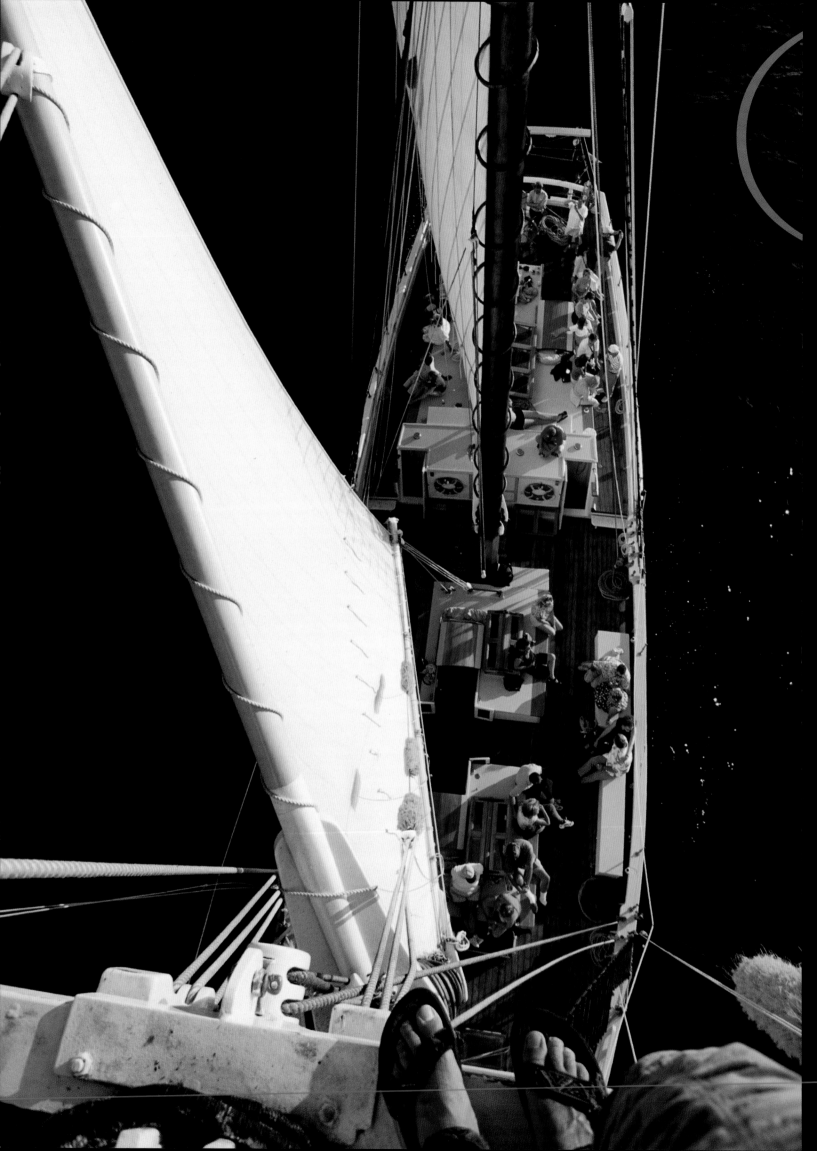

ollow your dreams to the top of a mountain or the banks of a trout stream. Ride that new bike trail or take sailing lessons on a Great Lakes schooner. Midwest summers issue a call to action as compelling as Fourth of July fireworks and as irresistible as a second bite of watermelon. This is the season to get out to the places we love or have been dreaming about—on a boat skimming across one of Minnesota's endless lakes, on a trail ride beneath wide, blue North Dakota skies or into the crowds streaming along Chicago's Magnificent Mile. We head for the cabin that's become a family tradition or make pilgrimages to the icons that we believe everyone should experience, whether it's South Dakota's Mount Rushmore or Hannibal, Missouri, the hometown of Mark Twain and, in a way, the whole Midwest.

This is the season that calls to our wandering spirit, the urge that prodded the pioneers across the Ohio River, then the Mississippi and Missouri onto the plains of Nebraska and Kansas. It's the force behind the daring monument to their passing, the St. Louis Arch, and the curiosity that propels hundreds to ride 630 feet to the top just for the long view. We want to see something new. Maybe a remote Lake Superior lighthouse hidden among Wisconsin's Apostle Islands and reachable only by water. Or a footprint-free beach in Nordhouse Dunes Wilderness along Michigan's western shore. We crave fresh, new tastes: inventive dishes chefs create from the season's bounty at city farmers markets or wines that seem to embody the rich soil and lake breezes of Michigan's Leelanau Peninsula.

Taste it. Do it. See it. If not now, when? Behind this question lies the urgency that makes every season so precious, but maybe summer most of all.

Crew members get a bird's-eye view from the foremast of the tall ship *Manitou*, which sails on Lake Michigan's Grand Traverse Bay out of Traverse City, Michigan. The Traverse Tall Ship Company offers two-hour tours and multiday cruises in which guests sleep aboard the ship and have a chance to take the ship's wheel.

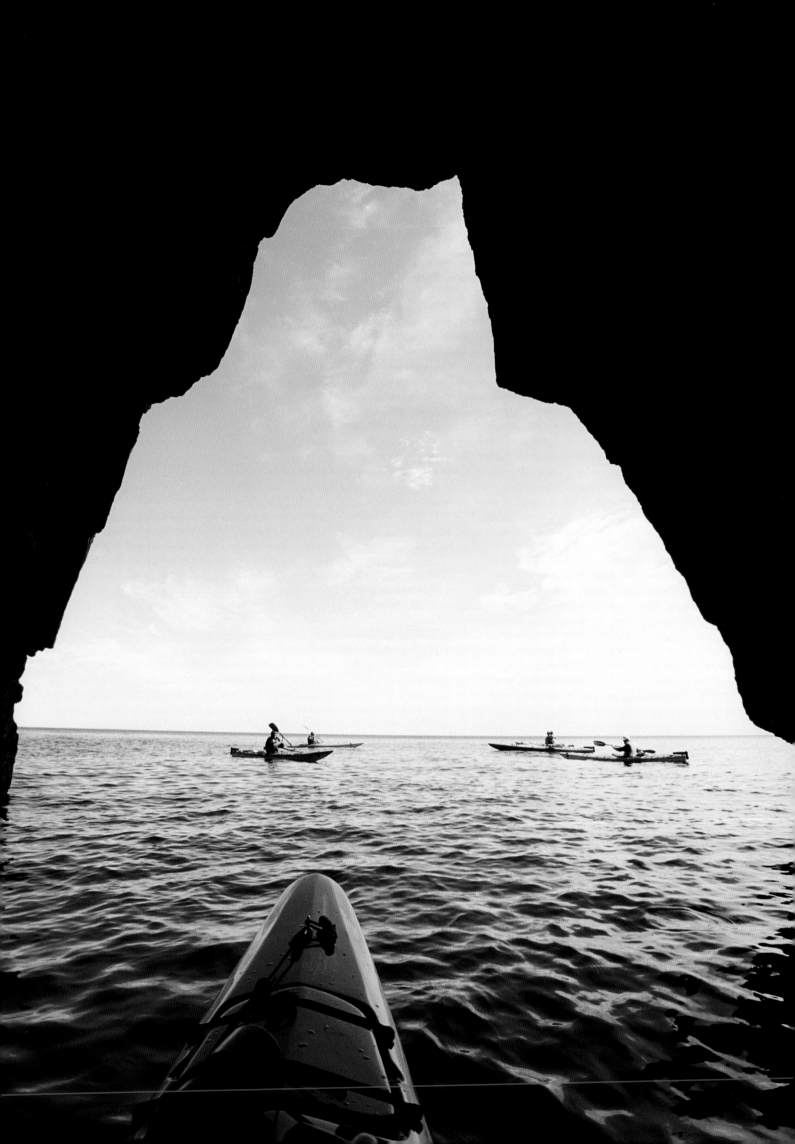

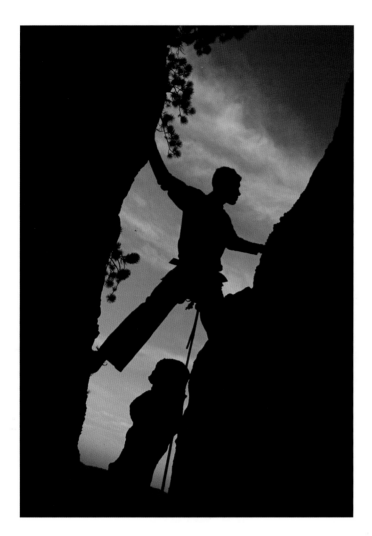

Vacations in lake country (north-central Minnesota, in my family's case) are a chance to step out of the whirlwind of regular life and be together. What do we do once we get to the lake cabin? Not much. That's what we love about these trips. Watching the lake is an important agenda item—over coffee in the morning and wine in the evening. Then there's swimming (more like floating), fishing, stretching out on the beach with books and playing games around the kitchen table after dinner. The best part is talking, talking and talking some more. That's something we never seem to find enough time for.

BARBARA MORROW
SENIOR TRAVEL EDITOR

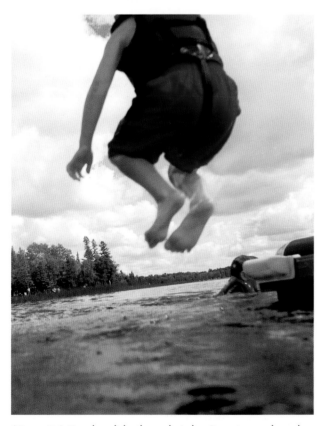

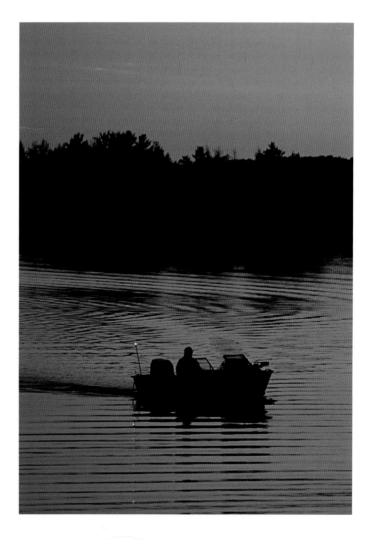

(Opposite) Kayaks glide through Lake Superior rock arches along Minnesota's North Shore. (Clockwise, from above) Summer brings the freedom to find adventure in resorts such as in Park Rapids, Minnesota; South Dakota's Black Hills; and Lake Chippewa in Hayward, Wisconsin.

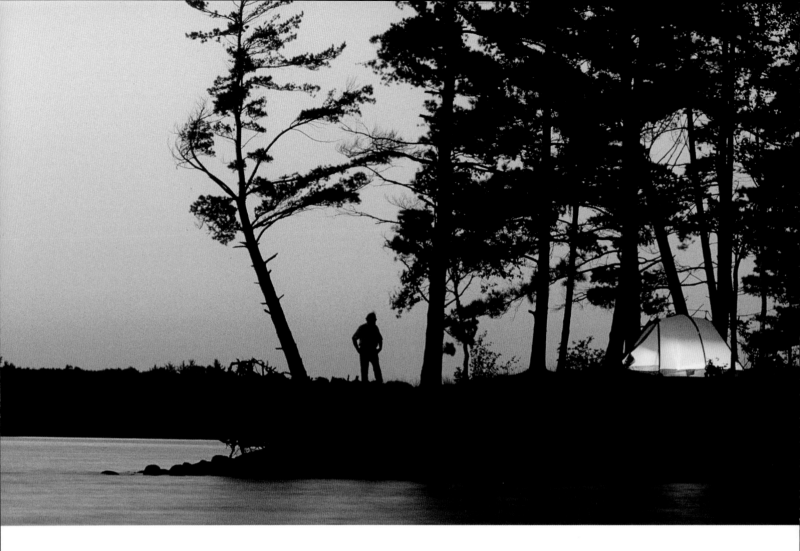

WE LOVE THE WATER—*the deep blue of North Woods*

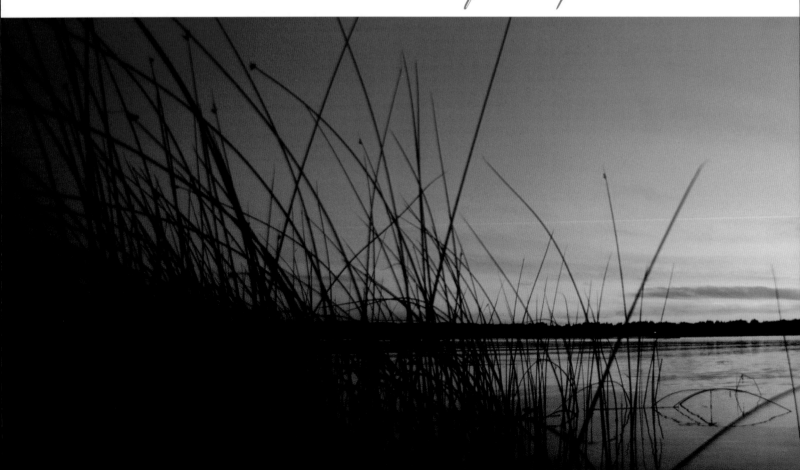

"WE'RE GOING TO THE LAKE." There's no need to say more, really.

We love the water—the deep blue of granite-rimmed North Woods pools, the topaz of waves lapping against a Great Lakes beach, the soft aqua of a summer-warmed reservoir. Floating, splashing, wading or skimming across the surface in a boat or on skis—all are the stuff of winter daydreams. And they're just part of the appeal of the lake.

In the tradition of 19th-century vacationers who left behind their formal city lives to head for lakeside summer houses and resorts, we look forward to laid-back days. We may head for that much-loved lake house or a basic "cabin." If it's at a resort, chances are the accommodations have many of the modern comforts of home.

If there is to be an agenda, it reads something like this:

pools, the topaz of waves lapping against a Great Lakes beach.

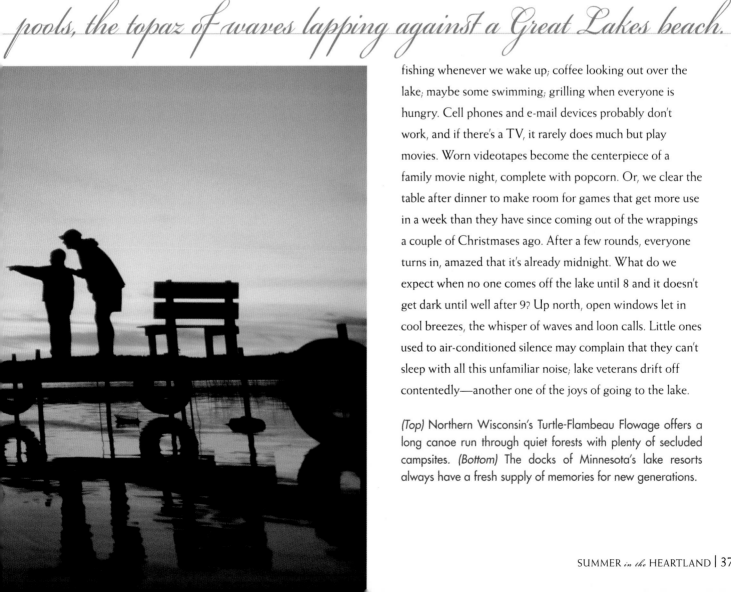

fishing whenever we wake up; coffee looking out over the lake; maybe some swimming; grilling when everyone is hungry. Cell phones and e-mail devices probably don't work, and if there's a TV, it rarely does much but play movies. Worn videotapes become the centerpiece of a family movie night, complete with popcorn. Or, we clear the table after dinner to make room for games that get more use in a week than they have since coming out of the wrappings a couple of Christmases ago. After a few rounds, everyone turns in, amazed that it's already midnight. What do we expect when no one comes off the lake until 8 and it doesn't get dark until well after 9? Up north, open windows let in cool breezes, the whisper of waves and loon calls. Little ones used to air-conditioned silence may complain that they can't sleep with all this unfamiliar noise; lake veterans drift off contentedly—another one of the joys of going to the lake.

(Top) Northern Wisconsin's Turtle-Flambeau Flowage offers a long canoe run through quiet forests with plenty of secluded campsites. *(Bottom)* The docks of Minnesota's lake resorts always have a fresh supply of memories for new generations.

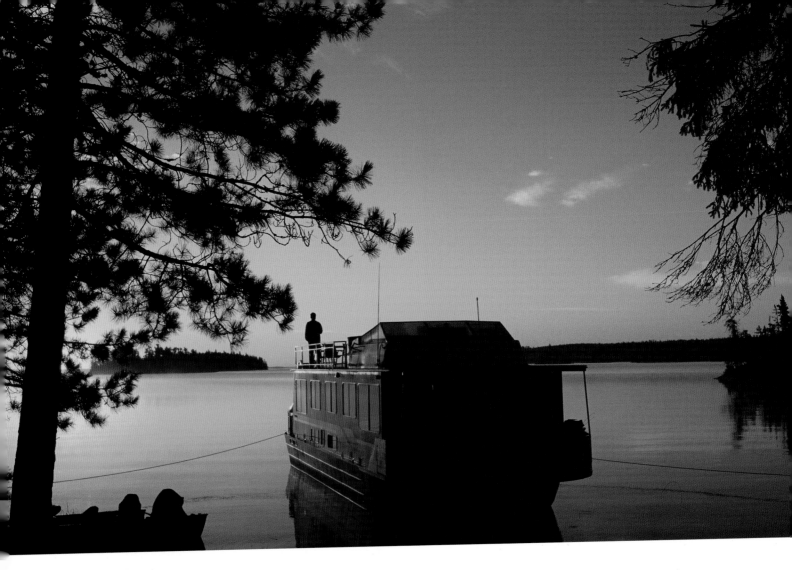

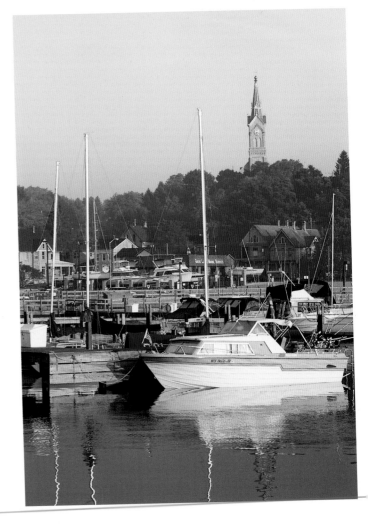

(*Top row, from left*) Houseboats reach the remote nooks of Minnesota's Voyageurs National Park. Cheery sunlight fills a lake home. (*Bottom row, from left*) Cabins tuck into the trees at Ross' Teal Lake Lodge in Hayward, Wisconsin. Boats loll in the harbor at Port Washington, Wisconsin. Docks are great for daydreams and dangling toes.

THE PERFECT LAKE TRIP

There are pros for everything, including having fun. Here are their tips for making the most of your lakeside vacation.

BUILD SAND CASTLES—Enrico Schaefer and his sons won the 2004 Traverse City, Michigan, Family Sand-Castle Building Competition. He suggests building where the sand is not too runny, but just wet enough to stick together. Build a pile first, and sculpt from that. Protect it with a breakwall, and don't forget a moat, which looks cool and is fun to splash in.

TELL A GHOST STORY—Carole Lanham, member of Midwest Horror Writers and a former Girl Scout, says use a whispery voice, personalize the tale and include the outdoors. Campfires create ghastly shadows. And every snap in the woods can play into stories about a night...just...like...tonight.

GET INTO A HAMMOCK—Bob McElroy, a vice president at Wisconsin-based Lands' End, suggests sitting in the hammock like a chair, then pivoting your feet and head into position.

MAKE A S'MORE—Here's how Bob and Jennifer Bateman of Two Inlets Resort in Minnesota make an easier version of this classic: Use fudge-striped or chocolate-covered cookies in place of graham crackers and chocolate bars.

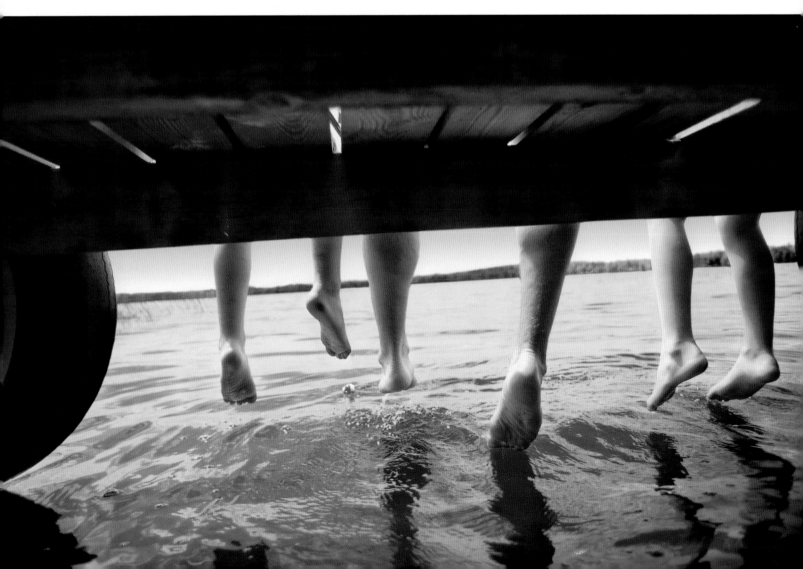

I've always loved the Midwestern landscape, and I just love coming home to the beautiful fields, hills, woods and streams of Missouri. Also, the Midwest is such a family-based area with a great neighborhood feel. That feeling has always been the major inspiration behind my work. People tell me they connect with my illustrations because I show everyday moments between families and friends, and those are experiences we all share.

MARY ENGELBREIT
St. Louis-based illustrator

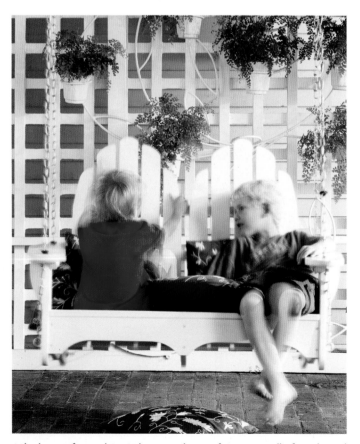

(Clockwise, from above) The ingredients of summer: idle friends and a moving swing, a welcoming front porch and a cool Double Berry Cobbler. *(Opposite)* Hot summer days pass leisurely with a rocking chair and a view, such as at this Bay View, Michigan, cottage.

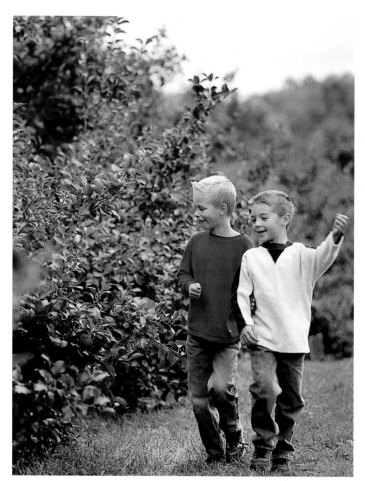

In the Midwest, sweet BLUEBERRIES AND CHERRIES

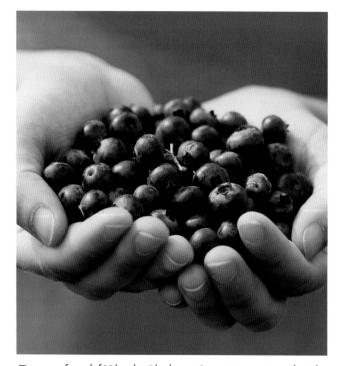

(Top row, from left) Blender Blueberry Sauce is easy to make. The tempo slows at Deer Lake Orchard near Buffalo, Minnesota. Berry-Apple Fantasy Pie features blackberries. *(Bottom row, from left)* Fresh blueberries star during summer. Raspberries and Cool Cheesecake Sauce perk up a parfait. Michigan cherries glisten. Two girls savor the berry harvest near Forest Lake, Minnesota.

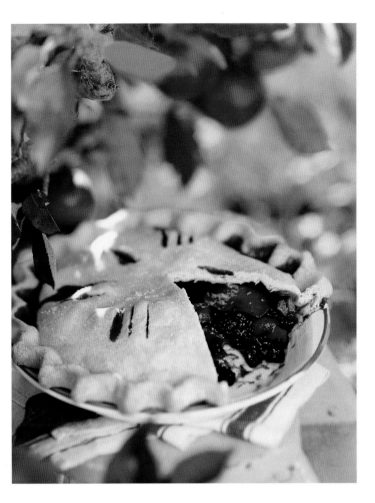

BRIMMING WITH BERRIES

Bite-size, boldly colored and bursting with juice—the summer berry brings memorable delights. In the Midwest, we cherish these mini fruits. Blueberries. Cherries. Raspberries. Blackberries. Strawberries. Even old-fashioned mulberries and gooseberries. As you sidle up to that mid-July slice of fresh blueberry pie, remember to thank Michigan. The Great Lakes State leads the nation in blueberry production, harvesting more than 18,000 acres that produce nearly a third of the blueberries eaten in the United States. The state's Fruit Belt also produces 250 million pounds of cherries each year, or three-quarters of the country's tarts. For most Midwesterners, the fruit we've been waiting for doesn't travel far from the growers to the grocers. Of course, for ultimate freshness, we can pluck our own right off of the bushes heavy with fruit, filling our baskets (and tasting just a couple). You-pick farms abound, especially in Michigan, Minnesota and Wisconsin, and many families make an annual tradition out of visiting one, sifting through nature's bounty under the warmth of the summer sun and bringing home the sweet rewards.

don't have to travel far from the growers to the grocers.

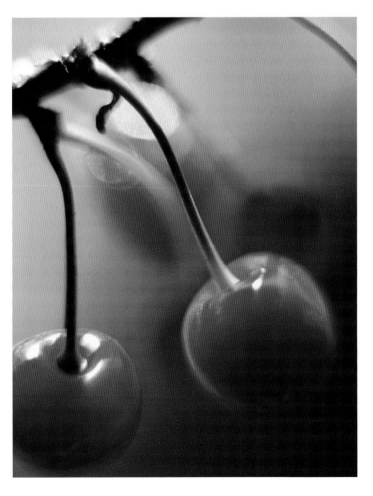

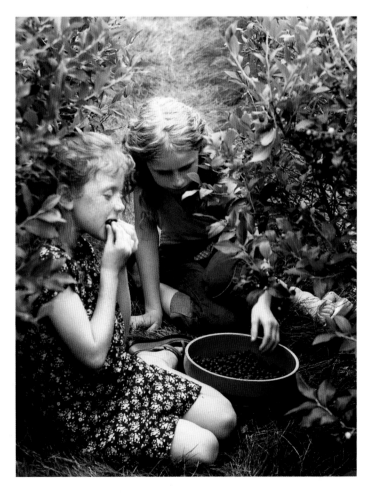

Our state fairs represent A UNIQUE CROSSROADS

(Top row, from left) Delectables like Canfield Fair Angel Food Cake win blue ribbons. Boys prep for the show ring. *(Bottom row, from left)* Many fair goers fall for corn dogs. Midway rides get the heart racing. Food stands blanket the Iowa State Fair.

A REGION'S LOVE A-FAIR

Where else can you gorge yourself on corn dogs, learn to milk a cow, climb a giant ear of corn, compete in a husband-calling contest and see a horse show and classic rock act—all in the same day? At a state fair, of course! It's a good thing these blowouts come only once a year. We need that long to work up our stamina and appetites. Michigan launched the country's first state fair in 1849 as a festive gathering of farmers. And while fairs continue to absorb society's changes, their spirit remains a celebration of roots. Innovations and the latest cultivars of plants share the stage with homemade jams from longtime family recipes or a youth representing a family's fifth generation to show livestock. Traditions stitch it all together. In Iowa, the muse for the novel and musical *State Fair*, it's Ye Old Mill, a tunnel-of-love ride couples have been cuddling in since 1921. In Minnesota, where typically more than 1.6 million people attend, it's Princess Kay of the Milky Way, honored each August by her image being carved in butter. And at every fair, it's knowing where to find your favorite food-on-a-stick vendor, year after year.

of a region's culture, including the many colorful quirks.

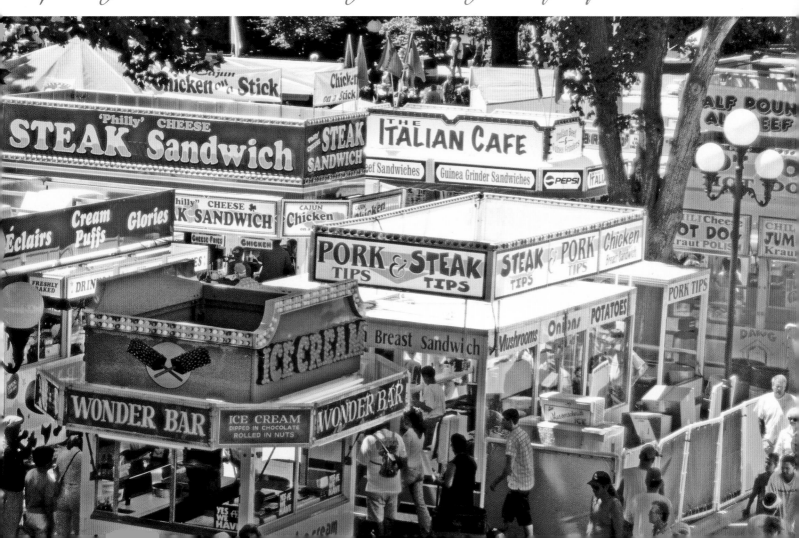

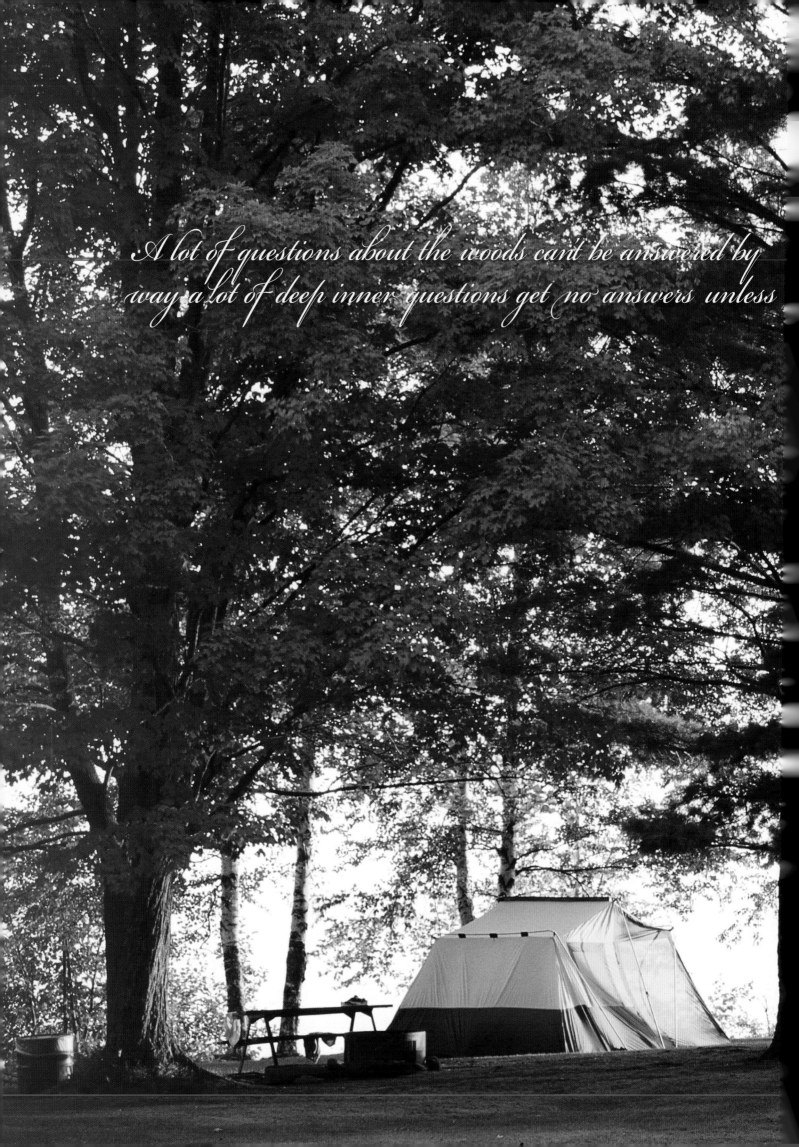

A lot of questions about the woods can't be answered by way a lot of deep inner questions get no answers unless

*staying all the time in the woods, and it also works the other
you go for* A WALK IN THE WOODS. NORMAN MACLEAN, AUTHOR
OF *A RIVER RUNS THROUGH IT*
AND UNIVERSITY OF CHICAGO
LITERATURE PROFESSOR FOR
MORE THAN 40 YEARS

Little Girl's Point overlooks Lake
Superior in Michigan.

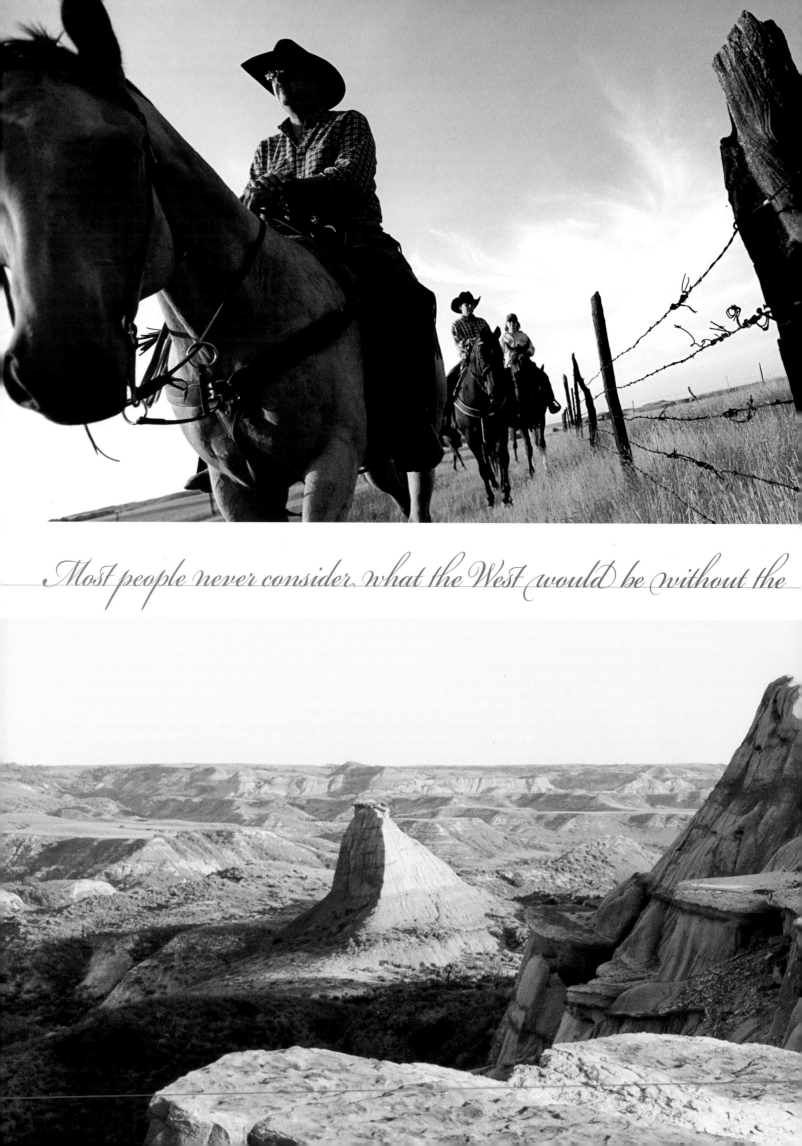

Most people never consider what the West would be without the

WHAT WOULD AMERICA BE WITHOUT THE WEST? About one-third as big, sure, but beyond that, the country would have an entirely different self-image. Our national identity is woven like a Navajo rug with legends of wide-open spaces and rugged individualism. But most people never consider what the West itself would be without the *Mid*west.

America's truly big country starts here. When you cross a Missouri River bridge at places like Omaha, you leave the forests and pocketed farm fields of the lush eastern prairie. You blaze along one of four parallel fingers pointing west (Kansas' I-70, Nebraska's I-80, South Dakota's I-90 and North Dakota's I-94), your windshield transforming into something akin to a portable IMAX screen. Sky and land bend away to the horizon, distorting distance until ridges 50 miles away seem within walking distance.

Midwest. AMERICA'S TRULY BIG *country starts here.*

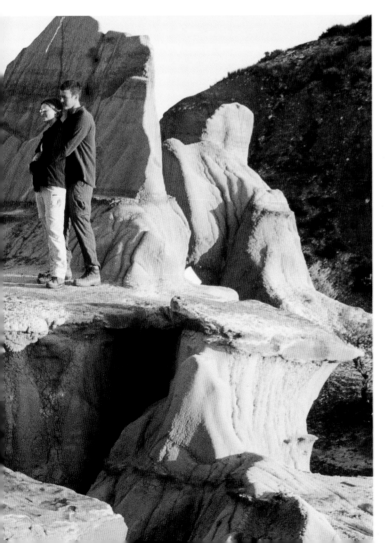

This is how many Midwest kids first taste the West. On summer pilgrimages to Mount Rushmore or the Rockies, they gaze out, seeing the first *and* last cars of a train simultaneously for the first time. They sit astride a horse in their sneakers and shorts, nervously taking the reins from a guy who just might make their summer by saying, "Here you go, *cowboy.*" Eventually, the families reach the real wonders, like the badlands of North and South Dakota. The places are so sweeping and surreal that the kids can describe them only in comparisons to Westerns—or video games—they've seen.

It's a landscape with a long history of shaping people. Illinois' Wyatt Earp first made his name in Dodge City, Kansas. Buffalo Bill invented his Wild West Show on a Nebraska ranch. Even that unmistakable New Yorker Teddy Roosevelt said, "I never would have been president if it had not been for my experiences in North Dakota." Not bad for a trip to the Midwest.

(Top) Riders explore the prairie of the Knife River Ranch near Golden Valley, North Dakota. *(Bottom)* The badlands of Theodore Roosevelt National Park in North Dakota make travelers feel as if they're the first to set foot in the place.

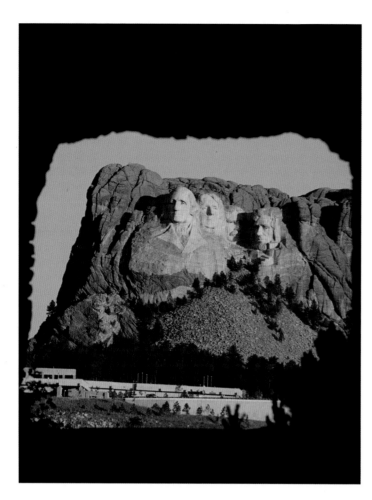

After a man has lived on or near them (the plains), their very

(Bottom row, from left) Horseshoes work as fence-tighteners on the Kansas range. The Tallgrass Prairie National Preserve near Strong City, Kansas, has hosted the Symphony in the Flint Hills. Horses are vital partners on North Dakota's Knife River Ranch. A classic Western feast: Smoked Beef Brisket with corn and beans.

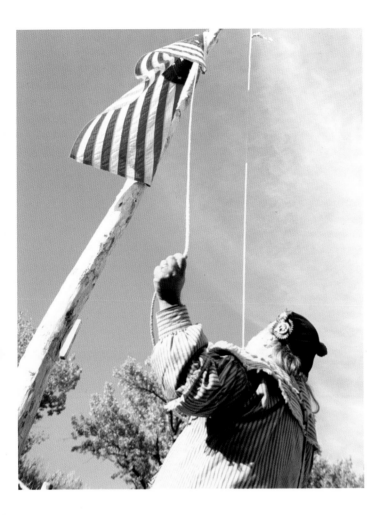

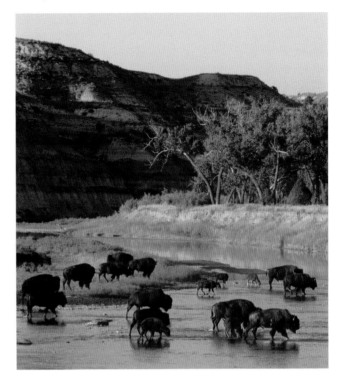

(Top row, from left) Highway tunnels frame views of Mount Rushmore in South Dakota. Kansas' Pawnee Rock Memorial honors the land's early settlers. Flag raisings at Fort Mandan, North Dakota, recall Lewis and Clark's time here. Buffalo roam through North Dakota's Theodore Roosevelt National Park.

vastness and loneliness have a STRONG FASCINATION.

THEODORE ROOSEVELT

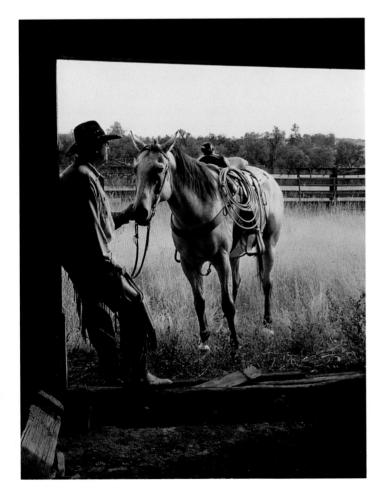

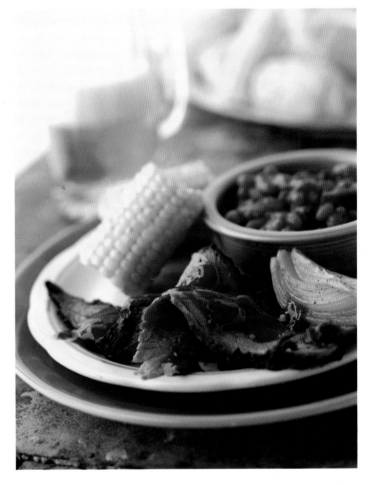

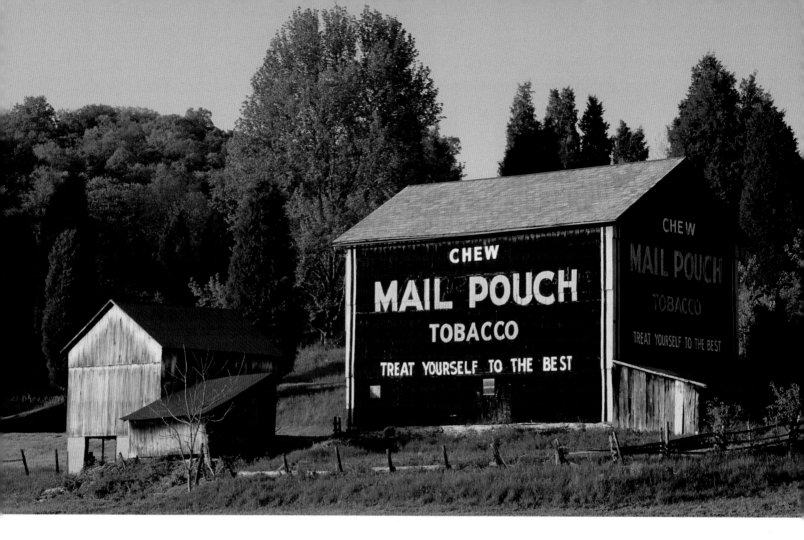

No one can appreciate my sadness at this parting.

(Top row, from left) Ohio country roads still lead past Mail Pouch Tobacco barns. Living history farms share the past. *(Bottom row, from left)* The Old Cowtown Museum in Wichita, Kansas, portrays pre-1880 life. A fur trader built the Villa Louis mansion on an 1814 battle site in Prairie du Chien, Wisconsin. The Old Capitol in Springfield, Illinois, holds poignant Lincoln history.

PRODUCT OF THE LAND

He was born into poverty in 1809, lived in a one-room log cabin with his parents and four siblings and had less than a year's worth of formal education. He taught himself to read by firelight, took his first job as a ferryman on the Mississippi River and won respect as a store clerk in New Salem, Illinois, by besting a local ruffian in an arm-wrestling contest. But by the time he died in 1865, Abraham Lincoln had served for four years as president of the United States, standing firm in his belief that the country should remain unified and all people, regardless of race and background, should be free. His election in 1860 led to the Southern states' secession and, six weeks after his inauguration, to the Civil War. Lincoln always cherished the time he spent in the Midwest before climbing onto the national stage. The short but emotionally charged speech he made at the depot near his home in Springfield, Illinois, before leaving for Washington, D.C., lives on at the Abraham Lincoln Presidential Library and Museum: "My friends, no one, not in my situation, can appreciate my feeling of sadness at this parting. To this place, and the kindness of these people, I owe everything."

To the kindness of these people, I OWE EVERYTHING.

ABRAHAM LINCOLN, UPON LEAVING ILLINOIS

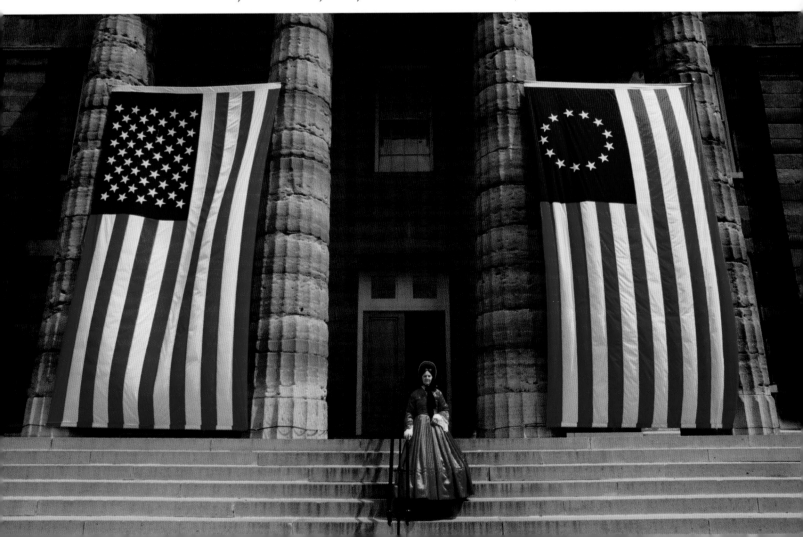

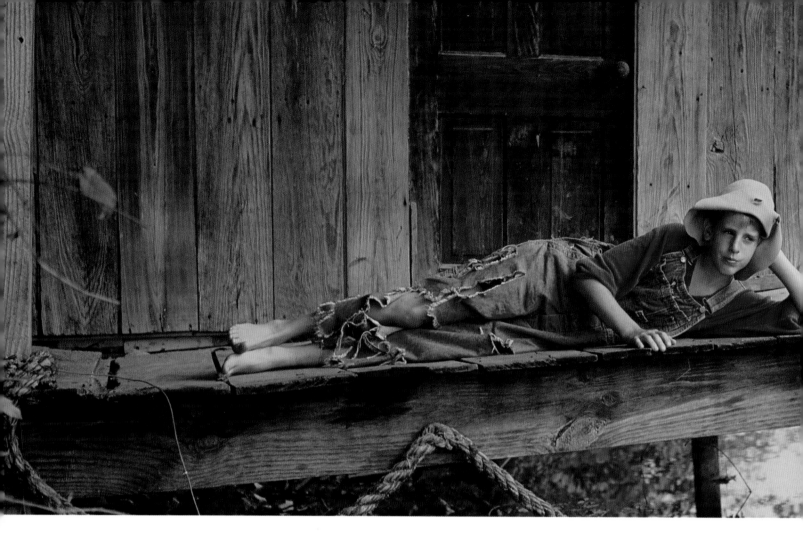

The river is a PATH TO OUR HISTORY, and towns and

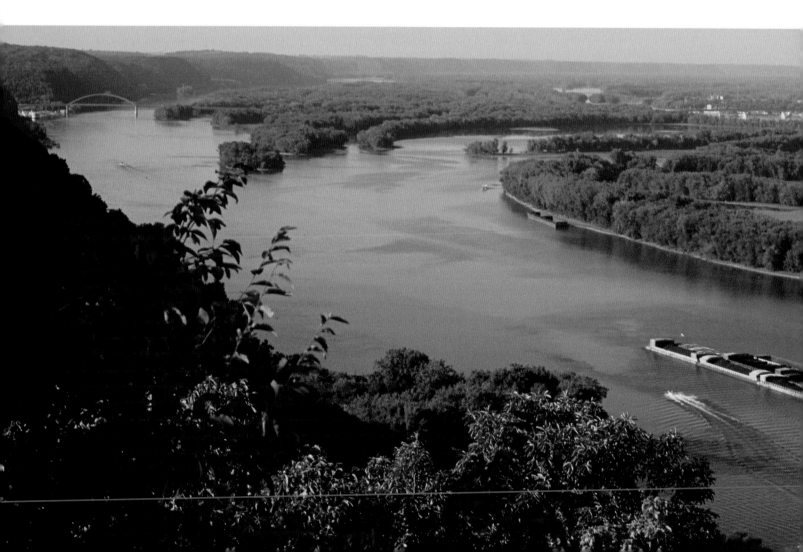

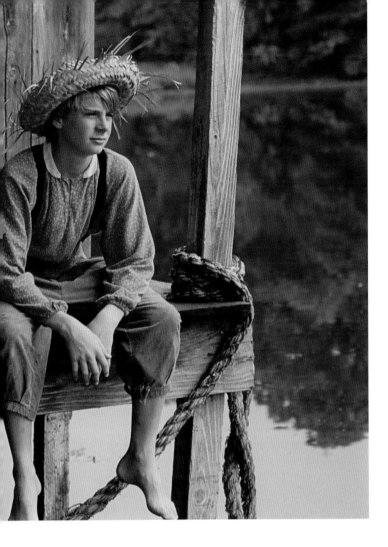

MARK TWAIN COMPARED the Mississippi River to a book. "And it was not a book to be read once and thrown aside, for it had a new story to tell every day," he wrote in *Life on the Mississippi*. The onetime river pilot probably would be gratified to know that the nation's mightiest waterway remains fascinatingly difficult to know.

Its length is 2,552; 2,300; 2,230 or 2,350 miles, depending on the source you consult. The shallow stream spilling from northern Minnesota's Lake Itasca bears little resemblance to the broad waterway spreading into Lake Pepin and around green islands south of the Twin Cities. The river transforms again into a muscular flow through 29 locks and dams and past St. Louis. It's a wilderness for eagles, tundra swans and other endangered birds that thrive in the Upper Mississippi River Wildlife Refuge, the country's longest at 261 miles.

historic sites on its banks hold significant parts of our story.

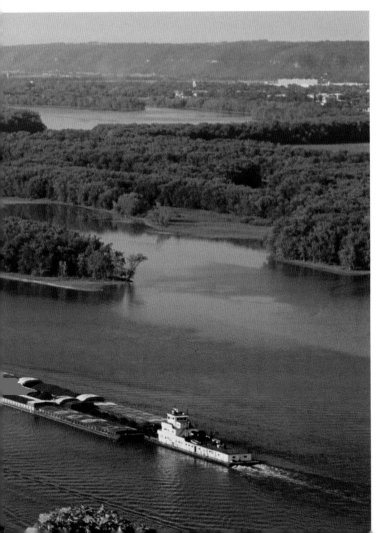

The towns and historic sites along the river's banks hold significant parts of our national story. Cahokia Mounds National Historic Site in Illinois near St. Louis preserves the remnants of a great city that thrived centuries before Europeans arrived. Ste. Genevieve, Missouri, and historic sites in southern Illinois recall French settlements that predate the Revolutionary War. In old river towns like Alton and Elsah, Illinois, and at the National Mississippi River Museum and Aquarium in Dubuque, Iowa, remnants of mid-1800s steamboat days survive. Twain's legacy lives on in Hannibal, Missouri, at his boyhood home and the caves he explored. Even the spirit of the river persists.

The Great River Road National Scenic Byway follows both banks to towns with new lives as enclaves for shop-keepers and artists. The mostly two-lane road threads through marshes and farmlands and beside 500-foot bluffs. The views change with the season, as does the river, en-suring that the Mississippi is a story that's always changing.

(Top) Tom Sawyer and Huckleberry Finn reenactors embody Mark Twain's America in Hannibal, Missouri. *(Bottom)* The Mississippi River remains an important commercial corridor for barges, including these passing the Iowa bank.

The river below St. Louis has been described time and again, and it is the least interesting part. Along the Upper Mississippi every hour brings something new. There are crowds of odd islands, bluffs, prairies, hills, woods and villages—everything one could desire to amuse the children. Dickens, Corbett, Mother Trollope and the other discriminating English people who "wrote up" the country before 1842 had hardly an idea that such a stretch of river scenery existed. Their successors have followed in their footsteps, and as we form our opinions of our country from what other people say of us, of course we ignore the finest part of the Mississippi.

MARK TWAIN
INTERVIEW WITH THE CHICAGO TRIBUNE,
JULY 9, 1886

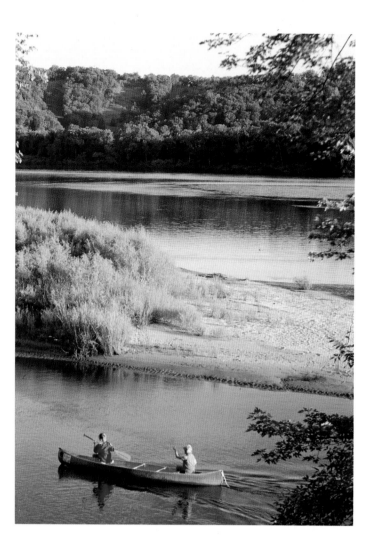

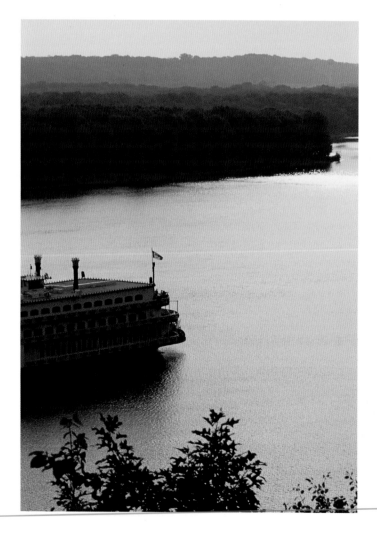

(Clockwise, from above) Scenic river towns, such as Weston, Missouri, climb the steep bluffs of the Missouri River, another storied waterway. Small rivers, such as the Wisconsin River, also provide contemplation. Options for Mississippi River cruises range from a few hours to a week. *(Opposite)* The sightseeing riverboat *Mark Twain* churns through the writer's immortalized stretch of the Mississippi around Hannibal, Missouri.

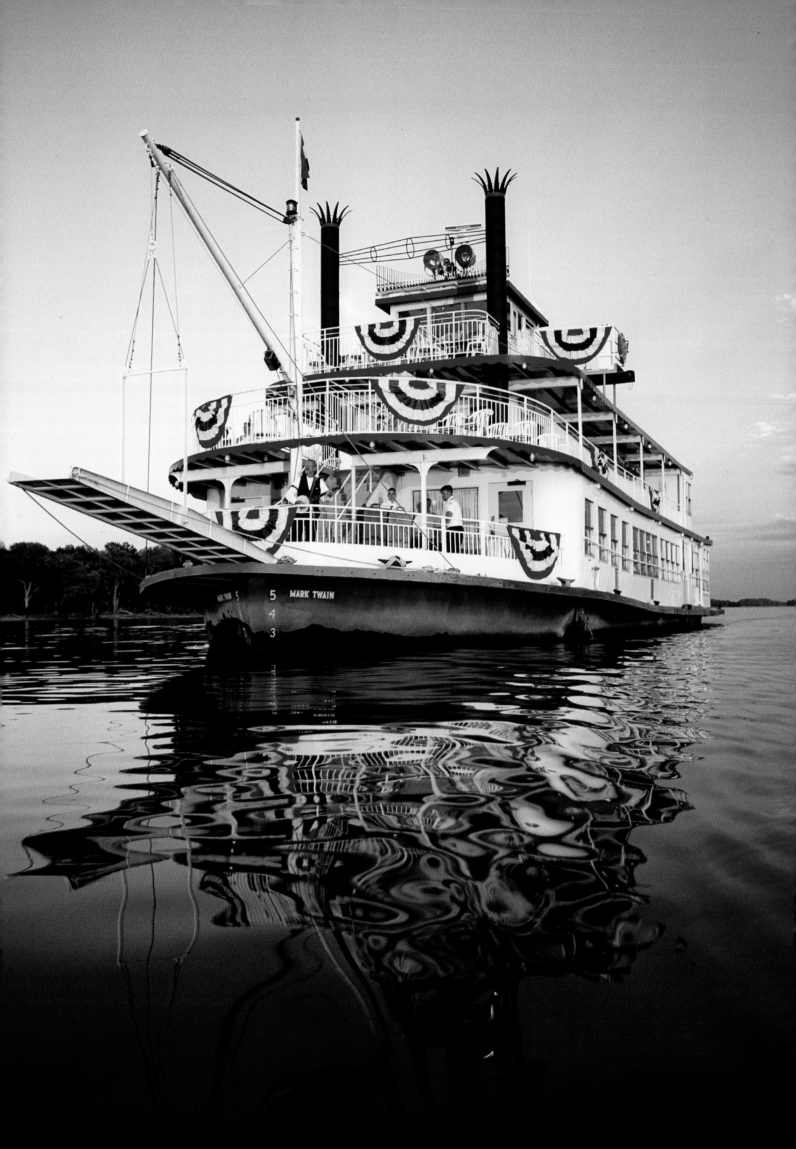

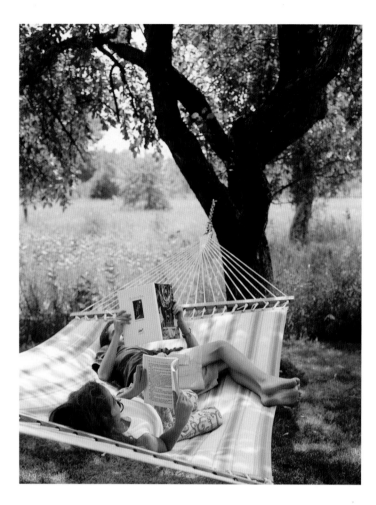

THE SLOW TICK OF SUMMER *matches our desires*

(Top row, from left) Summer's simple pleasures include idle time in hammocks, chasing lightning bugs at dusk and settling in at a baseball game, such as this park in Detroit. *(Bottom row, from left)* Explorations lead to local flavor: a Door County, Wisconsin, fish boil; small-town streets, such as Excelsior, Minnesota; a bicycling trek across Iowa; or a carefree rural swing.

It was June and the sun blazed down on the prairies. ... All nature seemed to invite sleep, rather than work. The gentle wind hardly moved the bended heads of grain; hawks hung in the air like trout sleeping in deep pools; the sunlight was a golden silence. ... Stand before it at eve when the setting sun floods the world with crimson and the bearded heads lazily swirl under the slow, warm wind, and the mousing hawk dips into the green depths like the seagull into the ocean, and your eyes will ache with the light and the color of it.

HAMLIN GARLAND
FROM BOY LIFE ON THE PRAIRIE,
ABOUT HIS 1870S CHILDHOOD
IN MITCHELL COUNTY, IOWA

to stroll together, drift down a lazy stream, or just sit and visit.

Cities mark the MIDWEST'S EVOLUTION. *They keep*

FOR THE MOMENT, forget fields, forests and lakes. Anyone who has admired a city skyline can thank the Midwest for the image. Chicagoans created the world's first skyscrapers, applying their can-do spirit to every big city's dilemma: lots of people, little space. The result is nothing less than awe. Planting your feet near the base of Chicago's John Hancock Building guarantees an invisible finger will tilt your head back as far as it'll go, and raise your eyes 94 floors to the spot where a skydeck with 80-mile views looks out over white boats dotting Lake Michigan's azure blue and a metropolis teeming with 10 million people. One of the world's fastest elevators—with an ever-so-subtle shimmy as it hurtles 30 feet per second—waits to whisk you up.

That's what Midwest cities are proud to do: quicken pulses. In the Cincinnati area, Newport on the Levee tempts

the best of the past as community leaders plan for the future.

families with 350,000 square feet of shopping, dining and attractions, including theaters. But those with a love of history are just as happy to browse among Cincy's boutiques in the stately 107-year-old Hyde Park Square neighborhood.

That's because cities mark the Midwest's evolution. They keep the best of the past as leaders plan for the future. Take St. Louis. Recently, the city celebrated the 200th anniversary of Lewis and Clark's return and christened a new Busch Stadium. The Gateway Arch stands nearby, letting Cardinals fans see a game, the Mississippi River and the Museum of Westward Expansion in the Arch's base, all in one day.

But don't let all the brick and steel mislead you. Midwest cities are also known for greenery. Minneapolis has 6,400 acres of parks, including the Grand Rounds National Scenic Byway. The 50.1-mile route loops the downtown riverfront, runs along a chain of lakes, includes a two-mile canoe route and ambles through the nation's oldest wildflower garden.

(Top) Detroit remains the Motor City, but the city is revamping its image with new sports venues and downtown development. *(Bottom)* Omaha's stockyard legacy has given way to a new skyline and a reputation as a business hub.

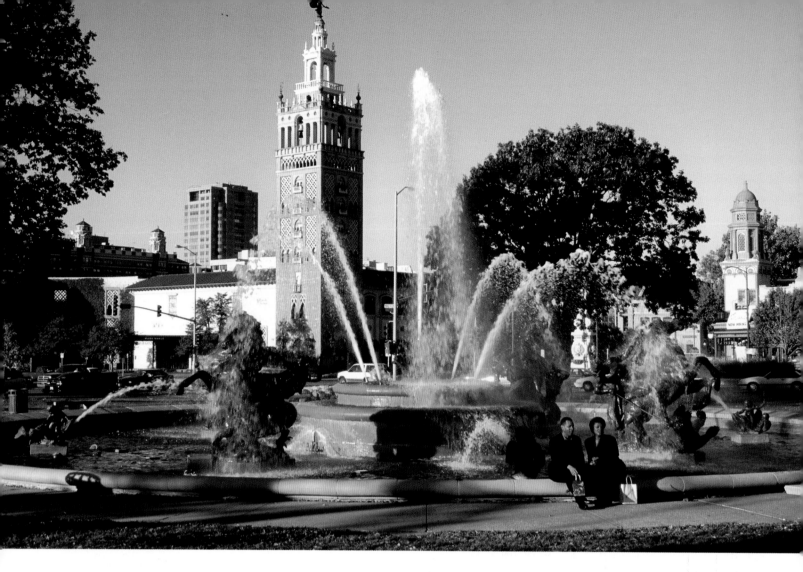

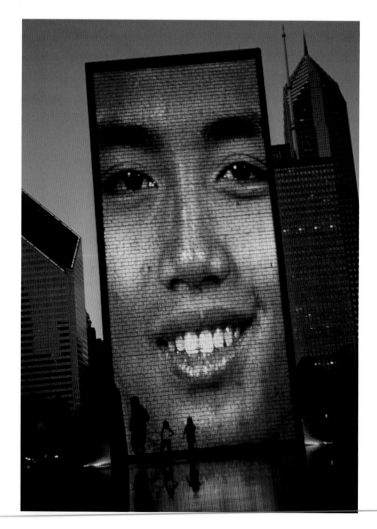

(Bottom row, from left) Milwaukee's public art scene includes landmarks such as *The Calling*. Crown Fountain in Chicago's Millennium Park features images of residents. Indianapolis' Central Canal river walk passes through a state park and leads to numerous museums.

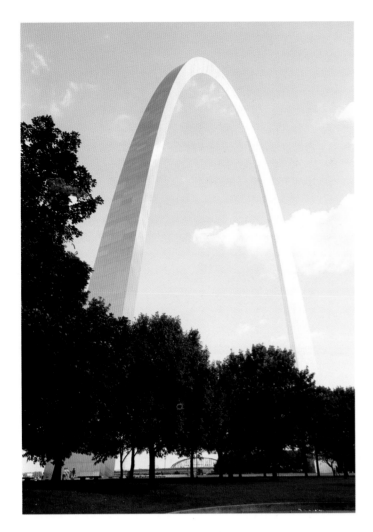

My favorite image of the Midwest is the St. Louis Arch. Even though as a young girl I lived across the river in East St. Louis, Illinois, it was awesome to see something towering and beautiful. Also, living in the Midwest taught me patience and gave me lasting friendships. There's a very comfortable and easygoing feeling you get living here.

JACKEE JOYNER-KERSEE
WINNER OF SIX OLYMPIC TRACK AND FIELD
MEDALS AND RESIDENT OF ST. LOUIS

(Top row, from left) Kansas City, Missouri's, Country Club Plaza is the first suburban shopping mall and features one of the largest collections of fountains. The 630-foot Gateway Arch in St. Louis is the country's tallest national memorial.

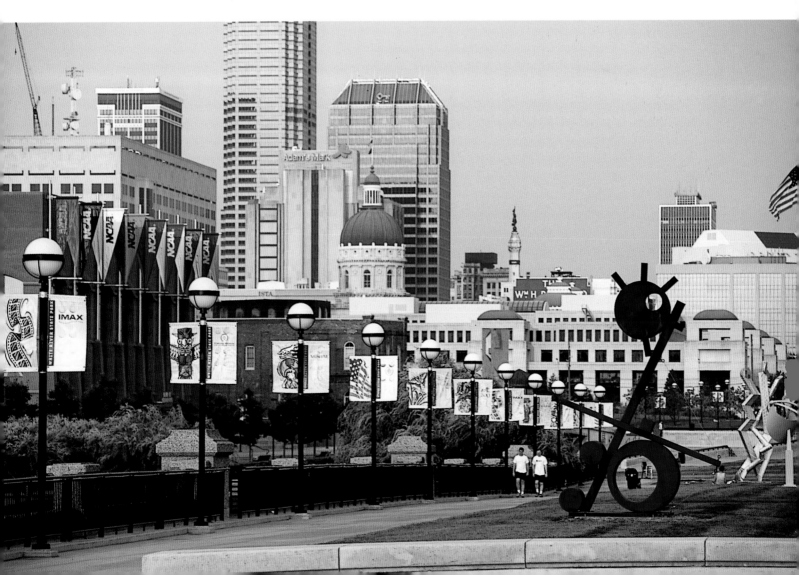

THOSE WHO TREAD *the Great Lakes shorelines can't* *the sky, and the towering stoicism of the lighthouses standing*

help but marvel at the magnitude of the waters, the vastness of guard, such as Ohio's Marblehead Lighthouse on Lake Erie.

exactly

Impressive sweeps of BEACHES AND DUNES *run along*

(Top row, from left) Fun on Midwest beaches means not only playing in the sand, but hiking to photo-friendly sights such as the Big Sable Lighthouse near Ludington, Michigan. *(Bottom row, from left)* Lunch on the shore doesn't have to be basic with dishes such as Oatmeal Cherry Cookies or Clearly Superior Trout.

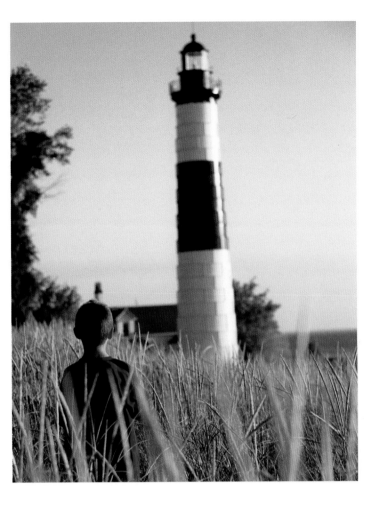

BEACH TIME

The hot sand crushing underfoot and the crashing, gliding surf make an unabashed statement: this is beach country. Beaches that would rival those anywhere are a Midwest surprise, at least for those who don't know the region. Sand rims the lakes that dot the North Woods and prairies, and Midwesterners vacation on thousands of sandy miles along the vast Great Lakes. Michigan's share alone is 3,200 miles, more beach-line than the entire West Coast. A highlight is Sleeping Bear Dunes National Lakeshore in northwest Michigan, with 37 miles of beaches and dunes so tall that visitors struggle to climb up. There are rugged beaches, rocky beaches and stretches of silky soft sand, such as along Lake Huron at Michigan's Tawas Point State Park and beside Lake Michigan at Ludington State Park. At Door County Wisconsin's Whitefish Dunes State Park, sand hills frame stretches of Lake Michigan. Indiana Dunes National Lakeshore and Ohio's Maumee Bay and Geneva state parks offer wide swaths of sand. Then, there are even the idyllic sandbars in our rivers. Sand castles and daydreams are never far away.

the Great Lakes—Michigan alone boasts 3,200 sandy miles.

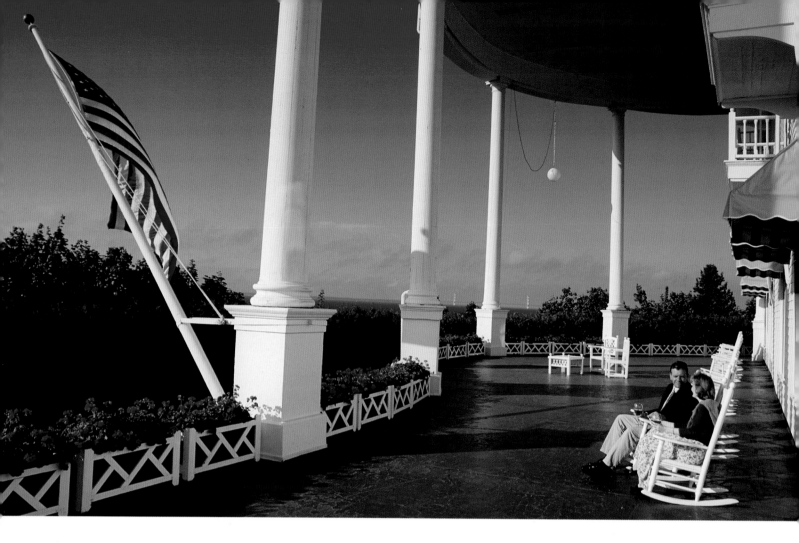

There's a FAIRY-TALE QUALITY to the island with no

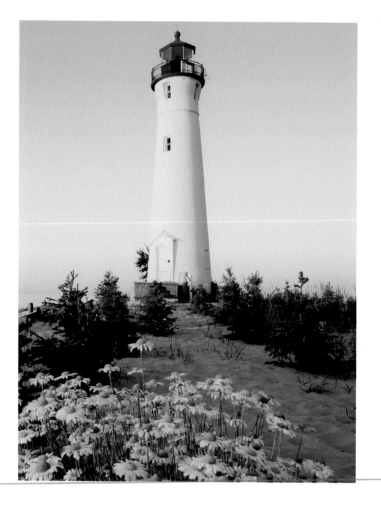

(Top row, from left) The Grand Hotel on Michigan's Mackinac Island features an enormous front porch. Petoskey, in northwest Michigan, offers unique shopping. *(Bottom row, from left)* Fort Mackinac teaches about the past. Crisp Point Lighthouse stands on the "shipwreck coast" along Lake Superior's south shore. The five-mile Mackinac Bridge connects Michigan's two regions.

MACKINAC MAGIC

A little bit of the grand era of Great Lakes resorts survives on Michigan's Mackinac Island. Town leaders banned motorized vehicles early on from this dollop of land (8.3 miles around) in the Straits of Mackinac, the waters that separate Michigan's Upper and Lower peninsulas. Horse-drawn carriages still meet visitors arriving by ferry and carry them to the island's inns and resorts, including the legendary Grand Hotel. Surrounded by green lawns and stately gardens, the white-columned 1880s hotel crowns the west bluff above the harbor. Visitors settle into a fleet of rockers on the 660-foot front porch, the world's longest, and arrive for dinner in the vast dining room. Fort Mackinac, with 14 original buildings and interpreters dressed as soldiers from the 1880s, commands the east bluff above the harbor. The town's famous fudge and gift shops captivate most visitors, but they shouldn't miss the state park covering much of the island, as well as the unusual assortment of plants and flowers that thrive here. And for sweeping views, there are few better than the one from the overlook at Fort Holmes.

cars, horse-drawn carriages and the legendary Grand Hotel.

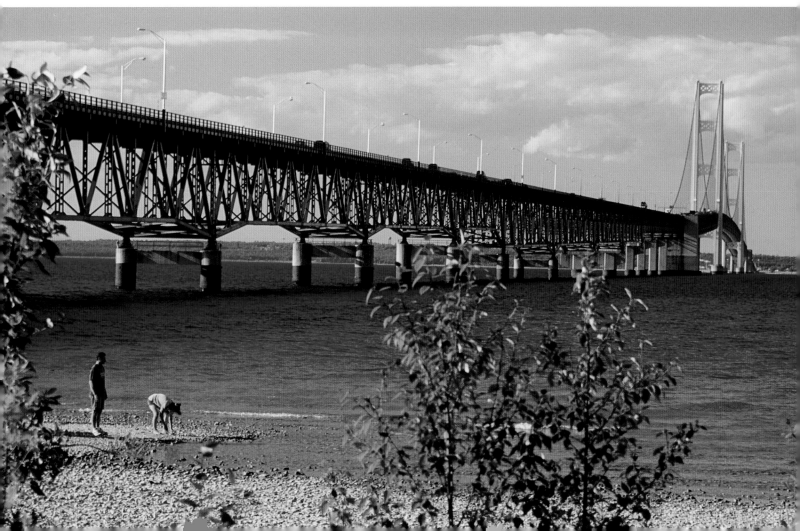

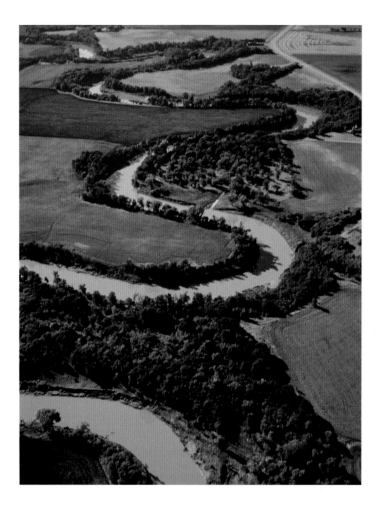

We live amid a LUXURY OF FRESHNESS with our

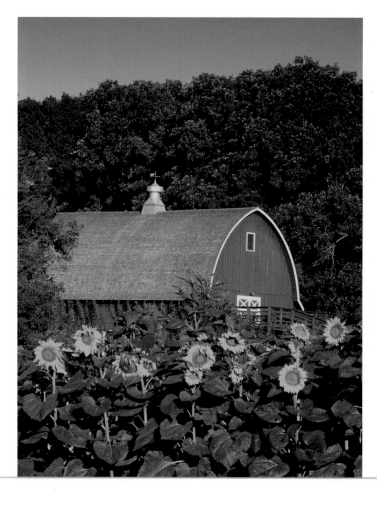

(Bottom row, from left) Peppers from The Chef's Garden, an Ohio farm known for its colorful, flavor-filled veggies. Sunflowers brighten this northeastern Iowa farm. Columbus, Ohio's, North Market is one of hundreds thriving in the region. A wall of late-summer corn flanks bicyclists on Wisconsin's Elroy-Sparta Trail.

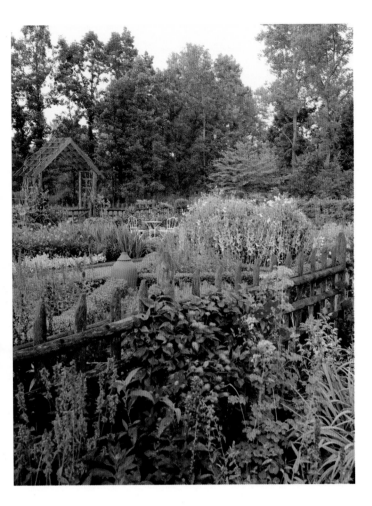

SUMMER-FRESH FLAVOR

We've always been close to the earth: our agricultural roots, our backyard gardens and our love of the land's fresh bounty. But perhaps no one better summarizes the passion for organic food nurtured by local farmers than Odessa Piper, an award-winning chef from Madison, Wisconsin. She believes her upbringing has the biggest impact on her approach to cooking. "For my parents, if something could be homemade, on principle, it was considered better," she says. "We baked bread. Bones and celery leaves didn't go in the trash or compost, they went in a stock pot. Thrift was what motivated us, but with this life, I developed an appreciation for authentic, unmanipulated food. Apples with weird little spots, because they were unsprayed, became equated in my mind with better taste." Real food. Real flavor. Real life.

(Top row, from left) The Red River forms a fertile valley on the North Dakota-Minnesota border. Ohio's Herban Acre Farm created this Heirloom Tomato and Onion Quiche. This suburban Chicago garden produces plenty of fresh flavors, plus flowers.

abundance of just-picked produce almost trembling with flavor.

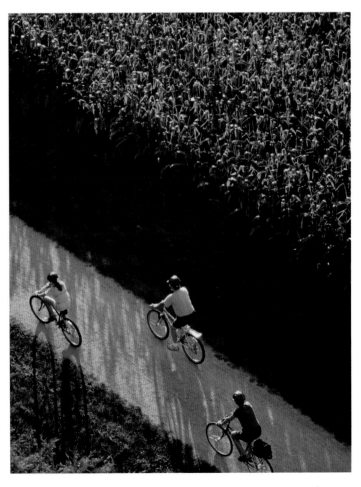

Every garden is beautiful. I learned this truth one summer
when a 10-year-old friend came to visit. As Chelsie stepped
into my modest backyard with its jumble of flowers, she sucked
in her breath with admiration. "Ooh, it's like a park!" she said
in an awed voice, then zoomed off like a bee toward the roses,
ready to sniff, touch and admire. Until that moment, I had
been almost ashamed of my garden, telling myself it was badly
designed and poorly tended. It should be so much better, I
thought. But this child's unbridled joy at my resplendent mess
of well-loved plants reminded me what's most important about
gardens, whether they're the Midwest's best public places or
your own haven: Getting out and enjoying them.

DEB WILEY
GARDEN EDITOR

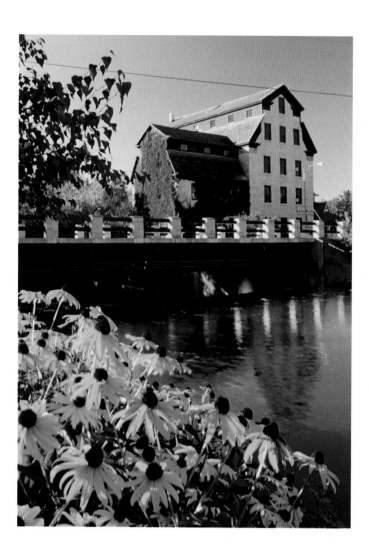

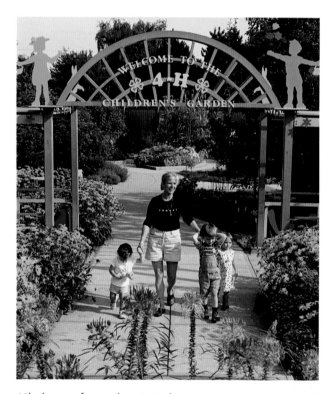

(Clockwise, from above) Michigan State University's 4-H
Children's Garden invites kids to experience the wonder of
plants. Black-eyed Susans pop against the background of a mill
in Cedarburg, Wisconsin. This Missouri country garden features
a replica of the St. Louis Arch made of construction materials.
(Opposite) Fresh flowers produce beautiful centerpieces like this
one from a Kansas cutting-flower co-op.

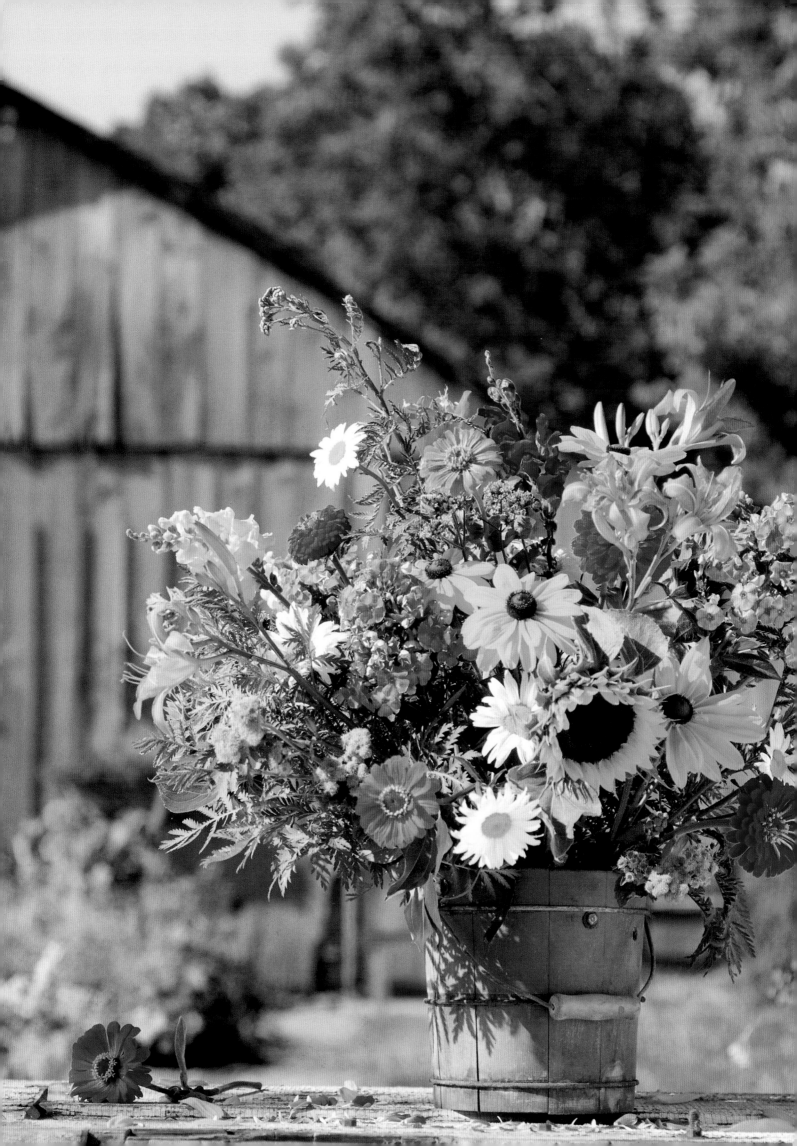

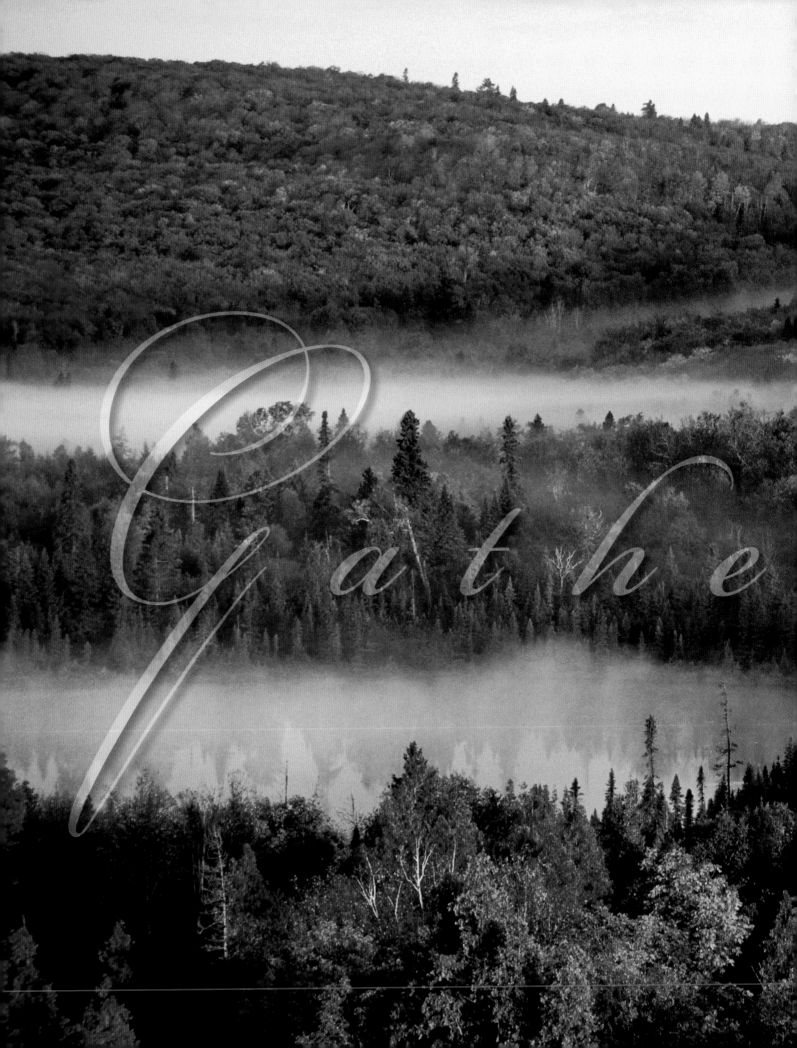

rings

A breathtaking view unfolds from Oberg Mountain along Minnesota's Lake Superior Shore.

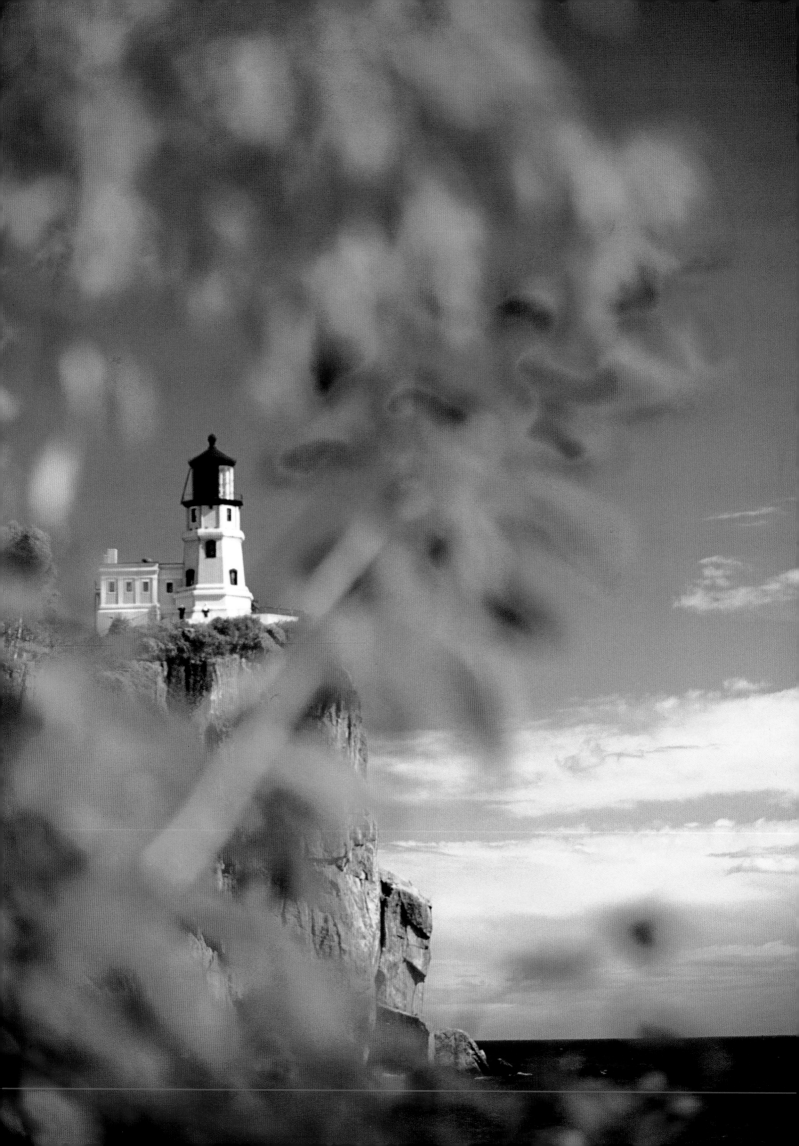

*E*ven with all our searching for those new paths in summer, come fall we're seeking ways back home—back to school, back to work, back to routine. It's time to settle in and share summer's exploits. We gather wood for fires and look forward to the season's first. Gardeners burrow in some bulbs. Otherwise, they let rest the beds so carefully tended a month earlier, layering on mulch and making a few mental notes for next year.

We turn to traditions, hunting for perfect pumpkins at patches across the region and celebrating the harvest at events such as the giant annual Pumpkin Festival in Circleville, Ohio. The events at Circleville, the Marigold Festival in Pekin, Illinois, and others seem to grow every year with parades, arts and crafts shows, the crowning of queens, pie-eating contests and more. We welcome friends and family for these events, as well as travelers from all over.

Apple picking is another perfect excuse for gathering. Just taking home a peck or two isn't enough, of course. On the way, we look at the leaves— maples in shades from pink-orange to deep crimson; aspen leaves, flashing like gold pieces; and reticent oaks, their leaves gradually turning to burnished copper. Have the colors ever been so brilliant? On this fall day as we're driving the back roads together, it doesn't seem so. Those roads might lead to any number of favorite orchards across the region: Eckerts in southern Illinois, Uncle John's Cider Mill in central Michigan, Rees Fruit Farm in eastern Kansas. Filling bags with Galas, Jonathans or whichever variety that family pie recipe requires is just part of the fun. Depending on where you go, there might be cider to sip, corn mazes to explore and other reasons to linger a little longer against the backdrop of the Midwest's most colorful season.

Split Rock Lighthouse presides on a cliff above Lake Superior along Minnesota's North Shore. No all-weather road to this part of the shore existed in 1909 when the beacon was built. All materials for the construction had to be transported by boat and hoisted up the 130-foot cliff. The crew worked atop the cliff through all but the worst part of winter to complete the lighthouse in midsummer 1910. Split Rock guided ships until 1969. The tower and keeper's quarters now are part of a state park and are open for tours.

PRAIRIES, FARMLANDS, BLUFFTOP OVERLOOKS–

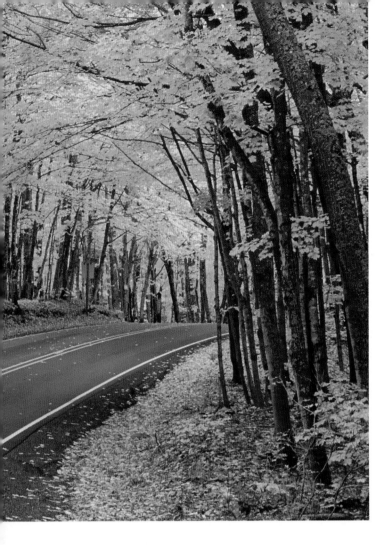

A NARROW BLACKTOP ROAD TWISTS
to the top of Brockway Mountain on northern Michigan's Keweenaw Peninsula. There's a spot to pull off the road, even if just barely. Good thing. This isn't a view you can absorb in a quick glance from behind the wheel. From this breezy, rock-rimmed overlook, forests sweep down to Copper Harbor and a Lake Superior harbor, where an 1800s lighthouse stands watch. In autumn, especially, it's a vista to be savored and captured on film. Maples exploding in bursts of red flank aspens gone golden. Photos never quite seem to do the scene justice. Neither do attempts at description. No matter how many times you've heard about it, there's no substitute for being there. And the views seem meant to be shared. When you say, "Amazing!", someone should be there to say, "Yes, it is."

the scenery varies, but the vistas bring us back year after year.

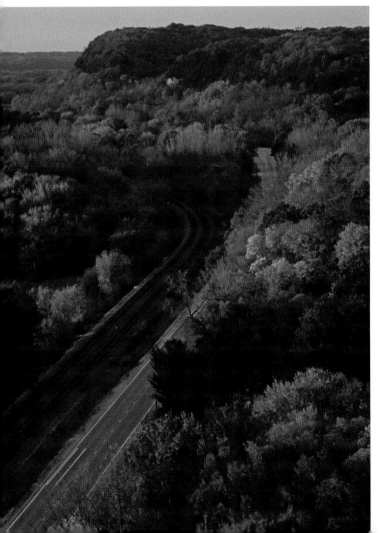

The Midwest has plenty of spectacular drives. Prairies, farmlands, blufftop overlooks—the scenery varies, but the vistas bring us back year after year. A few favorites: the Great River Road along both sides of the Mississippi River in Missouri, Illinois, Iowa, Wisconsin and Minnesota; the North Shore National Scenic Byway between cliffs, waterfalls and Lake Superior in northeastern Minnesota; the Ohio River National Scenic Byway beside bluffs and the wide, blue river; Ohio's Amish Country Byway through farmlands; the Flint Hills Scenic Byway in the world's largest remaining tallgrass prairie in Kansas; State-94 through eastern Missouri's wine country; the Loess Hills Scenic Byway in Iowa's wind-blown dunes; northern Michigan's "Tunnel of Trees," State-119, barely two lanes wide along Lake Michigan; the Peter Norbeck Scenic Byway, threading through canyons and rock spires of South Dakota's Black Hills. Even along that little country road near home, you'll find something special in the colors and freshness of this poignantly expressive season.

(Top) Trees cloaked in autumn gold create a tunnel of color on Michigan's Keweenaw Peninsula. *(Bottom)* Waves of color roll through Mississippi Palisades State Park, part of the Illinois section of the Great River Road.

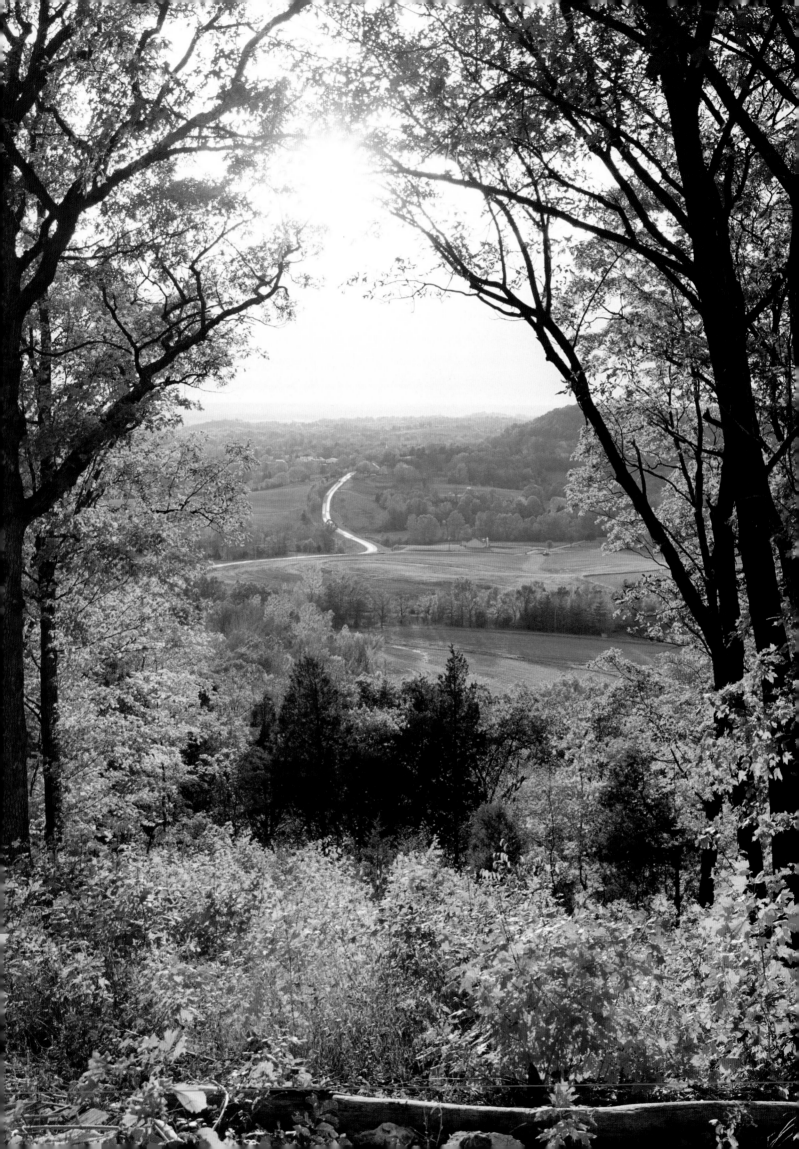

Fall always strikes me as the most urgent season. It seems like it's constantly rushing out from under us. We know autumn usually brings the year's best weather and bluest skies, so there never seems to be enough of it. Plus, winter's coming, which only makes each fall day seem that much quicker. And then there's the foliage. Peak color doesn't last long, so we're always trying to time our drives and hikes perfectly. The good news is that fall can be a fairly long process on a regional scale. If you're willing to make some longer road trips, you can stretch fall for a couple of months as it creeps down from Minnesota and Wisconsin to Missouri and southern Illinois.

TREVOR MEERS
MANAGING EDITOR

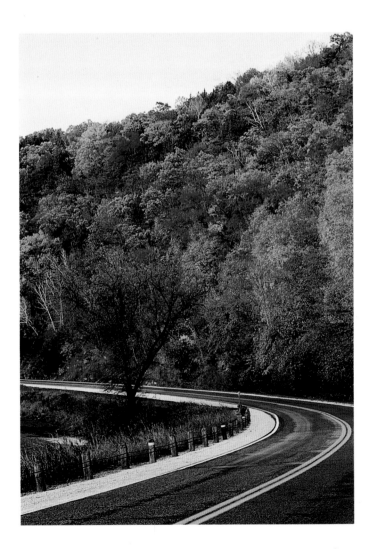

(*Opposite*) Autumn hues frame the Missouri River Valley near Hermann, Missouri. (*Clockwise, from above*) A fallen leaf stands out on a rocky Great Lakes shore. Leaves threaten to cover a route near Wisconsin's Horicon Marsh. State-16 follows a tree-covered bluff near Lanesboro, Minnesota.

Through produce, blooms and turning foliage, Midwest

(Bottom row, from left) Dried flowers extend the season. A scarecrow decorates a Michigan garden. There's plenty of color remaining in this early fall garden. A creative display pairs 'Ben Huston' dahlias and goldfish.

(Top row, from left) Blooming pots allow a movable fall vignette. Dried cornstalks and pumpkins create easy displays. Giant dahlias, such as in this Michigan field, make a big statement. Strawflowers and globe amaranth bring color and texture.

fall gardens SING IN THE COLORS OF EARTH.

Fall plays out in glorious sweeps of color, such as blue salvia and white globe amaranth, at this central Iowa flower farm.

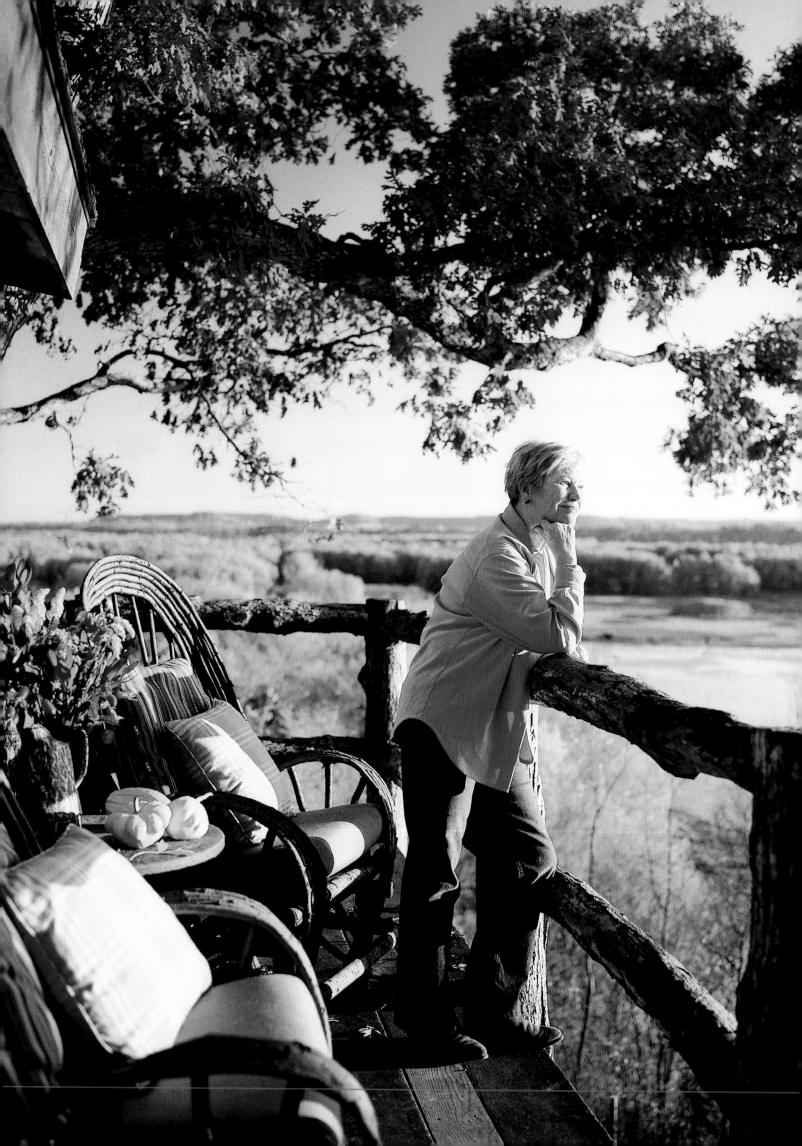

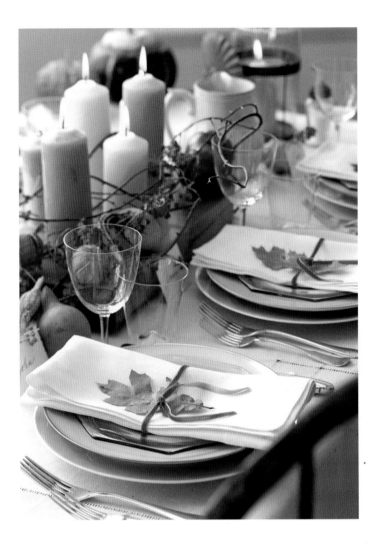

The Midwest is a land of comfort food, known for just-harvested ingredients and dishes that soothe, nurture and please. It's not about trends so much as traditions. It's food that fits the seasons and connects us to the land, is flavorful and filling, and that tugs on our memories, reminding us of special places or significant people in our lives. Autumn brings to the kitchen the long-anticipated harvests—apples, pumpkins, cranberries, potatoes and so much more—to tuck into a fluted piecrust or add to a casserole. Food has such power to tempt. And it's food that brings us a moment of rest and pleasure simply because it tastes sublime.

DIANA McMILLEN
SENIOR FOOD EDITOR

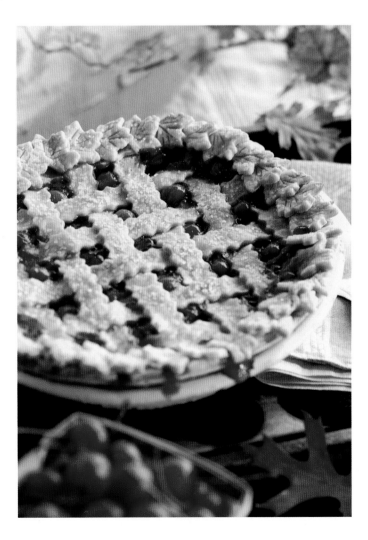

(Opposite) Autumn views from spots like this one near Galena, Illinois, provide a chance to gather our thoughts. *(Clockwise, from above)* Natural materials and the season's subtler shades come together in a wreath. A dinner party takes an autumn theme. Pie, such as this Cherry-Lemon Pie from Indiana, is one of our most satisfying comfort foods.

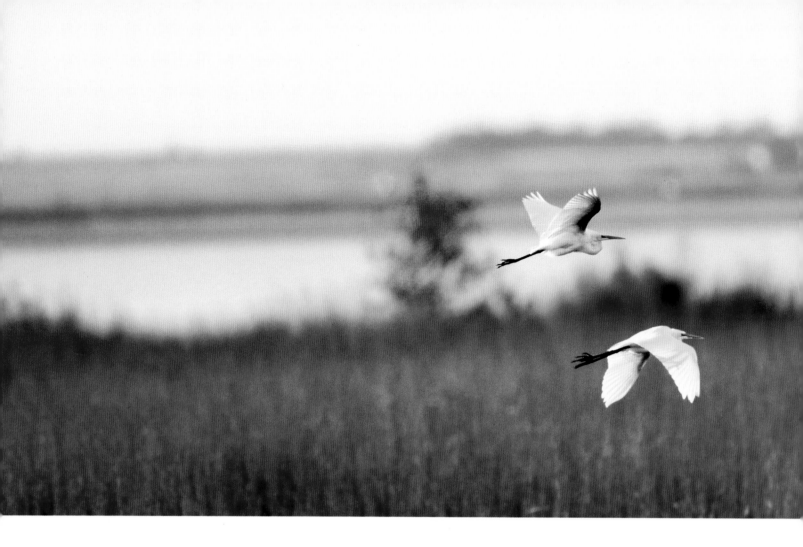

You can still be there WHEN BIRDS ARRIVE in

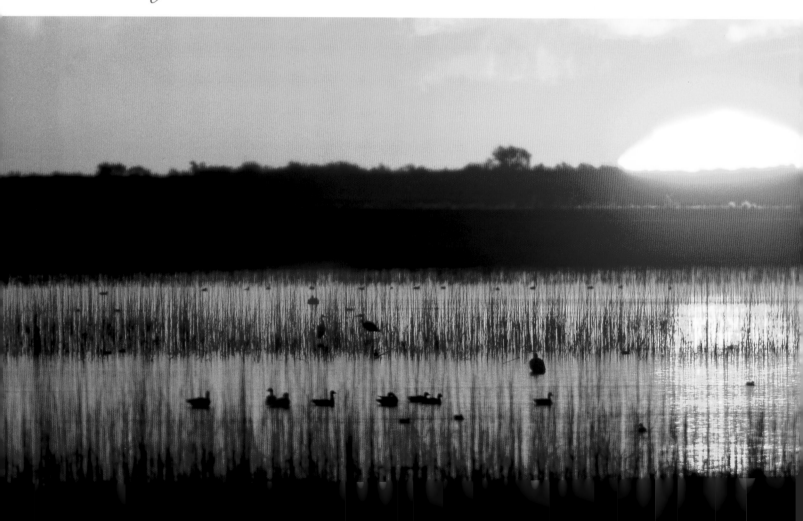

FALL BIRDING IN THE RIGHT PLACE

brings a glimpse of what wildlife once was. We've lost the horizon-to-horizon buffalo herds and sky-darkening passenger pigeon flocks, but you still can be there when birds arrive in seemingly biblical proportions. Hundreds of thousands of Canada geese spend part of each autumn at Wisconsin's Horicon Marsh. About 500,000 snow geese arrive in fall at De Soto National Wildlife Refuge near Omaha. The wetlands around Great Bend, Kansas, see a million or more birds in November, and they sometimes arrive in flocks that pass overhead for hours on end. The sensation of standing amid such a sheer mass of living things is something everyone should experience at least once.

The Midwest holds most of the Central and Mississippi Flyways, critical corridors between birds' northern summer

seemingly biblical proportions at the region's wildlife refuges.

nesting grounds and southern wintering grounds. Plovers, mergansers, herons, avocets and scores of other species thrive on the region's river valleys, wetlands and grain dropped in the fields during harvest. It's a scene so bustling, even rookie birdwatchers quickly rack up an impressive tally of species in a day's outing. A busy autumn wetland is like an avian international airport, with the world's birds rubbing wingtips during extended layovers, raising a deafening racket in countless native tongues.

A mix of certainty and mystery charges the atmosphere around the migrations. We can mark the time of year by when certain species arrive, but we're still guessing about a lot of the *why*. How do the birds know when it's time to go (probably shorter days)? How do they find their way (probably a combination of geomagnetism, landmarks and celestial bodies)?

One thing, at least, is certain: No matter where you live in the Midwest, there's sure to be a bird show going on somewhere nearby in fall.

In autumn, a million or more migrating birds flock to wetlands in Cheyenne Bottoms Wildlife Area and Quivira National Wildlife Refuge near Great Bend, Kansas.

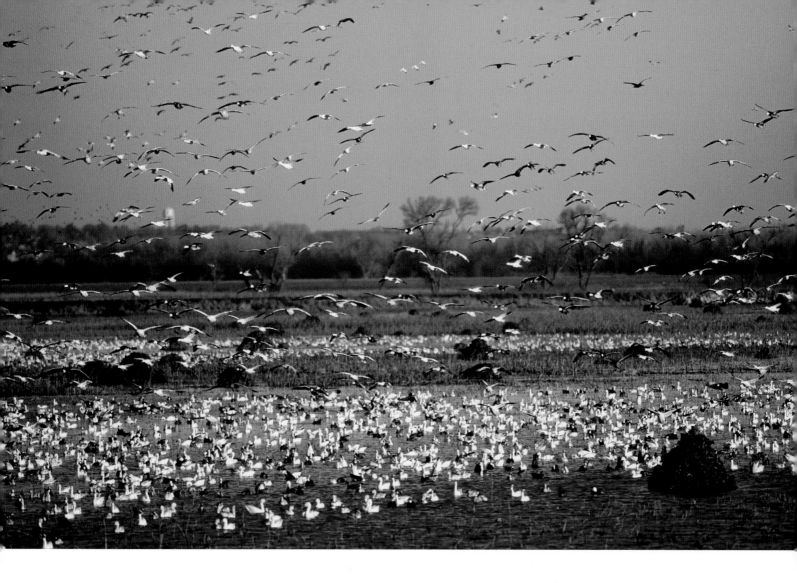

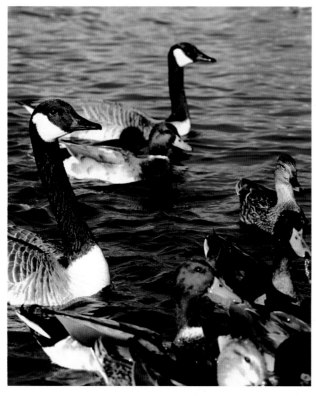

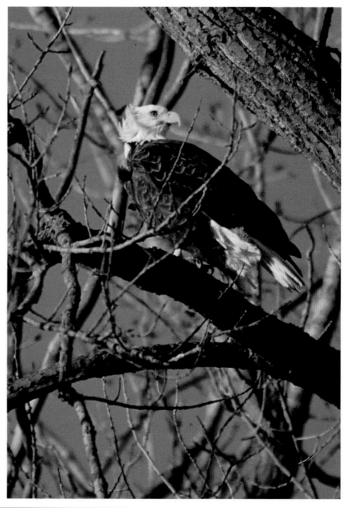

(Top row, from left) Snow geese rest at Missouri's Squaw Creek National Wildlife Refuge near Mound City. Buffalo graze in South Dakota's Black Hills. *(Bottom row, from left)* Canada geese and mallard ducks mingle in Minnesota. Bald eagles have come back to Squaw Creek and other areas. Horicon Marsh National Wildlife Refuge protects vast wetlands.

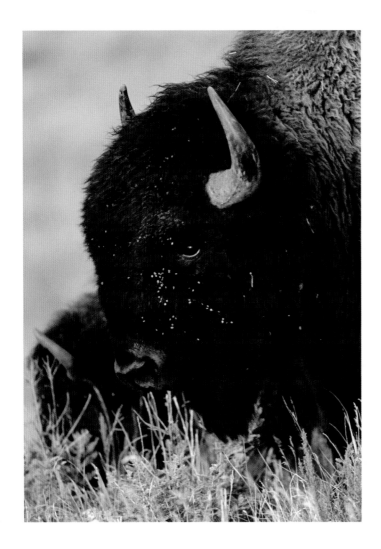

There are some who can live without wild things, and some who cannot. These essays are the delights and dilemmas of one who cannot. Like winds and sunsets, wild things were taken for granted until progress began to do away with them. Now we face the question whether a still higher "standard of living" is worth its cost in things natural, wild, and free. For us of the minority, the opportunity to see geese is more important than television, and the chance to find a pasque-flower is a right as inalienable as free speech.

ALDO LEOPOLD
WISCONSIN CONSERVATIONIST, IN THE
INTRODUCTION TO HIS CLASSIC BOOK,
A SAND COUNTY ALMANAC

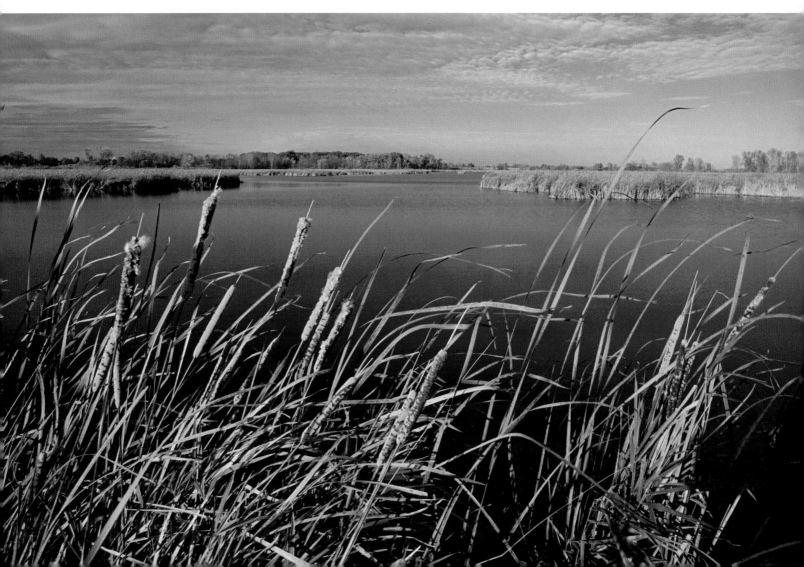

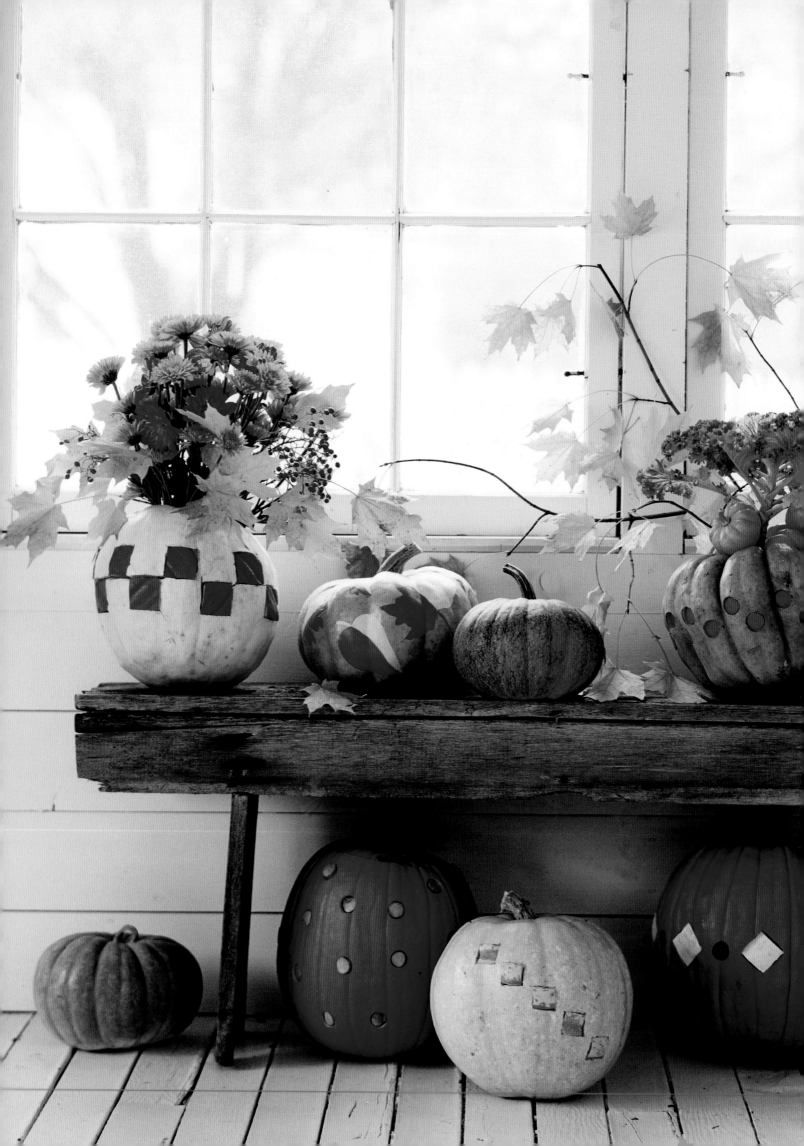

FALL'S FAVORITE FRUIT

No region does pumpkins like the Midwest. Illinois produces more of fall's signature gourd than any other state, and every frenetic Thanksgiving cook should thank the people of Morton, Illinois. The self-proclaimed Pumpkin Capital of the World is home to Libby's pumpkin processing plant, which turns out about 80 percent of the world's canned pumpkin. Libby estimates it helps form the fillings of more than 50 million pies in America each year. As for pumpkin parties, we do those right, too. Circleville, Ohio, has put on one of the country's largest pumpkin festivals for more than a century. Roughly 400,000 people come each year to watch parades, hear bands, buy upwards of 23,000 pumpkin pies and see one pie 14 feet wide and weighing more than a ton. And, of course, we're always looking for new takes on the traditional jack-o'-lantern, including the patchwork pumpkins on the opposite page. To make them, use a template to cut identical shapes out of two different-colored pumpkins, then swap the pieces. (White Lumina pumpkins add a unique glow to fall arrangements.) To paint the leaves on the pumpkin, lightly sand the pumpkin's surface and apply a paint sealer to prevent flaking. Then, create a design with stencils and acrylic paint. Finish it all with a top-coat sealer.

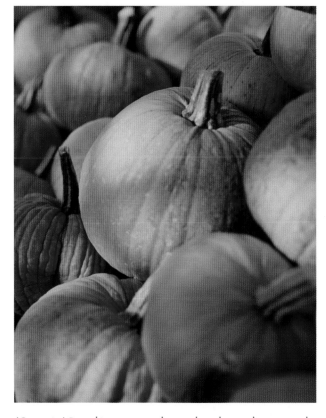

(Opposite) Pumpkins as art adorn a bench; see how to make them in the text above. *(Clockwise, from above)* Pumpkins pile up, waiting to be chosen. Simple pumpkins add relief to fall garden vignettes. A Seeley, Wisconsin, coffee shop serves up this twist on tradition: Pumpkin Cheesecake with caramel.

(Bottom row, from left) Just-picked apples are a wonderfully abundant treat. Farms and orchards let guests experience things with their own hands. Apples lend a sweet surprise to Pork and Ale Stew. Oktoberfests abound, such as in Amana, Iowa.

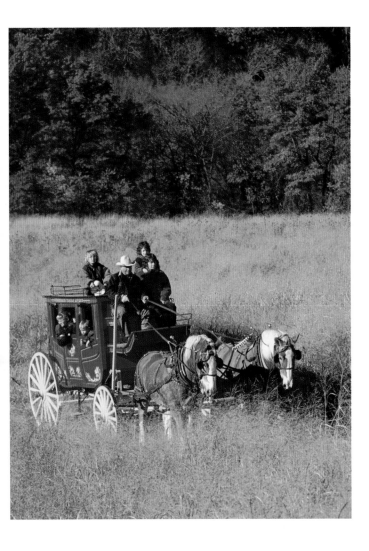

Those of us from the Midwest always believe that we are more centered, more grounded and more blessed with common sense than those from other regions. There is less baloney about being Midwestern—no weird traditions to uphold, no vestigial resentments of wars past, no sense of ourselves as a cultural Valhalla. We are simply who we are, and we like that about each other.

SCOTT TUROW
ATTORNEY AND BEST-SELLING AUTHOR
WHO LIVES IN THE CHICAGO AREA

(Top row, from left) Fall is a great time to get away together and shop in Put-in-Bay, Ohio. Produce stands lure travelers near Lanesboro, Minnesota. A stagecoach carries passengers through northwest Illinois fields.

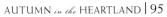

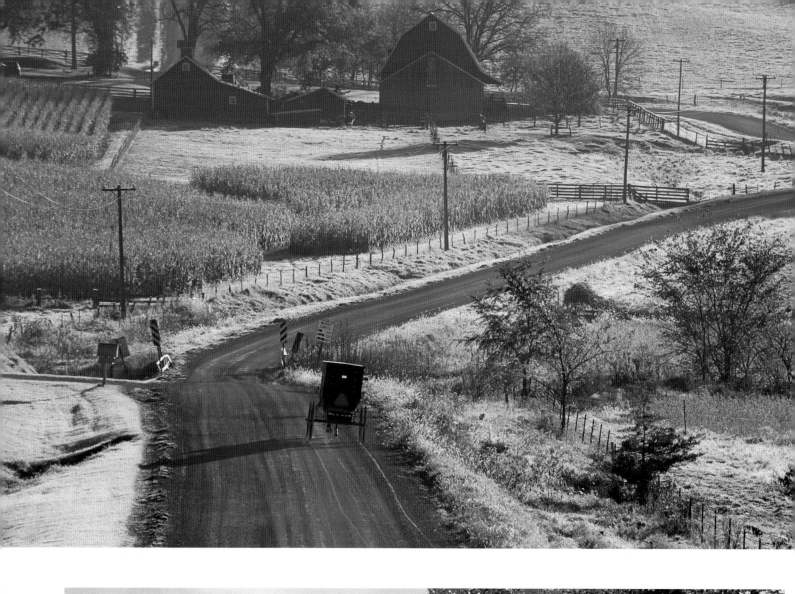

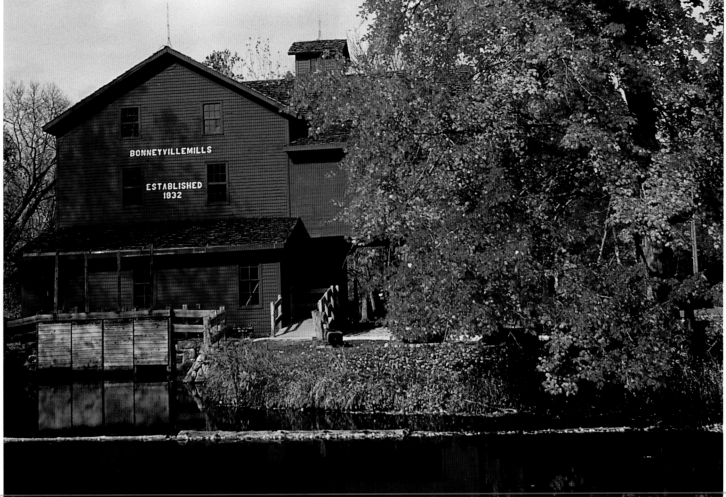

THE SIMPLE LIFE

The present looks a lot like the past in pockets of the Midwest where Amish communities flourish. Think way back, to burgs tucked into farmlands and roads where traffic often slows to wait for horses. This is the world of farm-style meals, plain clothing and quilts for sale. The Midwest is rich in these Amish enclaves, with some of the most-visited areas being northern Indiana near Shipshewana and east-central Ohio around Berlin. On a weekend visit, you can't help but appreciate the Amish focus on family and uncluttered living. Visitors sometimes confuse other villages with the Amish, such as the historic communal-living societies in places such as New Harmony, Indiana, and eastern Iowa's Amanas. Here, preserved buildings and shops offer a glimpse into attempts to create earthly Utopias. The experiments generally faded, but their remains provide pleasant getaways to a different way of life. Although few of us are willing to give up our modern conveniences, a visit to places such as these allows a refreshing taste of a slower pace.

(Top row, from left) The countryside is peaceful near Kalona, Iowa. Visitors study the West Branch, Iowa, house where Herbert Hoover was born. *(Bottom row, from left)* Colors reflect around a Bristol, Indiana, mill. This Indiana town is known for serenity.

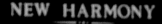

VIEWS LIKE THIS ONE *have inspired generations of artists to visitors seeking escapes from their busy lives with galleries,*

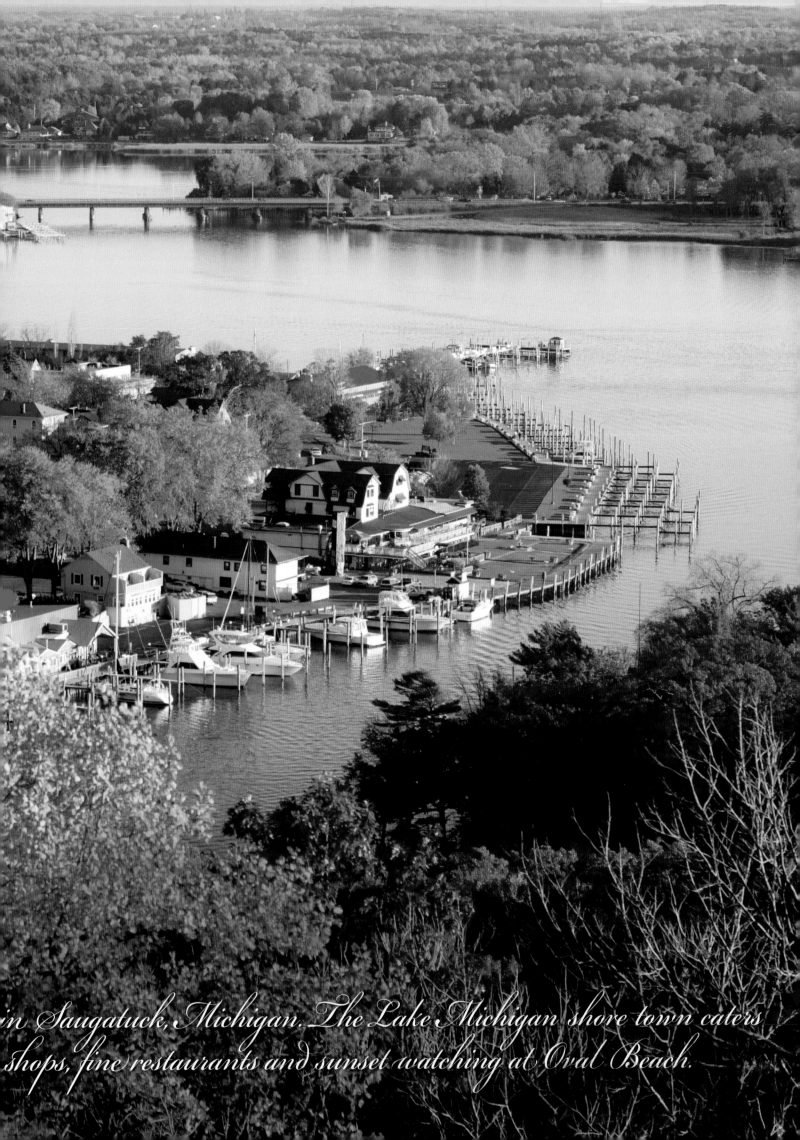

in Saugatuck, Michigan. The Lake Michigan shore town caters
shops, fine restaurants and sunset watching at Oval Beach.

THE PANORAMIC BACKDROP *of fall enhances favorite*

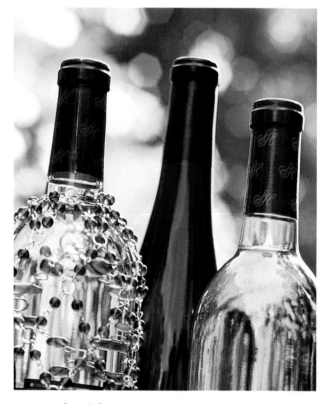

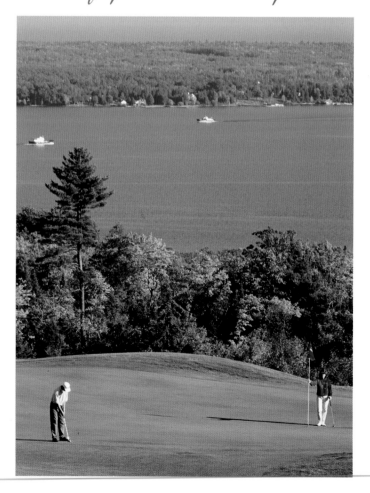

(Top row, from left) Wine country in central Missouri. Ripening grapes. *(Bottom row, from left)* A variety of Midwest wines. Autumn golfing on a Wisconsin course. Walking the Lake Michigan lakeshore in southwest Michigan.

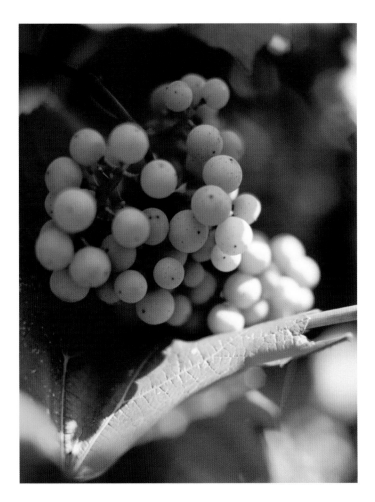

RAISING OUR GLASSES

As last year drew to a close and frost crusted fields across the Midwest, dozens of farmers in Iowa couldn't help but toast their fortune. Nineteen new wineries secured licenses, bringing the state's total to 68. In fact, as many as 600 acres are devoted to grape growing in Iowa today, compared to just 45 in 1997. But Iowa isn't alone. More acres, more cold-hardy (and hot-summer-hardy) grapes and more vacation destinations for wine lovers are turning the Midwest into a fine wine option. Indiana welcomes more than 800,000 visitors each year to its wineries, which pump roughly $33 million into the state's economy each year. And in Missouri, 1.5 million visitors a year sample acclaimed vintages, many made at seven historic wineries on the Hermann Wine Trail, a winemaking region established by German settlers in the 1850s. Midwest wines fare well in international competitions, but that's not necessarily the spirit in which they're made. Many wineries are small, and owners welcome guests to sit with them amid the scenic settings and gently turning crops, and sip and mingle as friends. That's the spirit that grows.

pursuits, such as golf, wine tours and quiet weekends together.

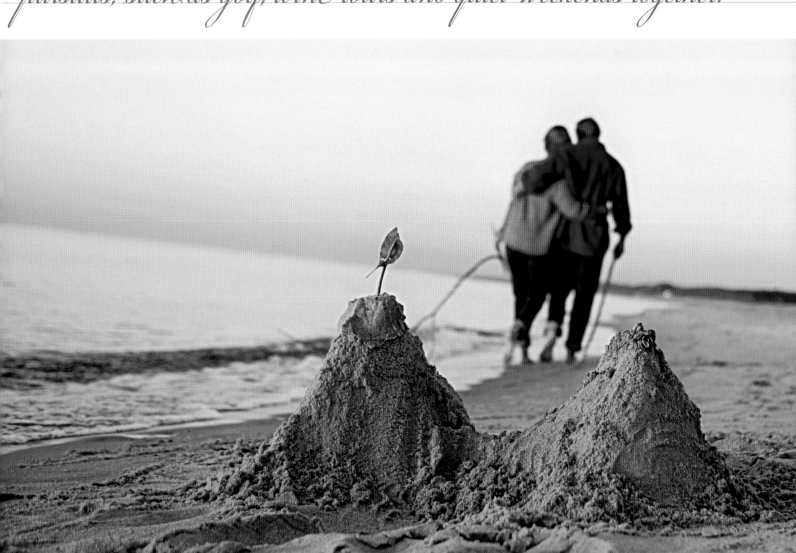

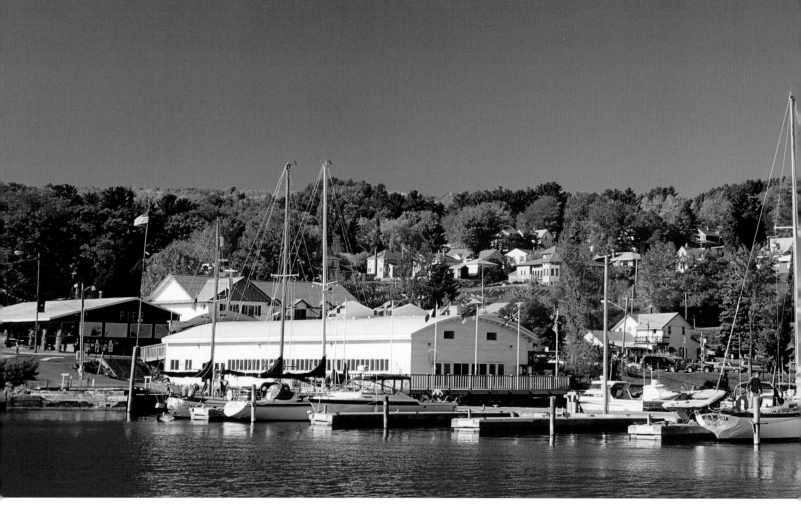

We love the new ENERGY AND CREATIVITY *that just*

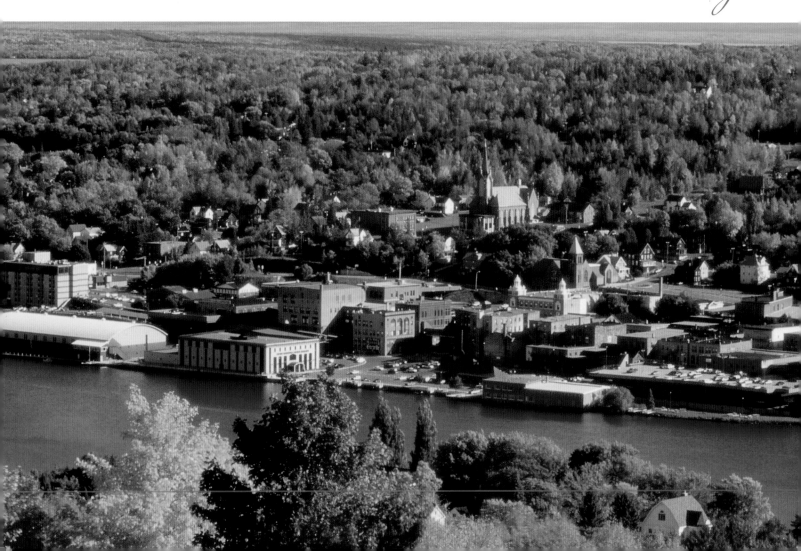

SIZE IS JUST THE BEGINNING OF WHAT WE LOVE about the Midwest's small towns. Sure, it's wonderful to be able to walk from one end of Main Street to the other in Galena, Illinois (population 3,500), and then stroll to the DeSoto House Hotel when it's time to call it a day. But even more appealing than that kind of ease—priceless in a world where many drive an hour or more through sprawling suburbs to get from home to work and back—are small towns' other qualities.

In these places so-called progress has bypassed, history endures in official sites such as Galena's Ulysses S. Grant home—but also in an irresistible, completely unplanned way. Brick buildings and ornate homes that are legacies of an 1800s boom survive because, well, no one could afford to tear them down and start over. Now, even if they weren't

seem to well up in some of the Midwest's small towns.

valuable, no one would think of replacing them.

We love the friendliness that also seems indigenous to places like Lincoln, Kansas (population 1,350), hardly more than a giant courthouse, a surprisingly hip coffee shop and a visitors center where you can buy crafts and pieces of pie. Ask to see the century-old Denmark church nearby, and someone's likely to drop everything to show it to you.

We love small-town quality and the quality of life—the perfectly prepared breakfast for less than $5 at a local cafe in Eminence, Missouri, as well as the fact that no one is too busy to know the best fishing, swimming and canoeing spots in the Current River, which flows through the town center.

We love the new energy and creativity that just seem to well up in these villages—in Grand Marais, Minnesota; Nashville, Indiana; and Clarksville, Missouri, all reborn as havens for artists and crafters. Often, these new pioneers see the pendulum swinging back to small-town life. For those of us who don't live in places such as these, we'll just visit whenever we can.

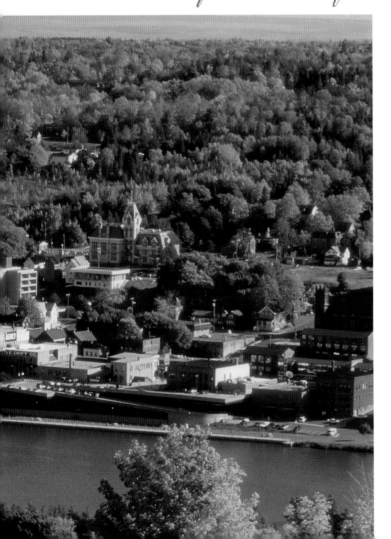

(Top) Pleasure craft dock in the harbor at Bayfield, Wisconsin. *(Bottom)* A shipping canal divides Houghton and Hancock on Michigan's Keweenaw Peninsula.

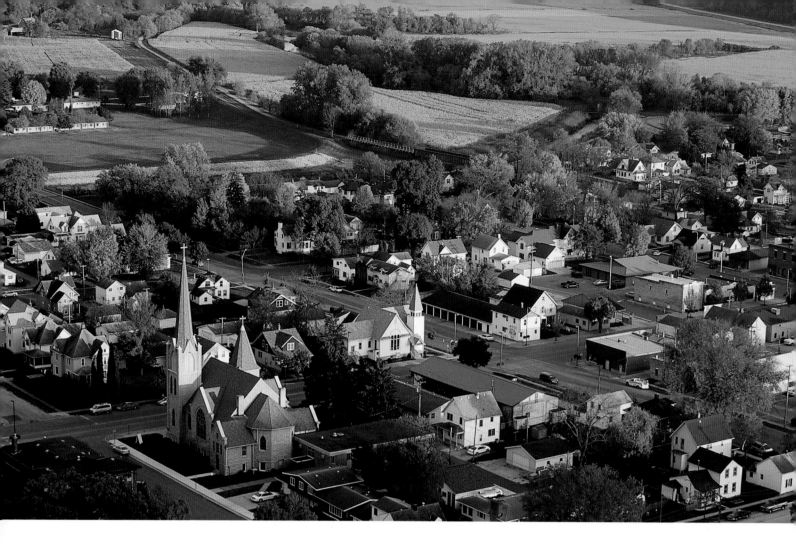

COOLING DAYS AND FALLING LEAVES *impel us*

(Bottom row, from left) Autumn brings students back to Indiana University in Bloomington. A horse-drawn carriage rolls through the post-Labor Day quiet in Lake Geneva, Wisconsin. Cornell College in Mount Vernon, Iowa, is especially pretty in fall.

(Top row, from left) Autumn lights up picture-book locations across the Midwest: Rushford, a scenic town in Minnesota's Root River Valley; Stillwater, Minnesota, along the St. Croix River; and Vevay, Indiana, an Ohio River town.

to invest peaceful, lazy time into this quickly drifting season.

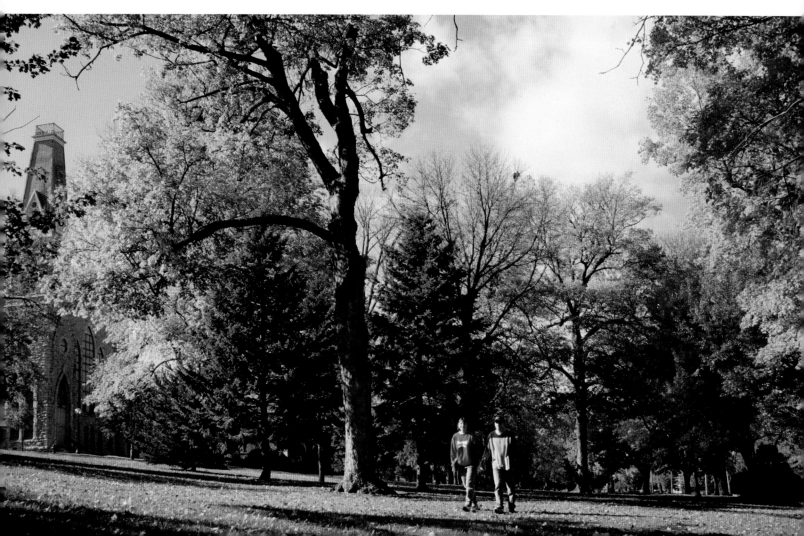

AUTUMN LEAVES *add to an already striking view of most vibrant cities. The river, where the city began, is a center*

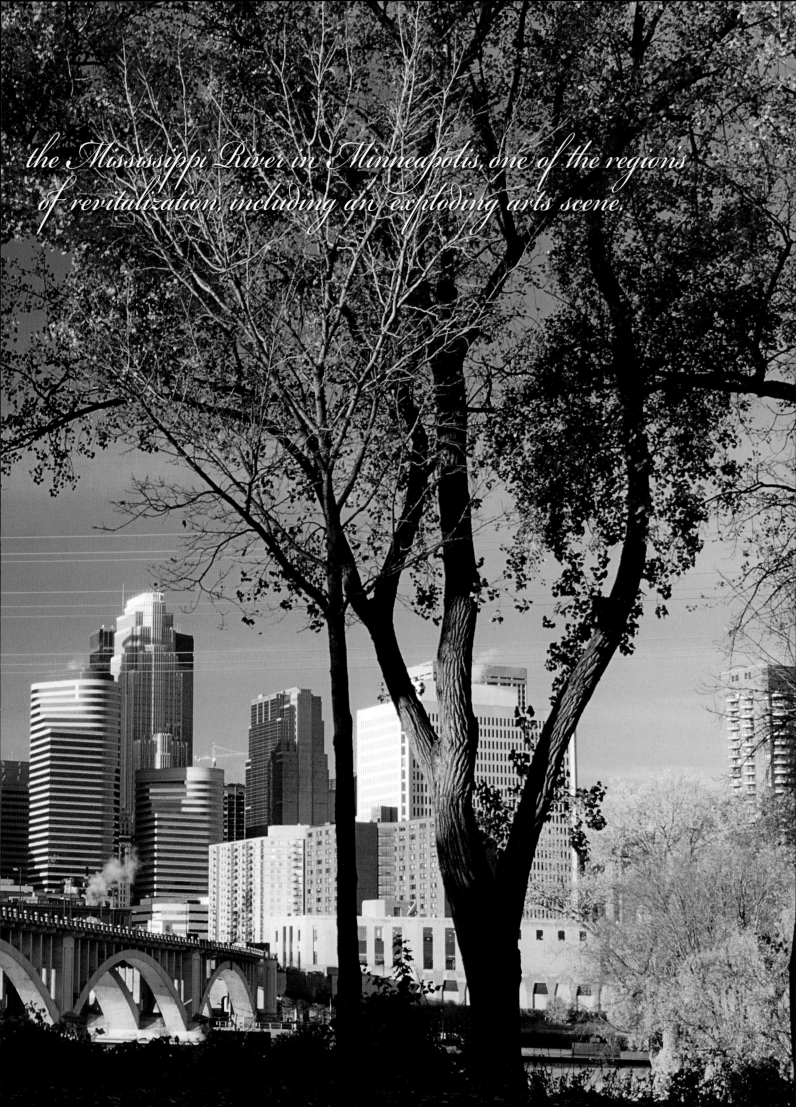
the Mississippi River in Minneapolis, one of the region's of revitalization, including an exploding arts scene.

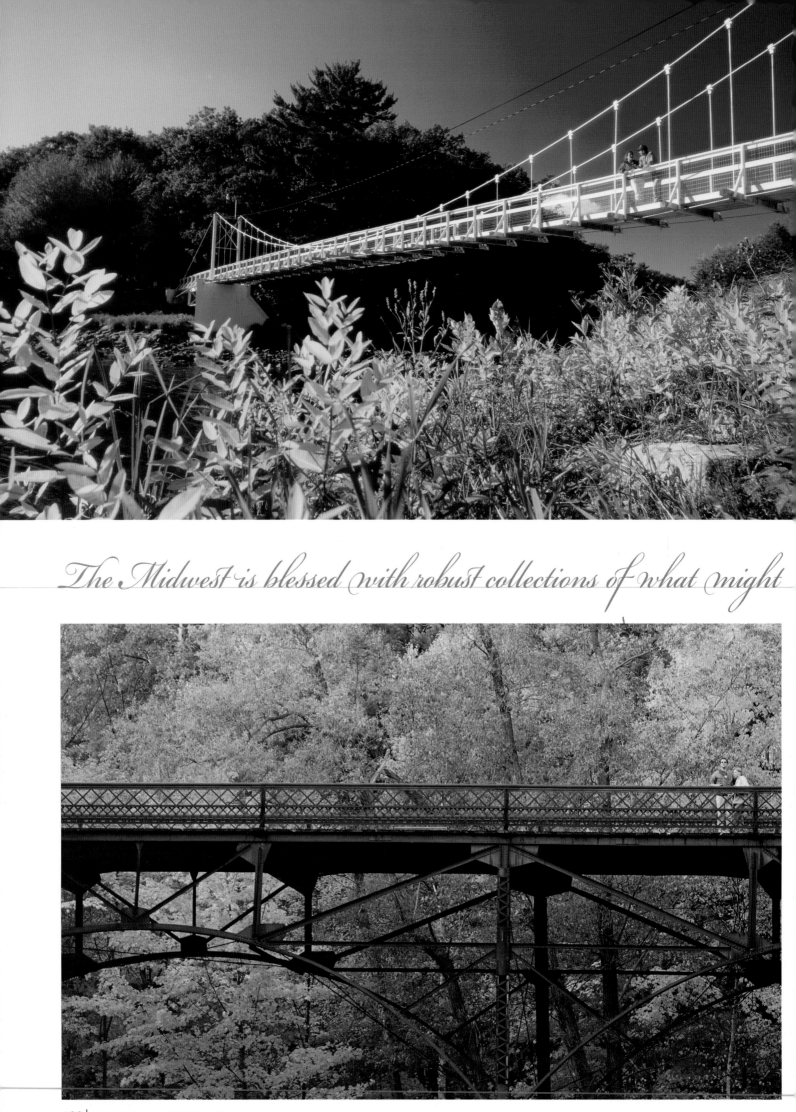

The Midwest is blessed with robust collections of what might

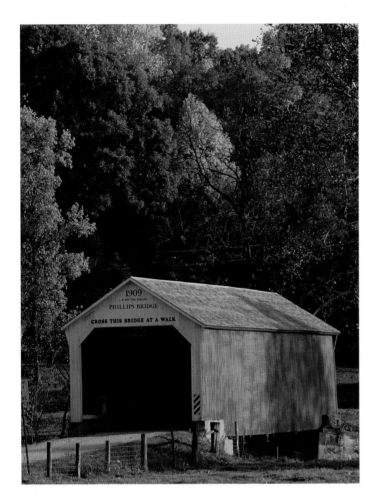

BRIDGES TO THE PAST

Bridges tend to produce nostalgia. They carry people home, carry them away, and they connect cultures. Plus, their architecture often reveals insights into and introduces wonder about the communities that erected them. The Midwest is blessed with robust collections of what might be the most romantic spans around: covered bridges, also known as "kissing" bridges. Central Iowa's handful was immortalized by the best-selling book and film, *The Bridges of Madison County*. Brown County, Indiana's, bridges became famous, thanks to all the artists who took up residence there and produced countless paintings of landmarks, such as the Bean Blossom Bridge. The 16 bridges in northeastern Ohio's Ashtabula County merit an autumn weekend drive. Plenty of other countryside bridges are worth their own trips, and the extensive rails-to-trails systems across the Midwest provide easy access to eye-catching old spans nestled in some of the region's most beautiful areas.

(Top row, from left) This Wisconsin Rapids bridge spans the Yellow River. Indiana's Phillips Bridge allows traffic. *(Bottom row, from left)* It's peaceful on an old iron footbridge near Bayfield, Wisconsin. This Parke County, Indiana, bridge runs 72 feet.

be the MOST ROMANTIC SPANS *around: covered bridges.*

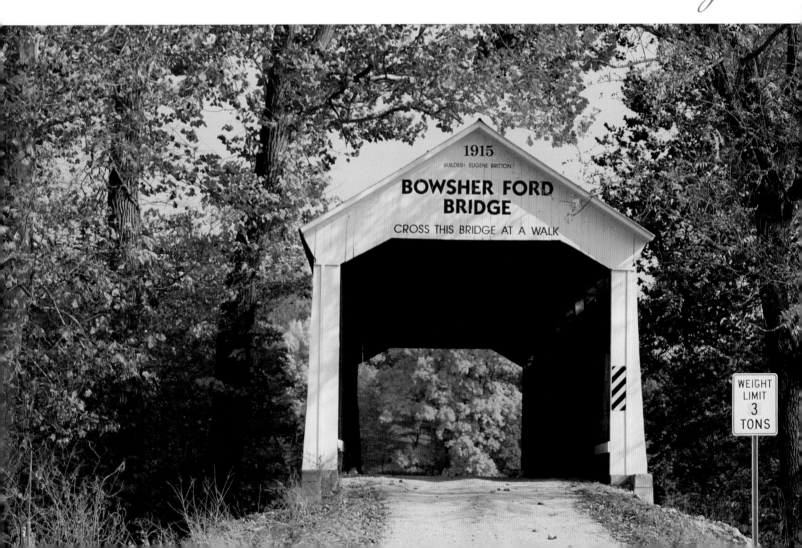

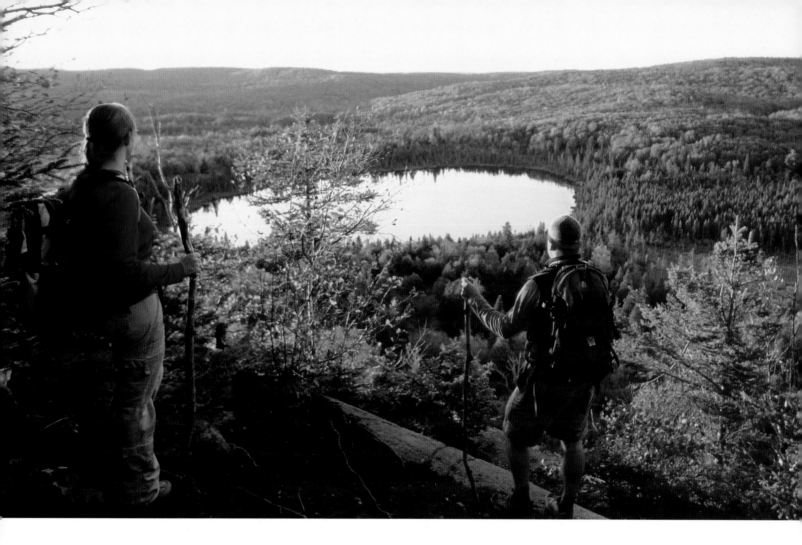

Our abundant hiking paths and smooth bicycle trails

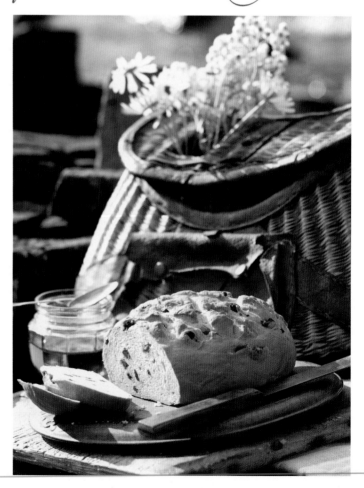

(Bottom row, from left) A paddle stirs the colors on Michigan's Nottawa Creek. Swedish Rye Bread from northern Minnesota's Lutsen Resort tastes great in fall. Fly fishermen covet the golden aspens and cool streams of South Dakota's Spearfish Canyon.

TRAIL RIDE

Trains helped to open the region, and now rail trails cut across almost every Midwest state, taking bicyclists into scenery unreachable any other way: trestles over streams, tunnels through bluffs and routes that sneak behind fields and seemingly worlds away from everyday traffic. The Midwest's longest—Missouri's Katy Trail—stretches 225 miles from east of Kansas City almost to St. Louis. Autumn is one of the best times to ride this 8-foot-wide, mostly level gravel path. The 114-mile section from historic Rocheport east to Augusta travels through the heart of wine country, a region that reminded German settlers of their homeland. Bluffs splashed with autumn hues loom overhead. Towns appear every 10 to 15 miles—Hartsburg preparing for its annual Pumpkinfest, Hermann beckoning with its inns and wineries and Dutzow and Marthasville showing off their stamped-metal storefronts. On this, the route that Lewis and Clark and Daniel Boone followed, explorations continue.

(Top row, from left) Hikers earn a rewarding vista on Minnesota's Superior Hiking Trail. Missouri's Katy Trail suits all ages.

CARRY US WORLDS AWAY *from everyday life.*

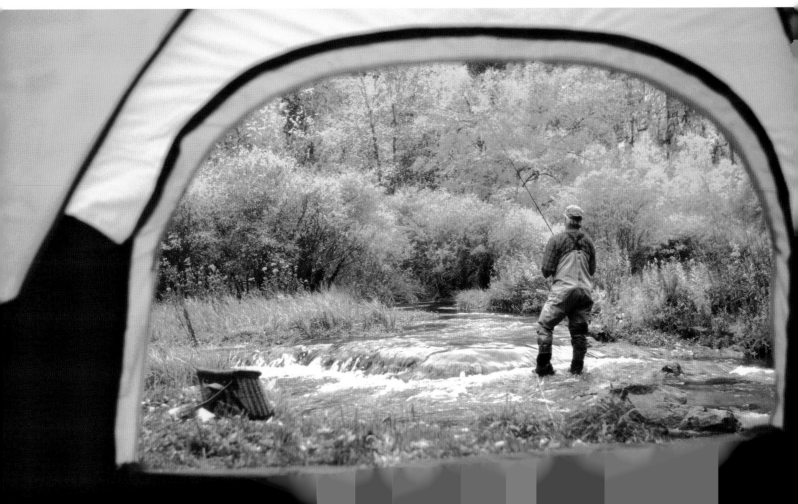

One of the best ways to enjoy autumn long after the leaves have fallen is to capture foliage on film. For particularly stunning fall photos, consider including water in your shots. The reflection of the leaves in the water brings spectacular beauty. Try taking pictures during the "magic hours" (just after sunrise and before sunset) when the light is best. And don't be afraid to click when the sky is cloudy: Fall color tends to pop when the sky is dim. For more intriguing images, put the subject off-center, about a third of the way from the middle, whether it is top, bottom, left or right. Or think simply: A bright red leaf on a gray rock makes a striking photograph.

TARA OKERSTROM-BAUER
PHOTO EDITOR

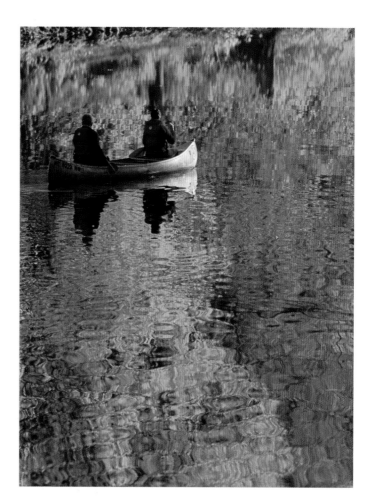

THE BEST PICTURES *often are close-ups. A bright*

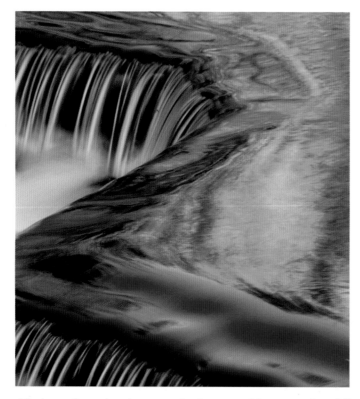

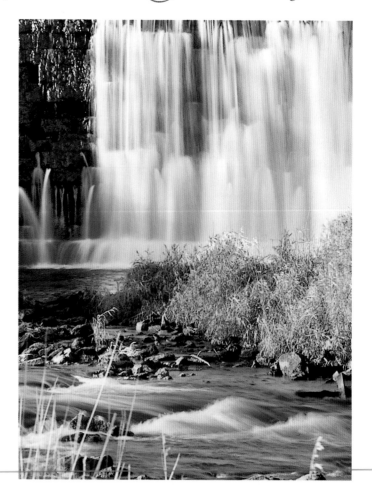

(Clockwise, from above) Water makes for some of the most striking fall photographs: northern Michigan's Bond Falls, southwest Michigan's Nottawa Creek and a dam on the Root River in Lanesboro, Minnesota. *(Opposite)* Scenic Spearfish Creek gushes in South Dakota.

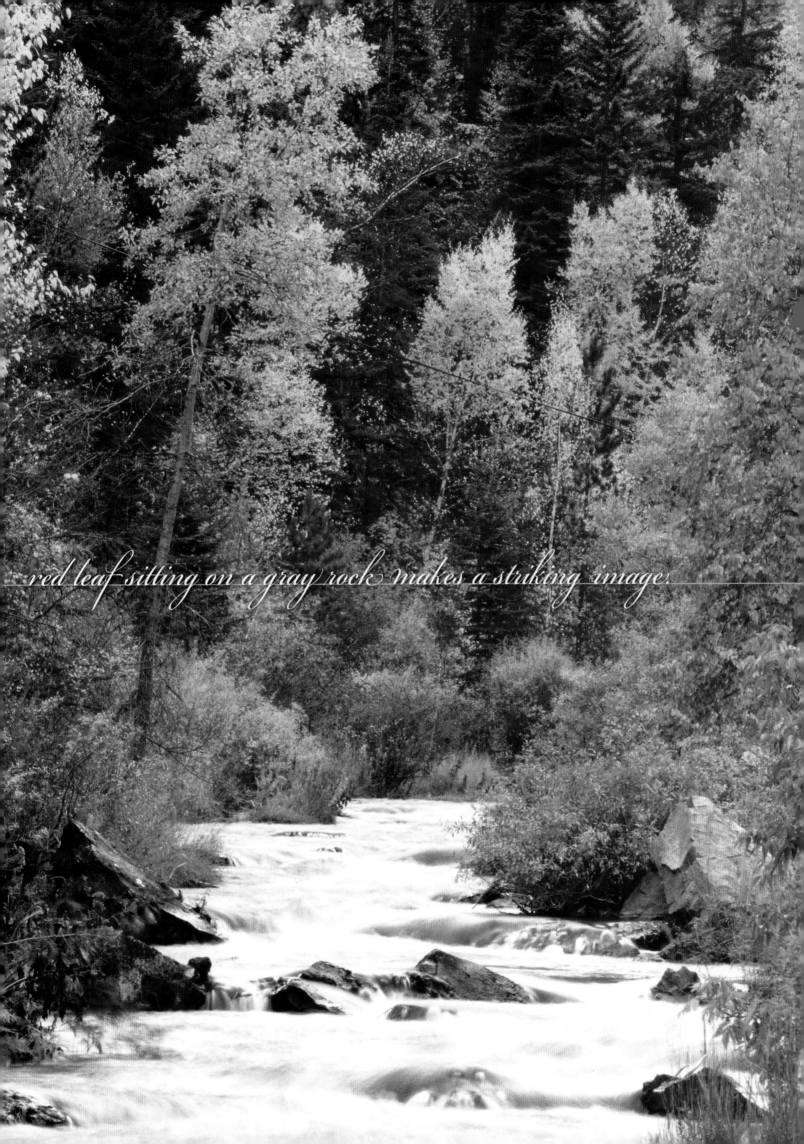

red leaf sitting on a gray rock makes a striking image.

WINTER *in the* HEARTLAND

ctions

Winter settles peacefully
around Hauge Lutheran
Church in Decorah, Iowa.

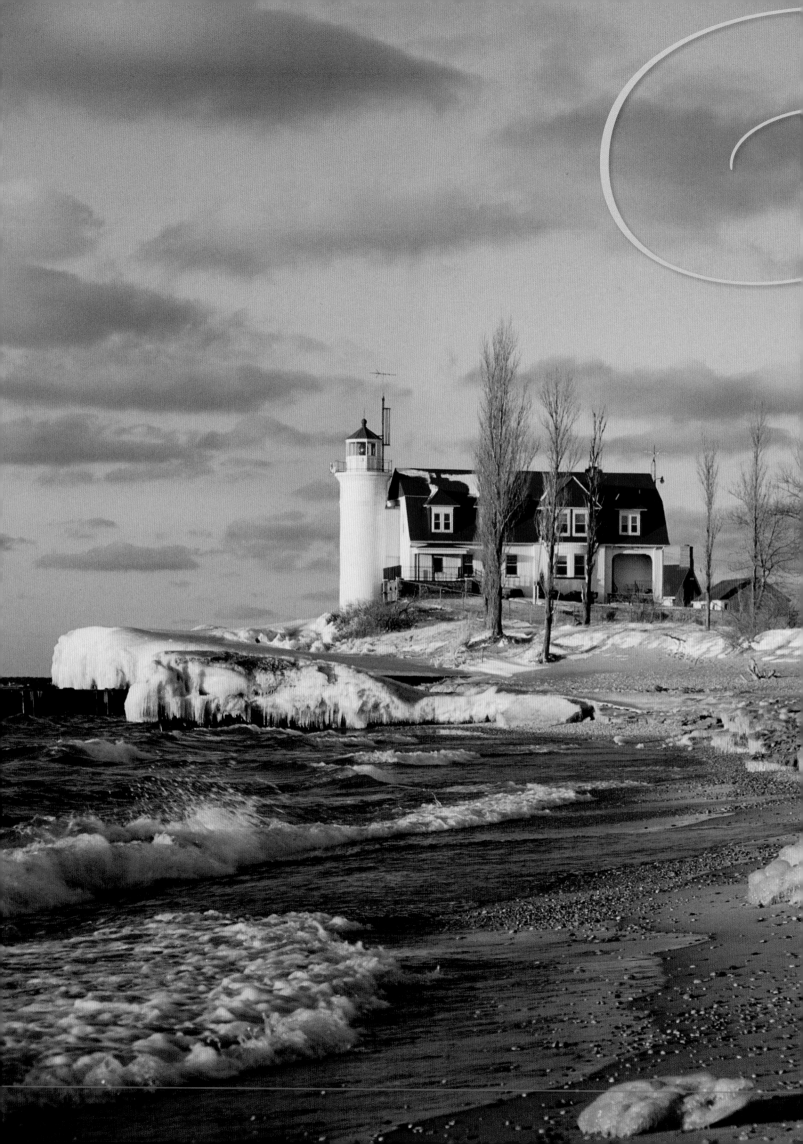

*W*hen we say the holidays are too busy, it's not all the decorating and celebrating that we're really complaining about. What we're longing for is the chance to connect in meaningful ways with each other. That's the elusive true spirit of the season that we hear so much about. These connections can happen amid the glitter of Chicago's Magnificent Mile or the bustle of the Twin Cities' Mall of America. But often, this spirit wells up in situations that aren't especially glittery or festive. We take time for coffee with an elderly neighbor; a smile and a wave head off a race for a mall parking space; someone invests the effort to make Grandma's special stuffing. Little things and extra effort mean a lot and make us think about the people we love and the good fortune we enjoy.

We refuse to let the shopping and preparations consume us completely; instead, we escape with friends or family for a couple of days to places like Minnesota's Gunflint Lodge or Michigan's Garland Resort, where someone else worries about all the preparations. Or maybe it's a matter of devoting a morning to building a snowman or taking the kids sledding.

Those moments together carry us into the New Year. After all the decorations come down, there's more time for thought. Last year's plans and projects resurface. We consider new directions for maintaining holiday connections, for healthier meals, for next spring's garden, for freshening up a room or two. We mull our plans, maybe beside the fireplace that becomes the home's focus this time of year. Or we take our musings out to places like Illinois' Starved Rock State Park, where trails lead to frozen waterfalls, or Michigan's Porcupine Mountains, with ski runs overlooking Lake Superior. For now, the joy is in reflection and in the beauty of this quiet season.

Ice piles up around Point Betsie Lighthouse on the northwestern shore of Michigan's Lower Peninsula. Built in 1858 at a cost of $5,000, the station marks the entrance to treacherous Manitou Passage.

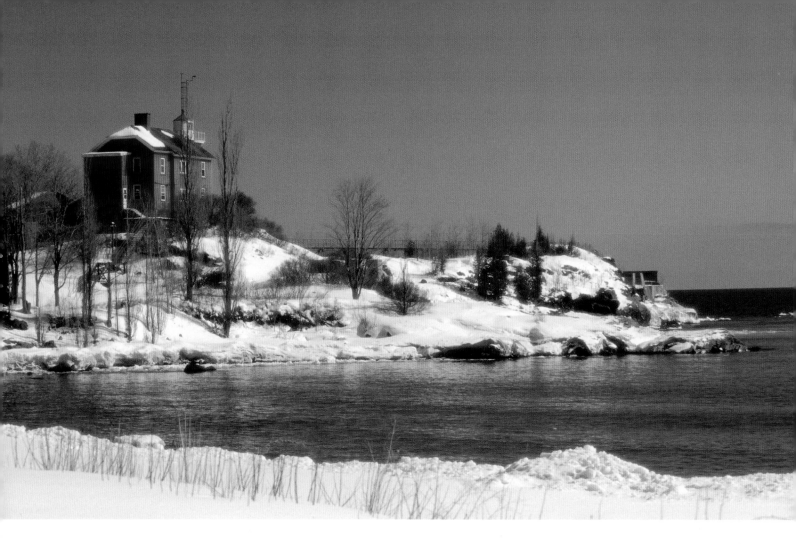

THE WINTER LIGHTHOUSE, *standing in majestic*

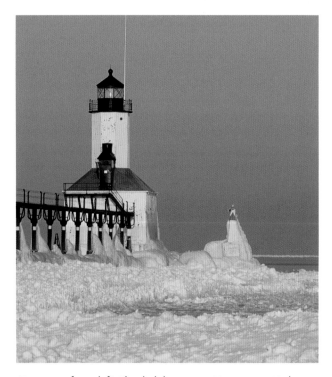

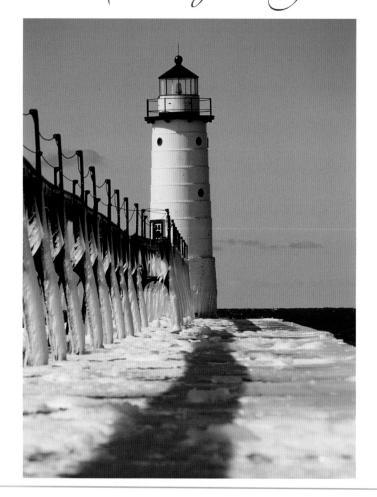

(Top row, from left) The lighthouse at Marquette, Michigan, marks an old iron port. Grand Haven, Michigan's, tower sits at the mouth of the town's harbor. *(Bottom row, from left)* Ice closes around the Michigan City, Indiana, lighthouse. Windswept ice adorns Manistee, Michigan's, light. Eagle Harbor Lighthouse stands watch on Michigan's Keweenaw Peninsula.

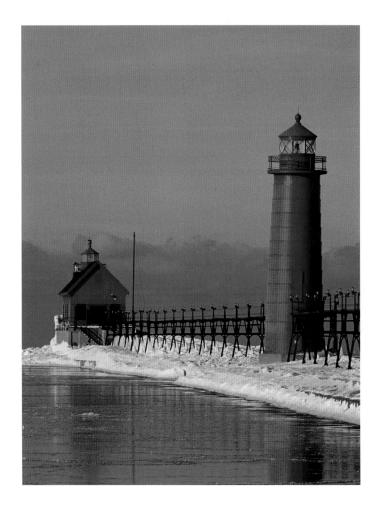

GREAT LAKES SENTINELS

By nature, perched on a bluff or at the tip of a point, light-houses claim some of the most picturesque sites. Their stories, too, are romantic: low foghorns reaching out like strong hands to guide ships through dangerous weather; captains fixing on the lights as their lifeline. All along the Great Lakes, lighthouses fascinate visitors. In Michigan, Indiana, Wisconsin, Ohio and Minnesota, dozens of these towers are open as historic sites. People tour lightkeepers' quarters, climb the towers and, looking at the sweeping views of water, imagine the days when lives and commerce depended on these guardians. But most don't see the lighthouses in winter, perhaps the most poignant glimpse into the loneliness and beauty of these outposts. Maybe an occasional photographer is around to witness what happens on long, solitary winter days. The Great Lakes pound them with freezing spray and pile forboding castles of ice around them. Snow sweeps in over the water and falls in sheets. There is little to tell sky from water from land. Through it, the lighthouse maintains its quiet task. Those who observe can't help but be beckoned by it.

solemnity on a cold, lonely point, steals the hearts of artists.

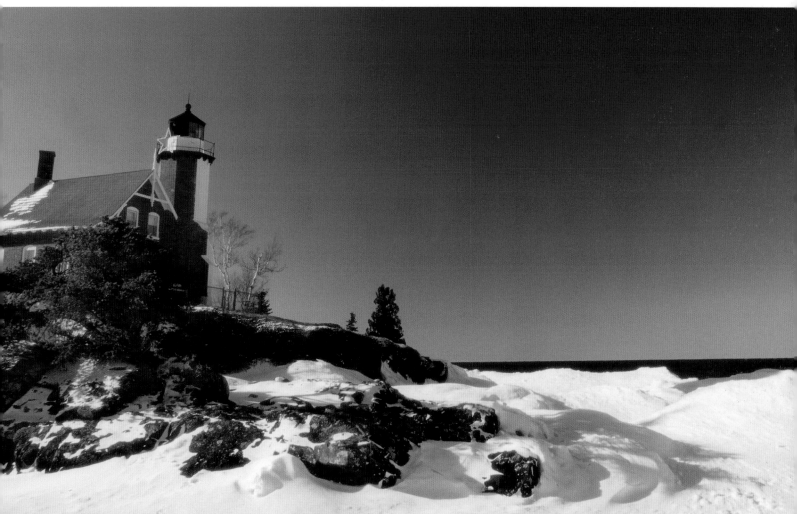

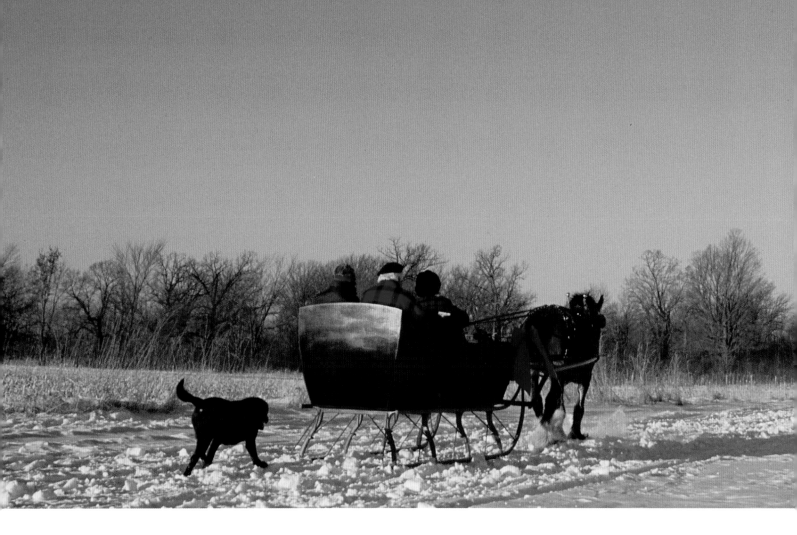

We weave a TAPESTRY OF TRADITIONS *from our*

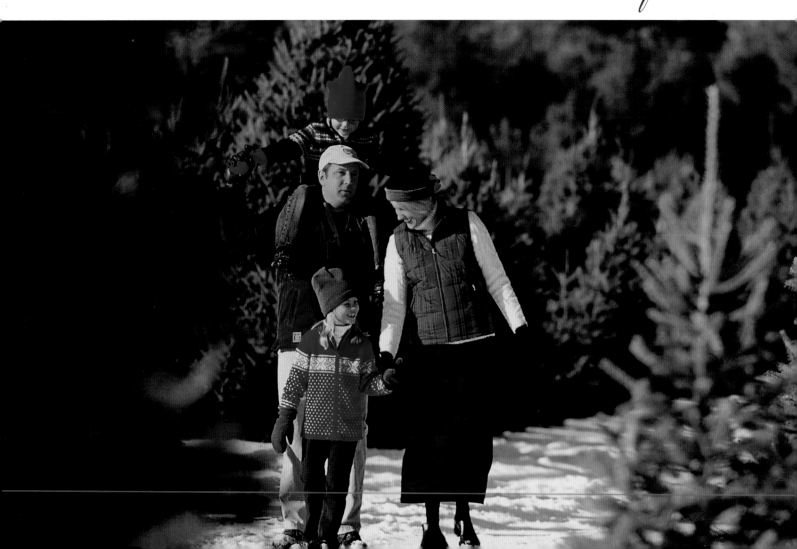

WE KNOW WE'RE BIASED, but to us, it seems only fitting that the country's most popular Christmas tune was born in the Midwest. When Chicago native Mel Torme wrote "The Christmas Song," complete with chestnuts roasting on an open fire, he wrapped up our holiday dreams. We want time with family and time for reflection; time for traditions and revelry; time for presents and food.

The Midwest's rich cultural heritage helps us realize those dreams. Door County, Wisconsin, residents honor their Scandinavian roots by decorating with hand-painted Dala horses and serving smorgasbords full of Swedish rye bread, *glögg* (mulled wine) and *julgrot* (Christmas rice pudding). Zingerman's deli in Ann Arbor, Michigan, makes *hamantaschen*, a three-cornered pastry stuffed with sweet filling. Ohio's Marion County Fairgrounds holds a "Christmas by Candlelight" driving tour with scenes from the area's agricultural past and a living nativity.

many roots and proudly pass it along to new generations.

A holiday home tour in Geneva, Illinois, inspires thousands of visitors to decorate their own homes in new and beautiful ways. Dozens of Midwest towns, including Lafayette, Indiana, celebrate the Victorian Era with Dickens-themed festivals, complete with horse-drawn carriages, strolling carolers and hot cider for shoppers. And Medora, North Dakota, salutes its Wild West past with an annual Cowboy Christmas celebration filled with music, dancing, food, a parade and pictures with Santa.

All these events weave a tapestry of tradition that Midwesterners are proud to pass on to new generations. But as much as we like to celebrate in our communities, we also like retreating to the warmth of home and family. We pull out recipe boxes and make a favorite stuffing or fudge, remembering in an instant the familiar scents and flavors we indulge in just once a year. With or without the chestnuts on an open fire, we work to ensure each Midwest Christmas is even better than the last.

(Top) Touring the countryside in a horse-drawn sleigh provides a welcome break from the holiday bustle. *(Bottom)* Choosing the perfect tree is a family tradition across the Midwest.

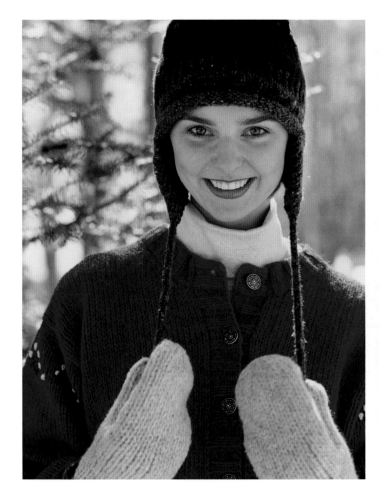

Shopping, celebrating and visiting become richer with a natural

(*Bottom row, from left*) Santa takes requests during Libertyville, Illinois', Dickens Festival. Built by the founder of Goodyear Tire Co., Stan Hywet Hall houses a holiday event in Akron, Ohio. A snowman borrows natty attire. A carriage ferries visitors around the American Club Resort in Kohler, Wisconsin.

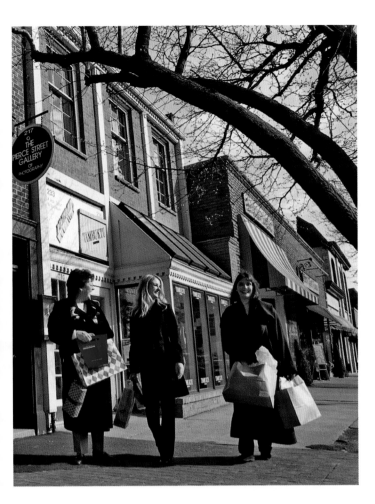

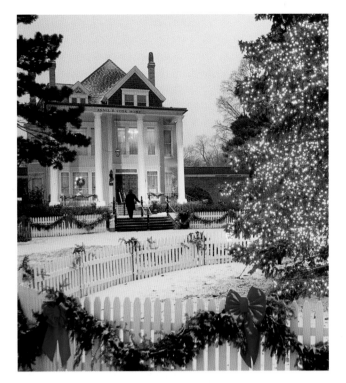

(Top row, from left) Petoskey, Michigan's, historic shopping district puts on fine trimmings. Michigan-made woolens provide winter warmth. Birmingham, a Detroit suburb, offers upscale shopping. The square in Libertyville, Illinois, welcomes the holiday with teas, carols and tours of the Ansel B. Cook Home.

friendliness and OPENNESS OF SPIRIT *with each other.*

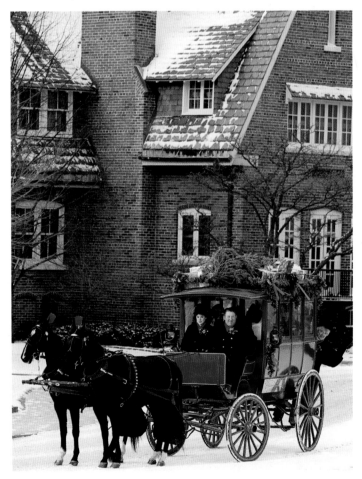

More often than not in recent years, a wreath has graced the cover of Midwest Living's® Christmas issue. That's partly because a circle is a perfect symbol of holiday hospitality— no beginning and no end. It's also because there are so many ways to get creative with this decoration. We've dressed wreaths with fresh and dried flowers, pussywillows, cranberries, seed pods—even sugar cookies. Our designers have added new twists to traditional reds and greens and veered into fresh territory with pinks, whites and earthy browns. We love festooning our front doors with new ideas. What we all really love, though, is what's behind the wreaths on countless Midwest doors—warm welcomes from family and friends.

GERI WOLFE BOESEN
CREATIVE DIRECTOR

(Opposite) Special holiday touches bring warmth to homes across the region. (Clockwise, from above) Bite-size Fairy Sandwich Cookies are a must at an Ohio family's annual cookie-baking party. Fresh flowers and an inverted tree topper enliven this wreath. A "stocking wreath" creates a unique welcome.

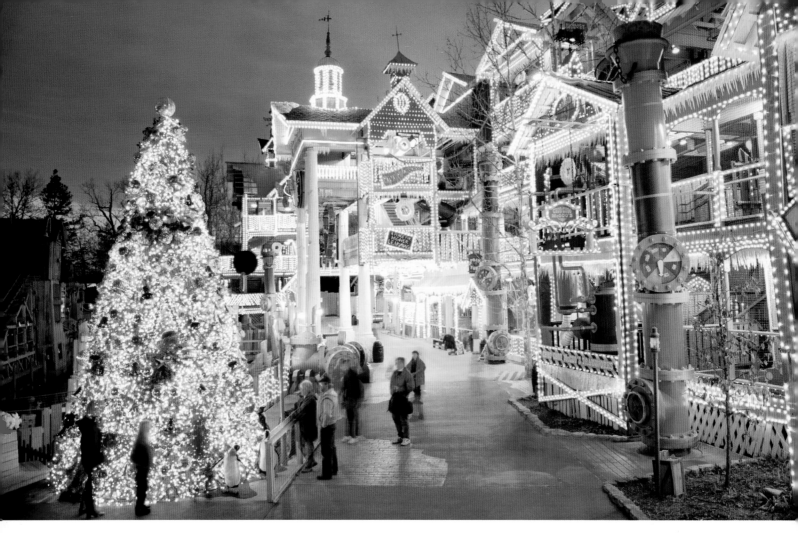

There's a SPARKLING ENERGY *as our cities and towns*

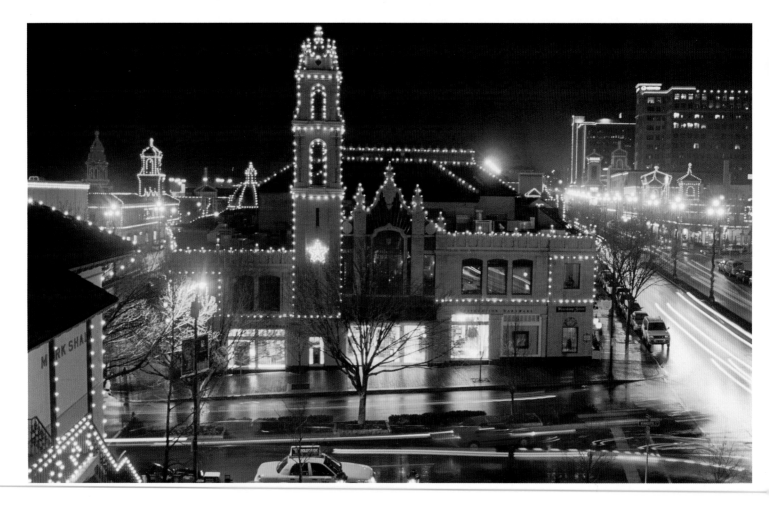

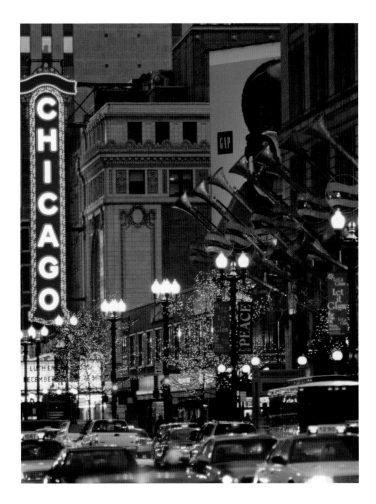

SPIRIT OF THE SEASON

We'd never dare try to choose where the holiday season shines brightest in the Midwest. Across the region, spirited cities, towns and attractions decorate for the season and stage memorable displays. Chicago's Magnificent Mile lights festival starts with a parade and fireworks. Then, the Mile and the nearby Loop light up with millions of tiny white sparklers. Lights, the colored variety, also outline the historic buildings of Kansas City, Missouri's, Country Club Plaza. At Branson, Missouri's, Silver Dollar City, a giant tree glows amid light-trimmed shops, crafts studios, restaurants and bakeries. East Peoria, Illinois, puts on one of the largest drive-through displays with all sorts of detailed, colorful creations, such as a train and a jack-in-the-box. Those are just some of the largest; small-town celebrations shine, too, like the ones in WaKee-ney, Kansas, which calls itself "The Christmas City." It's not just the size of the celebration that makes it glow. It's the heart.

(Top row, from left) Holiday lights dazzle at Branson, Missouri's, Silver Dollar City, and in Chicago's Loop. *(Bottom row, from left)* A festive mood colors Kansas City, Missouri's, Country Club Plaza and Minneapolis' Theater District.

decorate for the season and stage memorable displays.

Spread your love for the season's scents by making

(Top row, from left) Seasonal snacks entice at Illinois' Long Grove Confectionery. Tulips brighten a winter room. A rustic hearth brings cheer. *(Bottom row, from left)* Special touches enrich the holidays: cakelike Chocolate-Raspberry Souffle; clear vases for display; a creative frosted wreath; decadent Torta d'Alassio.

FESTIVE TOUCHES

Decorating. Shopping. Wrapping. Baking. Hosting. With a to-do list like that, it's easy to lose focus on the season's joy. But really, joy itself should be on your list. It's one of the season's best gifts—for others and for yourself—and there are easy ways to find it. Gathering with family and friends to sing Christmas carols slows down the holiday pace. Kissing under mistletoe brings fun—or romance—to everyone passing under it. Buying fresh flowers, especially those you wouldn't expect to see at Christmastime (tulips and hydrangeas, anyone?), refreshes your spirit. Sound simple? That's just the beginning. Remember to give yourself a day to rest. Or call a friend you haven't heard from all year. Try simmering a bag of spices on your stovetop, infusing your house with comforting aromas. Rather than planning an all-out dinner party, consider having a hot-cocoa-tasting party with a selection of tasty toppers. And there's nothing wrong with admiring your neighbors' handiwork. Driving through neighborhoods to admire Christmas lights is another simple way to slow down. Back at home, light a candle, wrap yourself in a cozy blanket and think of three ways you were blessed this year. It just might end up being your favorite gift of all.

SPICE BAGS FOR SIMMERING *for your friends.*

(Top row, from left) Simple blues and whites adorn an Illinois farmhouse at Christmas. An ivy wreath varies the holiday look. *(Bottom row, from left)* The Bayfield, Wisconsin, town tree serves as a beacon by the Lake Superior harbor. Blue provides a new take on Christmas color. The Rittenhouse Inn glows in Bayfield.

I grew up in a town full of basements and attics. All the dress-up clothes…the half-sewn curtains…the dolls who knew all my secrets…My house was this sweet little cocoon of stuff. We were protected from above and below by boxes and boxes of perfect memories and half-finished projects that, with one peek down the stairs or up through the secret hatch, conjured up all our families' pasts and promised our futures together. In Los Angeles, no one has basements and attics. People don't have to pass Grandma's wedding dress to get to the washing machine. Even in Los Angeles, I only need to shut my eyes and remember my cocoon to feel safe.

CATHY GUISEWITE
CREATOR OF "CATHY" COMIC STRIP WHO
GREW UP IN MIDLAND, MICHIGAN

The Great Lakes' notorious moodiness endures after the water
shoreline continually present A FRESH CANVAS OF

Lake Superior's shore glistens
near Bayfield, Wisconsin.

freezes for the season. The restless lake and its shifting FRACTURED ICE *for the colors of sunrise and sunset.*

Up north, people WELCOME THE WILD SEASON

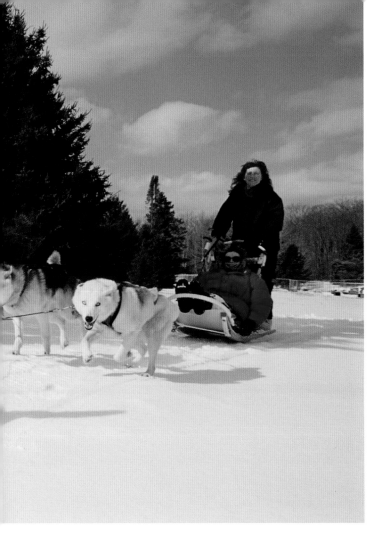

SOME ENDURE WINTER. OTHERS EMBRACE IT. Up north in the Midwest's wild snow country, people welcome the season like kids who have just received free passes to a particularly wonderful amusement park. That's sort of true, if you think about it. Consider this list: downhill and cross-country skiing, snowboarding, snowmobiling, snowshoeing, sleigh rides, dog sledding, ice skating, ice fishing, ice sculpting, winter carnivals. These people even camp in winter.

After all, the season up north is nothing like that along the Midwest's southern rim. Down there, winter is mostly a mild three-month vacation from mowing the lawn and a chance to reacquaint yourself with your remote. And there's usually at least one opportunity to terrify yourself driving in an ice storm. Northern winters are certainly nothing like those on the plains from Kansas to South Dakota, where false springs

Like kids who've just received passes to an amusement park.

give way to howlers that pile snow into drifts that bury tractor-trailer trucks.

No, in Minnesota, Wisconsin, Michigan, North Dakota, northern Iowa and Ohio along the Lake Erie shore, abundant snow defines the season. At winter's onset, and at its end, big, wet, ornate flakes flock pine trees and telephone poles with equal artistry. In the heart of the season, moisture off the Great Lakes and Minnesota's 10,000 lakes feeds almost daily squalls of powdery fluff that accumulates to staggering depths. Over the fence. Over your head. Over the roof. Snow gathers on stumps and barns and bridge railings. It turns parked cars into three-dimensional art.

And the view is even better if you're the one jamming along a snowmobile trail or busting your best X Games moves coming off a terrain park rail.

(Top) Adventurers learn mushing as part of a winter getaway on Michigan's Upper Peninsula (UP). *(Bottom)* Despite frigid temperatures, snow lovers camp during the winter on the UP.

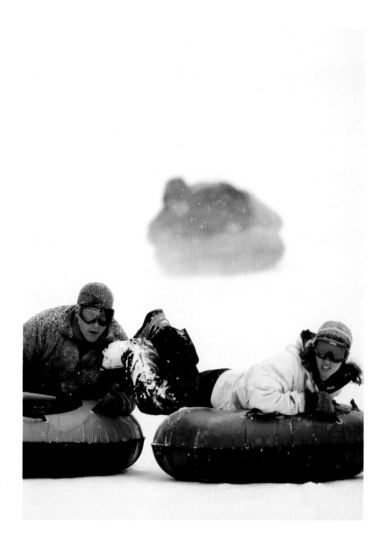

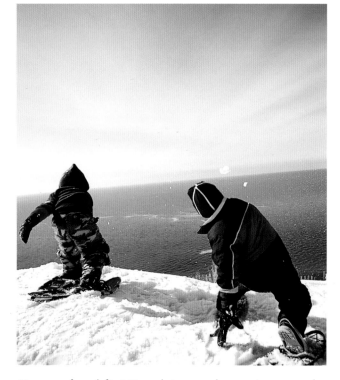

(Top row, from left) Winter brings outdoor excitement at the Plymouth, Michigan, Ice Sculpture Spectacular, as well as tubing and snowboarding hills throughout the Midwest. (Bottom row, from left) Snowballs fly far off Michigan's Sleeping Bear Dunes National Lakeshore. Young skaters learn the ice in southeast Minnesota's bluff country. "Sledders" follow South Dakota trails. In the Upper Peninsula, Michigan, residents love the snow.

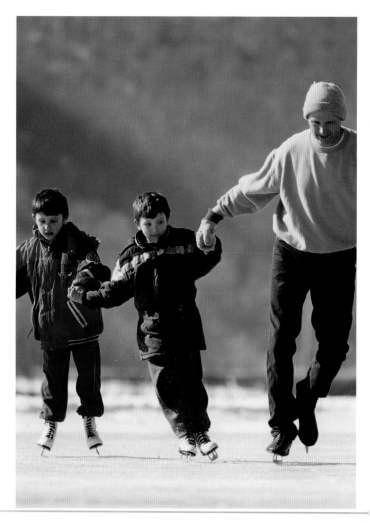

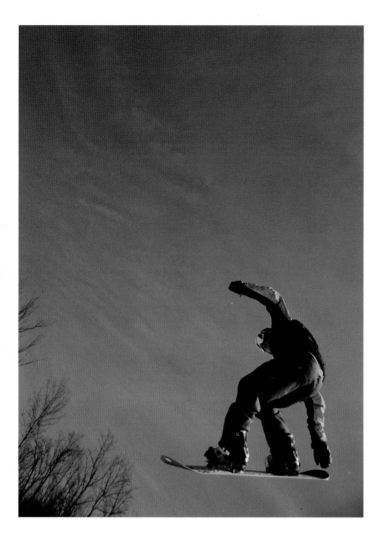

WACKY WINTER FUN

The Midwest has its share of skiing, skating and other common winter sports, but we also find more creative ways to keep having fun when temperatures drop. Some popular diversions include frozen turkey bowling, broomball games and building ice-fishing villages complete with road signs, satellite television and "shacks" that rival some small homes. The epicenter of the wacky winter scene rests on Leech Lake in northern Minnesota each February during the International Eelpout Festival, going strong since 1979. Participants known as "pouters" pursue the largest eelpout, an aesthetically challenged fish that looks like a cross between an eel and a catfish. Other events include car races and a rugby match held on the ice, judging of fishing "encampments" and swimmers taking polar plunges. Minnesota also hosts the World Pond Hockey Championships, when more than 200 teams compete on Minneapolis' Lake Calhoun for a coveted prize: the Golden Shovel. Another classic: the 27-year-old University of Okoboji Winter Games, hosted in northwest Iowa by a mythical university. Take your favorite laid-back sport—say, softball or miniature golf—and put it on ice, and you'll get the idea.

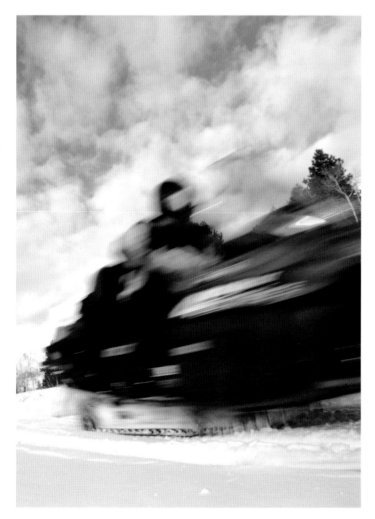

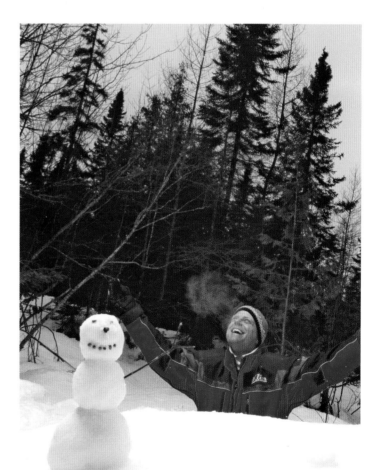

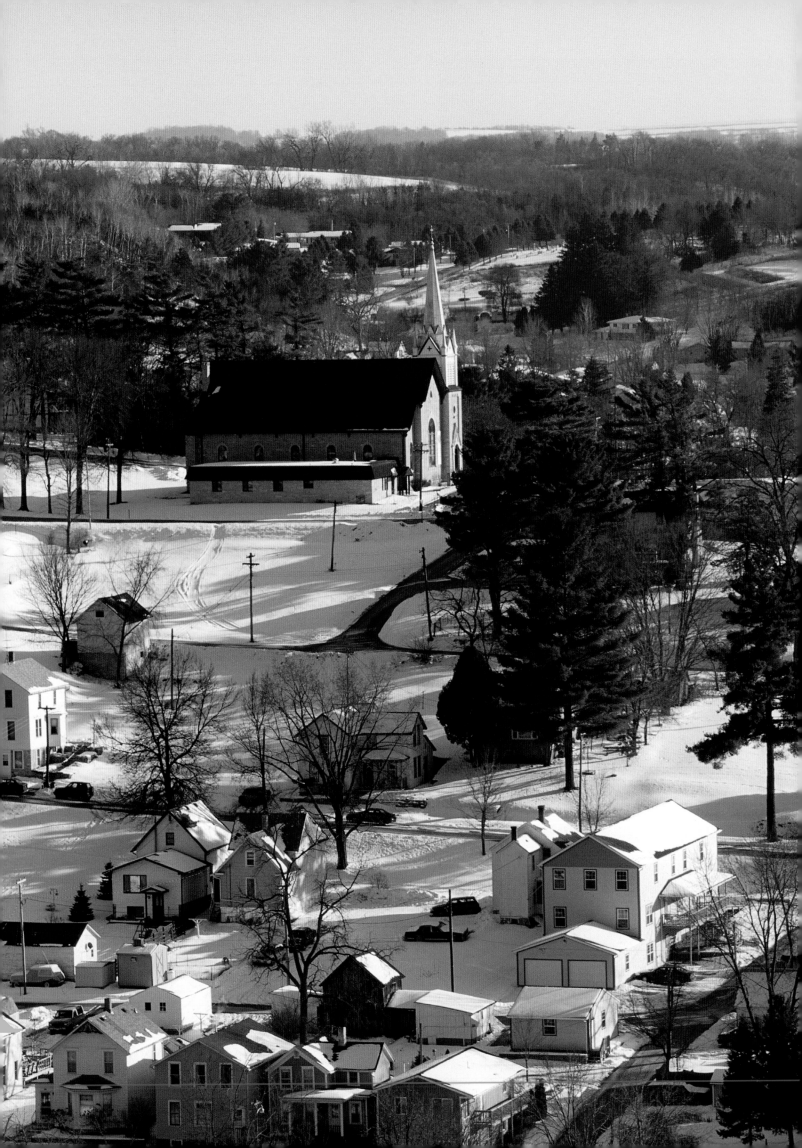

There's a reason weather plays a role in literature and film. Weather is emotion. And that first snowfall of winter, the one that breaks open from a blank gray sky, the one that tumbles impossibly large flakes, the one that transforms familiar land into something utterly new, the one that blurs earth and sky into a soft, swirling chaos and pulls you untethered into it, that snowfall brings a special sensation. It's excitement. It's serenity. It's enclosing, and it's freeing. It's an old friend, and it's wonderfully wild. I anticipate this snow all year. And no matter how many first snows of winter I've seen, each year when it happens, it's as though it's for the very first time.

GREG PHILBY
EXECUTIVE EDITOR

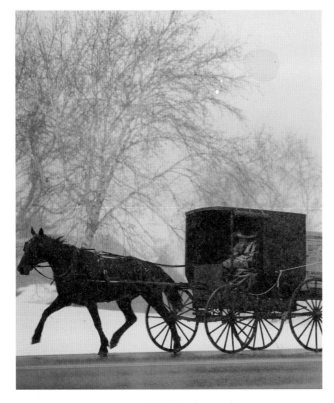

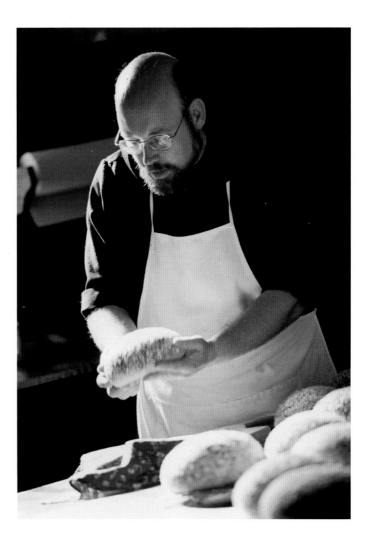

(Opposite) Fresh snow blankets Lanesboro, Minnesota. (Clockwise, from above) An Amish driver braves the snow in southeastern Minnesota. Interpreters in old-time dress glide on the skating rink at Greenfield Village, part of The Henry Ford museum near Detroit. Cookbook author the Rev. Dominic Garramone bakes bread at St. Bede Abbey in Illinois.

We forget to listen for little things of enormous importance

(Top row, from left) December snow dusts New Ulm, Minnesota. A quiet moment captivates a couple in Ellison Bay, Wisconsin. (Bottom row, from left) The holiday classic The Nutcracker, such as this Chicago performance, is a tradition for many. Winter paints a soft scene near Brainerd, Minnesota.

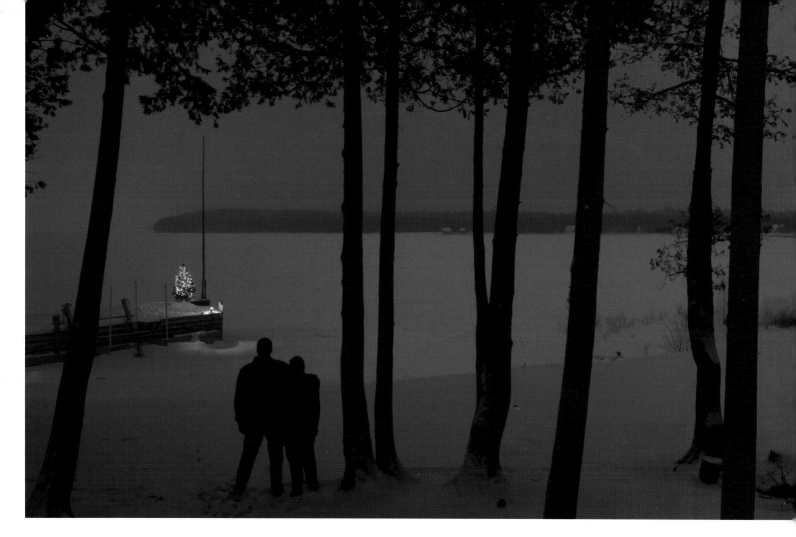

that heaven is gently WHISPERING IN OUR EARS.

MICHAEL CARREY, A POET, FARMER AND LECTURER LIVING IN FARRAGUT, IOWA

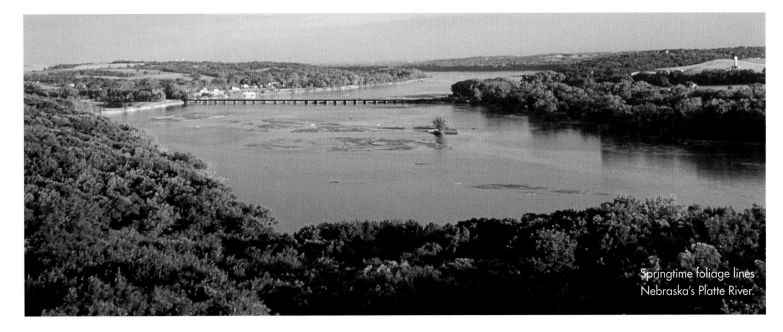

Springtime foliage lines Nebraska's Platte River.

SPRING

CHOCOLATE-PECAN PIE

Page 21: This chocolate version of pecan pie from Clifton Mills restaurant in Clifton Mills, Ohio, disappears fast. It features some no-fail favorite ingredients: pecans and chocolate.
Prep: 30 minutes. Bake: 40 minutes.
Cool: 1 hour

 Pastry for Single-Crust Pie
 (recipe follows)
1/4 cup butter
 2 ounces unsweetened chocolate
 3 eggs
 1 cup dark-colored corn syrup
3/4 cup sugar
1 1/2 teaspoons vanilla
 1 cup pecan halves

1. Line a 9-inch pie plate with pastry. Trim and crimp the edges of the pastry as you like; set aside. (If you like, make pastry cutouts from scraps of pastry. Bake on an ungreased baking sheet in a 350° oven for 10 to 12 minutes, or until they're golden brown.)
2. In a small, heavy saucepan, combine the butter and chocolate. Cook the mixture over low heat until melted; stirring to mix. Remove the saucepan from the heat and let the chocolate mixture cool.
3. In a bowl, beat eggs slightly. Stir in corn syrup, sugar, vanilla and chocolate mixture. Stir in pecans. Place pastry-lined pie plate on oven rack. Carefully pour in filling.
4. To prevent overbrowning, cover edge of pie with foil. Bake in a 350° oven 20 minutes. Remove the foil from the edge. Bake the pie for 20 to 25 minutes more or until a knife inserted near the center comes out clean.
5. Cool the pie at room temperature for 1 to 2 hours on a wire rack. Refrigerate the

cooled pie within 2 hours. To serve the pie, decorate top with baked pastry cutouts, if you like. *Makes 10 servings.*
Pastry for Single-Crust Pie: In a mixing bowl, stir together 1 1/4 cups all-purpose flour and 1/4 teaspoon salt. Using a pastry blender, cut in 1/3 cup shortening until pieces are pea-size. Sprinkle 1 tablespoon of cold water over part of the mixture; gently toss with a fork. Push moistened dough to the side of the bowl. Repeat moistening dough, using 1 tablespoon cold water at a time, until all the dough is moistened (4 to 5 tablespoons cold water total). Form dough into a ball.
Nutrition facts per serving: 432 cal, 23 g fat, 76 mg chol, 143 mg sodium, 54 g carbo, 1 g fiber, 5 g pro.

BIG CHEESE APPETIZER

Page 24: Shelley Krakenbuhl of Prima Kase cheese factory in Monticello, Wisconsin, loves to share this recipe. She brushed Gouda with mustard, wrapped the cheese in phyllo and baked it until it was spreadable. Here's our version.
Prep: 25 minutes. Freeze: 1 hour.
Bake: 12 minutes

 6 sheets frozen phyllo dough (18x14-inch
 rectangles), thawed
1/4 cup butter, melted
 1 tablespoon sweet-hot or coarse-grain brown
 mustard
 1 7- or 8-ounce round Gouda cheese (with
 paraffin covering removed)
 Pear slices, grapes, crusty bread slices
 and/or crackers

1. Unfold phyllo dough and cover with plastic wrap. Removing one sheet at a time, lay sheet flat on work surface. Brush with a little of the melted butter. Top with another sheet of phyllo and brush with more of the butter. Repeat with the remaining sheets of phyllo dough and butter to make one phyllo stack.

2. Carefully cut a 10- to 11-inch circle from the phyllo stack. Cover and reserve the phyllo trimmings to garnish the top.
3. Spread mustard on top of the Gouda cheese. Place cheese, spread side down, in center of the circle of phyllo dough.
4. Gently bring the edges of the phyllo dough up and over the cheese, pleating and pinching to seal. Brush the cheese bundle with some of the remaining butter.
5. Cut decorative designs from the phyllo trimmings and place on seam side of bundle, brushing with butter. Wrap cheese bundle in clear plastic wrap or foil; freeze for 1 hour.
6. To serve, unwrap the frozen bundle and place, seam side up, on a foil-lined baking sheet. Bake in a 400° oven about 12 minutes, or until the pastry is golden brown and cheese is just softened. Let stand about 5 minutes before serving. Serve with fruit, bread and/or crackers. *Makes 6 servings.*
Nutrition facts per serving: 250 cal, 18 g fat, 59 mg chol, 459 mg sodium, 12 g carbo, 0 g fiber, 10 g pro.

EGGS FLO

Page 26: The refreshing lemony flavor of the hollandaise sauce finishes this version of eggs Benedict. It's a turkey-spinach recipe similar to one served at Flo restaurant in Chicago.
Start to finish: 20 minutes

 Basil Hollandaise Sauce (recipe follows)
 4 eggs
 4 3/4-inch slices of challah, brioche or egg bread
12 ounces sliced smoked turkey breast
 2 cups fresh baby spinach leaves
1/4 cup shredded Asiago or Parmesan cheese
 (1 ounce) (optional)

1. Prepare the Basil Hollandaise Sauce. Keep warm while preparing eggs.
2. Lightly grease a large skillet. Fill the skillet half full with water. Bring water to boiling;

reduce the heat to simmering (the bubbles should begin to break the surface of the water). Break one of the eggs into a dry measuring cup. Carefully slide the egg into the simmering water, holding the lip of the cup as close to the water as possible. Repeat with the remaining eggs, allowing each egg an equal amount of space while cooking.

3. Simmer the eggs, uncovered, for 3 to 5 minutes, or until the whites are completely set and yolks begin to thicken but are not hard. Remove eggs with a slotted spoon and place them in a large pan of warm water to keep them warm, if necessary.

4. Meanwhile, place bread slices and turkey slices on a large baking sheet. Broil 3 to 4 inches from the heat for 1 to 2 minutes, or until bread is toasted. Turn bread slices and turkey slices over. Broil for 1 to 2 minutes more, or until the bread is toasted and the meat is heated through.

5. To serve, top each bread slice with one-quarter of the spinach leaves, one-fourth of the smoked turkey and 1 poached egg. Spoon Basil Hollandaise Sauce over eggs. Sprinkle with some Asiago cheese, if you like. *Makes 4 servings.*

Nutrition facts per serving: 910 cal, 72 g fat, 760 mg chol, 1,408 mg sodium, 31 g carbo, 3 g fiber, 36 g pro.

BASIL HOLLANDAISE SAUCE

Serve this tangy sauce with the Eggs Flo, or use it to top an omelet or cooked fish.
Stand: 45 minutes. Prep: 15 minutes

1/2 cup unsalted butter
3 beaten egg yolks
1 tablespoon water
1 tablespoon lemon juice
1 tablespoon snipped fresh basil
1/8 teaspoon salt
1/8 teaspoon ground white pepper

1. Cut the butter into thirds and bring to room temperature (allow about 45 minutes).
2. In the top of a double boiler, combine egg yolks, water and lemon juice. Add a piece of the butter. Place over gently boiling water (upper pan should not touch water). Cook, stirring rapidly with a whisk, until butter melts and sauce begins to thicken. (Sauce may appear to curdle at this point, but will smooth out when remaining butter is added.)
3. Add the remaining butter, a piece at a time, stirring constantly until melted. Continue to cook and stir for 2 to 2 1/2 minutes more, or until sauce thickens. Immediately remove from heat. If sauce is too thick or curdles, immediately whisk in 1 to 2 tablespoons hot water. Stir in the basil, salt and white pepper. Serve with the Eggs Flo. *Makes 3/4 cup sauce, 4 servings.*

Nutrition facts per serving: 261 cal, 28 g fat, 225 mg chol, 82 mg sodium, 1 g carbo, 0 g fiber, 2 g pro.

24-HOUR TEX-MEX SALAD

Page 27: We took the classic layered salad and gave it a south-of-the-border flavor. Layer the ingredients in one large glass bowl or individual containers to serve.
Prep: 45 minutes. Chill: 6 to 24 hours

6 cups torn iceberg lettuce
1 15-ounce can black beans, black-eyed peas or pinto beans, rinsed and drained
3 medium tomatoes, seeded and chopped
1 10-ounce package frozen whole kernel corn
1 cup chopped red, green and/or yellow sweet pepper
1 cup peeled and cubed jicama or shredded carrot
1 cup diced cooked ham or chicken
1/4 cup thinly sliced green onions
4 ounces Monterey Jack cheese with jalapeño peppers, shredded (1 cup)
1 cup mayonnaise or salad dressing
1 8-ounce carton dairy sour cream
1 1/2 teaspoons chili powder
1/2 cup sliced radishes
2 tablespoons snipped fresh cilantro or parsley

1. Place 3 cups of the lettuce in the bottom of a 3-quart clear salad bowl. Layer the ingredients in the following order: black beans, tomatoes, frozen corn, sweet pepper, jicama, the remaining lettuce, ham, green onions and shredded Monterey Jack cheese.
2. For dressing: In a small bowl, stir together mayonnaise, sour cream and chili powder. Spoon dressing over salad, sealing to edge of bowl. Cover tightly with plastic wrap. Chill in the refrigerator for 6 to 24 hours.
3. To serve, garnish with radish slices and sprinkle with cilantro. Toss lightly to coat evenly to serve. *Makes 8 to 10 side-dish salads.*

Nutrition facts per serving: 443 cal, 35 g fat, 45 mg chol, 625 mg sodium, 23 g carbo, 5 g fiber, 13 g pro.

GOUGÈRE SALAD

Page 28: Gougères are like cheesy popovers. The combination of these salty, cheesy puffs filled with the first crisp greens of spring and a tangy vinaigrette is irresistible. This recipe, from L'Etoile in Madison, Wisconsin, can be served as bite-size canapés when gougère is piped out in mini puffs, or as a lunch entree when the batter is piped out to a 3-inch diameter.
Prep: 45 minutes. Bake: 12 minutes

4 large eggs
1 cup all-purpose flour
1 cup water
1/2 cup unsalted organic butter (1/4 pound)
1/8 teaspoon salt
1 cup grated hard aged cheese, such as Parmigiano-Reggiano, pecorino, Romano or Asiago
1/3 cup olive oil or salad oil
1/3 cup lemon juice
1 tablespoon snipped fresh basil
2 teaspoons sugar
1 teaspoon Dijon-style mustard
1 clove garlic, minced

1/8 teaspoon ground black pepper
6 cups mesclun or mixed salad greens

1. For the gougères: Preheat the oven to 400°. Pre-warm the mixing bowl and paddle attachment with warm water. Pre-warm the eggs while in the shell by running hot tap water over them. Change the hot tap water two more times to warm the eggs through. While eggs are warming, measure out flour and sift; set aside. Line a large baking sheet with some kitchen parchment paper or a nonstick silicone baking mat, or grease the baking sheet; set aside.
2. In a medium saucepan, bring the water, butter and salt to boiling; reduce heat to low. Add flour all at once and stir it vigorously with the wooden spoon about 1 minute, or until the dough pulls away from the sides of the pan and forms a ball.
3. Drain the eggs and wipe the warm mixing bowl dry. Immediately transfer the dough to the warm bowl. Fit the electric mixer with the paddle attachment and turn to medium speed. Crack 1 egg at a time into an unbreakable dish and add egg to the batter; combine completely. Add the remaining 3 eggs, one at a time, and combine completely before adding the next egg. When all the eggs are in the bowl, scrape the bottom of bowl and mix in the grated cheese. (Don't worry about overmixing dough, but work quickly to keep batter warm.) Spoon the dough into a pastry bag fitted with a 1/2-inch diameter round or star tip, or use a tablespoon.
4. Pipe dough into twenty-four 1-inch (for canapé size) or twelve 2-inch (for entree size) mounds, or drop 12 heaping tablespoons of dough onto prepared pan, spaced evenly apart. Bake in a 400° oven for 5 minutes. Turn oven temperature to 375°. Bake about 7 minutes more for the 1-inch or 12 minutes more for the 2-inch, or until evenly golden. Transfer gougères to a wire rack; cool.
5. For vinaigrette: In a screw-top jar, combine oil, lemon juice, basil, sugar, mustard, garlic and black pepper. Cover and shake the vinaigrette well; set it aside.
6. For salad: When the baked gougères are cool enough to handle, cut off the top one-third of each. Carefully remove any soft dough inside the gougère with a fork or spoon. Spoon 1/4 teaspoon of the vinaigrette into the base of each canapé-sized gougère. Use 1 teaspoon of the vinaigrette in the base of an entree-size gougère. Pour the remaining vinaigrette over the mesclun and toss lightly to coat the mesclun.
7. To serve, stuff some of the dressed salad into each gougère, allowing the greens to poke out. Serve immediately. *Makes 6 servings (about twenty-four 1 1/2-inch or twelve 3-inch gougères)*

Nutrition facts per serving: 752 cal, 56 g fat, 248 mg chol, 1,631 mg sodium, 22 g carbo, 1 g fiber, 41 g pro.

SUMMER

DOUBLE BERRY COBBLER

*Page 40: Customers buying big, juicy
summertime blackberries and blueberries at the
Plummer Berry Farm near Grafton, Illinois,
often pick up a copy of this recipe. Using ready-
to-bake refrigerated biscuits saves time.*
Prep: 30 minutes. Bake: 18 minutes.
Cool: 45 minutes

1⅓ cups sugar
 3 tablespoons cornstarch
 ½ teaspoon salt
 ½ teaspoon ground cinnamon
 ¼ cup water
 4 cups fresh or frozen blackberries
 ½ cup fresh or frozen blueberries
 ½ teaspoon lemon juice
 2 tablespoons butter
 1 10-ounce package (8) cinnamon-flavored
 refrigerated biscuits or (10) flaky buttermilk
 refrigerated biscuits
 1 tablespoon milk
 1 tablespoon sugar
 Vanilla ice cream (optional)

1. In a large saucepan, stir together 1⅓ cups
sugar, the cornstarch, salt and cinnamon.
Add water and stir until sugar is mostly dis-
solved. Add blackberries, blueberries, lemon
juice and butter. Cook, stirring frequently,
until thickened and bubbly.
2. Meanwhile, split each biscuit horizontally
into thirds. Arrange 16 of the biscuit pieces
in the bottom of a lightly greased 8x8x2-inch
baking dish (2-quart square), gently pressing
the pieces of biscuit together.

3. Pour the hot berry mixture over the split
biscuits. Arrange the remaining 8 or 14
biscuit pieces on top of the berry mixture.
Brush biscuit tops lightly with the milk and
sprinkle with the 1 tablespoon sugar.
4. Bake the fruit cobbler in a 400° oven for
15 to 18 minutes, or until the biscuits are
golden brown. Cool the cobbler for about
45 minutes before serving. Serve the dessert
warm with a scoop of ice cream, if you like.
Makes 8 servings.
Nutrition facts per serving: 322 cal, 7 g fat, 8 mg chol,
459 mg sodium, 64 g carbo, 5 g fiber, 3 g pro.

BLENDER BLUEBERRY SAUCE

*Page: 42: This no-fuss blueberry sauce from
Paul Otten of Natura Farms in Forest Lake,
Minnesota, tastes sweet and fresh. Serve it over
anything that could use a good dessert sauce,
from fresh-off-the-griddle pancakes to ice cream.*
Start to finish: 15 minutes

 3 cups fresh blueberries
 ¾ cup sugar
 1 tablespoon lemon juice
 Fresh-cut fruit, cake slices and whipped cream
 (optional)

1. In a food processor or blender, combine
blueberries, sugar and lemon juice. Cover
and process or blend for 15 seconds. Stop
the machine and scrape sides with spatula.
Process the mixture for 2½ to 3 minutes
more, or until the blueberry skins are almost
smooth.
2. Serve the blueberry sauce over pancakes
or as an ice cream topping. Cover and store
in refrigerator for up to 3 days; bring to room
temperature and stir before serving. If you
like, spoon the sauce over fresh fruit and cake
slices topped with some whipped cream.
Makes 3 cups.
Nutrition facts per serving: 67 cal, 0 g fat, 0 mg chol,
2 mg sodium, 17 g carbo, 1 g fiber, 0 g pro.

COOL CHEESECAKE SAUCE

*Page 42: Got a craving for cheesecake? Here's a
smooth and chilly make-ahead dessert sauce full
of that creamy flavor. Serve it over fresh fruit or
pour in a parfait glass with fruit, cookies or cake
for a special-occasion dinner finale.*
Prep: 15 minutes. Chill: 1 hour

 1 8-ounce package cream cheese, softened
 ½ cup light dairy sour cream
 ⅔ cup powdered sugar
 ½ teaspoon vanilla
 Fresh raspberries, blueberries, and/or
 strawberries

1. In mixing bowl, beat cream cheese and
sour cream with an electric mixer until fluffy
and combined. Add powdered sugar and
vanilla; beat smooth.

2. Cover and chill in the refrigerator at least
1 hour. Spoon over fresh berries. *Makes 4
to 6 servings.*
Nutrition facts per serving without berries: 305 cal, 22 g fat,
72 mg chol, 188 mg sodium, 20 g carbo, 0 g fiber, 6 g pro.

BERRY-APPLE FANTASY PIE

*Page 43: This golden, two-crust creation oozes
with apples and blackberries. Top with ice cream
for the perfect fantasy.*
Prep: 30 minutes. Bake: 45 minutes

 Pastry for a double-crust pie (for the recipe,
 turn to page 148)
 1 cup sugar
 4 teaspoons quick-cooking tapioca
 ½ teaspoon ground cinnamon
 2 cups fresh blackberries
 2 cups sliced, peeled apples
 2 tablespoons butter, cut up

1. Prepare pastry and divide in half. Form
each half into a ball. On a lightly floured sur-
face, roll one ball of the pastry into a 12-inch
circle. Transfer pastry to a 9-inch pie plate.
2. In large mixing bowl, stir together the
sugar, tapioca and cinnamon. Add the black-
berries and apple slices. Toss gently until
coated. Let stand 15 minutes.
3. Spoon filling into pastry-lined pie plate.
Dot with butter. Trim pastry even with the
edge of the pie plate. Moisten the edge of the
pastry with water.
4. On a lightly floured surface, roll out the
remaining pastry to form a 12-inch circle.
Cut slits in the pastry to let steam escape.
Place pastry on top of the filling. Trim the
top crust to ½ inch beyond edge of pie plate.
Fold top pastry under bottom pastry and
crimp edge. Cover edge of piecrust with foil
to prevent overbrowning.
5. Bake the pie in a 375° oven for 25 minutes.
Remove the foil. Bake for 20 to 25 minutes
more, or until the crust is golden and the
filling is bubbly. Cool the pie on a wire rack.
Makes 8 servings.
Nutrition facts per serving: 419 cal, 21 g fat, 8 mg chol,
165 mg sodium, 57 g carbo, 3 g fiber, 3 g pro.

CANFIELD FAIR ANGEL FOOD CAKE

*Page 44: In 1994, Julie Herron lived in Salem,
Ohio, and used her mother's recipe for this
angel food cake to win a blue ribbon at Ohio's
Canfield Fair. Homemade angel food cake is
worth the effort. It melts in your mouth.*
Prep: 50 minutes. Bake: 35 minutes.
Cool: 2 hours

 12 egg whites (1½ cups)
1½ cups sifted powdered sugar
 1 cup sifted cake flour
1½ teaspoons cream of tartar
 ¼ teaspoon salt
 1 cup granulated sugar

1½ teaspoons vanilla
½ teaspoon almond extract

1. Allow the egg whites to stand at room temperature for 30 minutes before using.
2. Sift together the powdered sugar and the cake flour; set the mixture aside.
3. In a large mixing bowl, beat the egg whites, cream of tartar and salt until foamy.
4. Gradually add granulated sugar, 2 tablespoons at a time, beating the mixture on high speed until stiff peaks form.
5. Quickly beat in the vanilla and almond extract. Sprinkle the flour-sugar mixture, ¼ cup at a time, over the beaten egg whites, folding in gently just until the flour-sugar mixture disappears into the batter.
6. Transfer the mixed cake batter into an ungreased 10-inch tube pan. Gently cut through batter with a knife or spatula to remove any large air pockets.
7. Bake in a 375° oven for 35 to 40 minutes, or until the top springs back when touched lightly with your finger. Invert cake in pan on a funnel and let the cake hang until completely cool. Loosen the sides of the cake with a narrow-bladed spatula or knife; remove cake from pan. *Makes 12 servings.*
Note: For easy entertaining, serve fresh fruit and fruit sauce over the cake.

Nutrition facts per serving: 176 cal, 0 g fat, 0 mg chol, 106 mg sodium, 39 g carbo, 0 g fiber, 5 g pro.

SMOKED BEEF BRISKET

Page 51: At Oklahoma Joe's Barbecue Restaurant in Kansas City, Kansas, this brisket cooks slow and low to give you amazing flavor and tenderness. Eat it straight or on a bun.
Prep: 1¼ hour. Chill: 20 minutes. Grill: 3 hours. Stand: 20 minutes. Bake: 1 hour

6 to 7 cups hickory or fruit wood chips
1 5- to 6-pound fresh beef brisket
½ cup Mustard Rub (recipe follows)
 Brisket Rub (recipe follows)
 Apple juice
 Joe's KC-Style Barbecue Sauce (recipe follows)
 or other barbecue sauce

1. At least 1 hour before grilling, soak wood chips in enough water to cover. Cover both sides of brisket (do not trim fat) with the Mustard Rub. Evenly sprinkle the Brisket Rub over Mustard Rub. Cover and chill for 20 minutes or up to 4 hours.
2. Drain wood chips. For a charcoal grill, arrange medium-low coals around a drip pan. Test for low heat above the pan. Place about half of the drained wood chips over the coals. Place brisket, fat side up, on grill rack over drip pan. Cover and grill for 1½ hours without removing the lid.
3. After 1½ hours, use a spritzer bottle to lightly spray the brisket with apple juice. Add the remaining half of the wood chips while

lid is off. If necessary, add additional charcoal to maintain medium-low coals. Cover and grill 1½ hours more, spraying brisket with apple juice 2 to 3 times and adding additional coals as needed to maintain medium-low coals. (For a gas grill, preheat grill. Reduce heat to low. Adjust for indirect cooking. Add wood chips according to manufacturer's directions. Grill as above, except place meat, fat side up, on a rack in a roasting pan.)
4. Remove brisket from grill. Place in a foil-lined 13x9x2-inch baking pan. Bake, covered, in a 275° oven for 1 hour, or until the meat is very tender and internal temperature registers 190° to 195°. Remove from oven. Let the barbecued beef brisket stand, covered, for 20 minutes before carving.
5. To serve, thinly slice meat across grain. If you like, serve with Joe's KC-Style Barbecue Sauce. *Makes 12 to 14 servings.*

Nutrition facts per serving: 288 cal, 9 g fat, 109 mg chol, 1,191 mg sodium, 6 g carbo, 0 g fiber, 43 g pro.

JOE'S KC-STYLE BARBECUE SAUCE

Prep: 20 minutes. Cook: 1 hour. Cool: 2 hours

3 cups ketchup
1 cup granulated sugar
½ cup packed brown sugar
½ cup cider vinegar
¼ cup water
2 tablespoons molasses
1 tablespoon Dijon-style mustard
1 tablespoon Worcestershire sauce
2 teaspoons garlic powder
2 teaspoons ground black pepper
1 teaspoon salt
1 teaspoon onion powder
¼ teaspoon liquid smoke

1. In a medium saucepan, combine ketchup, granulated sugar, brown sugar, vinegar, water, molasses, mustard, Worcestershire sauce, garlic powder, black pepper, salt, onion powder and liquid smoke. Bring to boiling; reduce heat. Simmer, uncovered, for 1 hour, stirring sauce often.
2. Remove from heat. Cool to room temperature. Cover and chill in the refrigerator for up to 2 weeks. *Makes about 4 cups.*

Nutrition facts per serving: 129 cal, 0 g fat, 0 mg chol, 685 mg sodium, 33 g carbo, 1 g fiber, 1 g pro.

MUSTARD RUB

Start to finish: 5 minutes

½ cup Dijon-style mustard
2 tablespoons Worcestershire sauce
1 tablespoon reduced-sodium soy sauce
1 teaspoon red wine vinegar

1. In a small bowl, stir or whisk together mustard, Worcestershire sauce, soy sauce and vinegar until well-combined. Use immedi-

ately or cover and chill in the refrigerator up to 2 weeks. *Makes about 1 cup.*

Nutrition facts per tablespoon: 10 cal, 0 g fat, 0 mg chol, 240 mg sodium, 2 g carbo, 0 g fiber, 2 g pro.

BRISKET RUB

Start to finish: 10 minutes

2 tablespoons sugar
1 tablespoon salt
1 tablespoon MSG (optional)
1 tablespoon chili powder
2 teaspoons paprika
2 teaspoons lemon-pepper seasoning
2 teaspoons onion powder
2 teaspoons garlic powder
2 teaspoons ground black pepper
1 teaspoon cayenne pepper

1. In a small bowl, combine sugar, salt, MSG (if you like), chili powder, paprika, lemon-pepper, onion powder, garlic powder, black pepper and cayenne pepper. *Makes about ½ cup rub mixture.*

Nutrition facts per serving: 8 cal, 0 g fat, 0 mg chol, 385 mg sodium, 2 g carbo, 0 g fiber, 0 g pro.

BARBECUED VIDALIA ONIONS

Page 51: The naturally sweet Vidalia onions featured here can cook in a foil pan on the grill or in the oven. The recipe is from Fiorella's Jack Stack Barbecue in Kansas City, Missouri.
Prep: 10 minutes. Grill: 40 minutes

4 medium Vidalia onions, cut into quarters*
1 tablespoon olive oil
¼ teaspoon salt
⅛ teaspoon ground black pepper
⅛ to ¼ teaspoon cayenne pepper
½ cup butter, cut into ½-inch pieces
1 12-ounce can beer or 1½ cups apple juice

1. Grease 10-inch round disposable foil pan. Arrange onions in pan. Drizzle with oil. Sprinkle with seasonings. Dot with butter.
2. For a charcoal grill, place pan on rack of uncovered grill directly over medium-hot coals. Add beer to pan. Cover pan with foil. Grill 40 to 45 minutes, or until onions are tender. (For a gas grill, preheat grill. Reduce heat to medium-high. Place pan on grill rack over heat. Add beer to pan. Cover pan with foil. Close grill; cook as above.) Serve with grilled meat. *Makes 8 side-dish servings.*
Oven Directions: Arrange onions in a greased 2-quart casserole dish. Drizzle with oil. Sprinkle with seasonings. Dot with butter. Add beer to dish. Cover with foil. Bake in a 375° oven 1 hour, or until tender.
*Note: Leave the root end of the onion intact so the onion quarters hold their shape.

Nutrition facts per serving: 162 cal, 14 g fat, 32 mg chol, 163 mg sodium, 7 g carbo, 1 g fiber, 1 g pro.

HICKORY PIT BEANS

Page 51: What's barbecue without the beans? This saucy recipe comes from Fiorella's Jack Stack Barbecue in Kansas City, Missouri.
Prep: 20 minutes Cook: 20 minutes

1 31-ounce can pork and beans in tomato
 sauce, drained
1 cup Joe's KC-Style Barbecue Sauce (see recipe,
 page 145) or your favorite barbecue sauce
1 cup chopped Smoked Beef Brisket (see recipe,
 page 145) or purchased cooked beef brisket
1/2 cup water
1/4 cup ketchup
1/4 cup packed brown sugar
1 teaspoon liquid smoke

1. In a large saucepan, stir together the drained beans, sauce, beef brisket, water, ketchup, brown sugar and liquid smoke. Bring the mixture to boiling; reduce heat. Simmer, uncovered, for 20 to 30 minutes, stirring occasionally, or until desired consistency. Serve this side dish while it's hot. *Makes 10 to 12 servings.*

Nutrition facts per serving: 203 cal, 2 g fat, 14 mg chol, 887 mg sodium, 39 g carbo, 5 g fiber, 8 g pro.

TOUCH OF THE WILD RICE

Page 67: At the Angry Trout Cafe in Grand Marais, Minnesota, the cooks use naturally grown wild rice from the northern lakes. Tangy dried cranberries, peas and chopped hazelnuts also speckle this North Woods side dish.
Start to finish: 55 minutes

2 cups wild rice, rinsed and drained
4 cups boiling water
1 cup sliced fresh shiitake or button mushrooms
1/4 cup chopped onion
1/4 cup chopped celery
1 tablespoon cooking oil
3/4 cup frozen peas, thawed
1/3 cup dried cranberries
1 tablespoon tamari sauce or soy sauce
1/4 cup chopped hazelnuts (filberts), toasted

1. In a large, covered saucepan, cook wild rice in boiling salted water for about 40 minutes, or until rice is tender and most of the liquid is absorbed.
2. Meanwhile, in a medium skillet, cook mushrooms, onion and celery in hot oil for 5 minutes, or until tender.
3. Add the vegetable mixture, peas, cranberries and tamari sauce to rice. Cook, uncovered, for 3 to 4 minutes more, or until the mixture is heated through and the remaining liquid is absorbed.
4. To serve, transfer the rice mixture to a serving bowl. Top with the toasted hazelnuts. *Makes 8 servings.*

Nutrition facts per serving: 211 cal, 4 g fat, 37 g carbo, 0 mg chol, 146 mg sodium, 2 g fiber, 7 g pro.

CLEARLY SUPERIOR TROUT

Page 67: Chefs at the Bluefin Bay Resort Restaurant in Tofte, Minnesota, dress up this firm, mild fish with a Chardonnay-orange cream sauce. (The nautical-themed restaurant and the resort's condominiums edge a Lake Superior bay.) Other white-fleshed fish works well in this recipe. The addition of delicate fresh dillweed gives this dish a summertime seasoning.
Prep: 35 minutes. Bake: 8 minutes

1 cup orange juice
1 cup Chardonnay, other dry white wine
 or chicken broth
2 medium leeks, chopped (2/3 cup)
1 1/2 teaspoons minced shallot
3 tablespoons unsalted butter or butter
1/2 cup whipping cream
1 tablespoon snipped fresh dillweed
 Nonstick cooking spray
1 1/2 pounds lake trout or other white-fleshed
 fish fillets
 Salt and pepper
2 tablespoons olive oil
2 tablespoons snipped fresh dillweed
 Finely shredded orange peel and orange
 wedges (optional)
 Fresh dill sprigs (optional)

1. For the cream sauce: In medium skillet, heat the orange juice and white wine or chicken broth to boiling. Reduce the heat and boil gently, uncovered, for 15 minutes, or until the mixture is reduced to 2/3 cup. Set the mixture aside.
2. In small saucepan, cook the chopped leeks and chopped shallot in butter until tender. Add to the wine mixture. Add the whipping cream. Return to boiling. Reduce heat and simmer, uncovered, for 5 to 10 minutes or until the mixture is thickened, stirring occasionally. Just before serving, stir in the 1 tablespoon snipped dillweed.
3. Place a cooking rack in a baking pan. Coat the rack with nonstick cooking spray; set aside. Rinse the fish; pat dry with paper towels. Cut the fish fillets into 6 serving pieces. Sprinkle with some salt and pepper.
4. In a skillet, cook the fish in olive oil for 1 minute on each side. Arrange the fish on a rack in the baking pan. Sprinkle with the 2 tablespoons snipped dillweed. Bake in a 450° oven for 6 to 8 minutes, or until the fish flakes easily when tested with a fork.
5. On each of the warm serving plates, spoon a small circle of the leek sauce. Arrange a piece of fish on top of each. Serve remaining sauce with the fish. If you like, garnish with orange peel and dill sprigs. *Makes 6 servings.*
Note: Reduce the cholesterol by serving less sauce and smaller portions of fish.

Nutrition facts per serving: 377 cal, 25 g fat, 9 g carbo, 105 mg chol, 137 mg. sodium, 2 g fiber, 23 g pro.

OATMEAL CHERRY COOKIES

Page 66: Dried cherries make oatmeal cookies even more memorable in this recipe from American Spoon Foods, with locations in the Traverse City, Michigan, area. You'll like the crisp edges and chewy centers.
Prep: 30 minutes. Bake: 12 minutes/batch.
Cool: 1 minute/batch

1 cup butter, softened
1 cup packed dark brown sugar
1/2 cup granulated sugar
1 1/2 teaspoons baking powder
1 teaspoon ground cinnamon
1/2 teaspoon salt
1/2 teaspoon baking soda
2 eggs
1 teaspoon vanilla
2 cups all-purpose flour
2 cups rolled oats
1 cup snipped American Spoon Dried Red Tart
 Cherries or dried tart cherries (6 ounces)

1. In a large mixing bowl, beat butter with an electric mixer on medium to high speed for 30 seconds. Add brown sugar, granulated sugar, baking powder, cinnamon, salt and baking soda. Beat until combined, scraping sides of bowl occasionally. Beat in eggs and vanilla until combined. Beat in as much of the flour as you can with the mixer. Stir in the remaining flour. Stir in oats and dried cherries.
2. Drop the dough by rounded teaspoons 2 inches apart onto ungreased cookie sheets. Bake in a 350° oven about 12 minutes, or until the edges are lightly browned. Cool on cookie sheets for 1 minute. Transfer the cookies to wire racks and let cool. *Makes about 60 cookies.*

Nutrition facts per serving: 85 cal, 4 g fat, 16 mg chol, 63 mg sodium, 12 g carbo, 1 g fiber, 1 g pro.

HEIRLOOM TOMATO AND ONION QUICHE

Page 70: North Market vendor Jessica Evans of Herban Acre Farm in Hilliard, Ohio, suggests using Cherokee Purple and/or Brandywine heirloom tomatoes in this quiche. Drain sliced tomatoes on a paper towel before adding them to the quiche, and they won't release as much water. It's perfect for brunch or a light dinner with a salad.
Prep: 25 minutes. Bake: 35 minutes.
Stand: 10 minutes

1/2 of a 15-ounce package (1 crust) rolled
 refrigerated unbaked piecrust
12 ounces assorted garden heirloom tomatoes
 (Cherokee Purple and/or Brandywine) or
 regular tomatoes, cut into 1/4-inch-thick slices
1 tablespoon butter
1/2 cup chopped onion (1 medium)
3 eggs
3/4 cup half-and-half, light cream or milk

3 tablespoons all-purpose flour
1 tablespoon snipped fresh basil or 1 teaspoon dried basil, crushed
1/2 teaspoon salt
1/4 teaspoon dry mustard
1/8 teaspoon ground black pepper
1 cup shredded Swiss, cheddar, Monterey Jack, and/or Havarti cheese (4 ounces)
Paprika

1. Let piecrust stand at room temperature according to package directions. Unroll piecrust into a 9-inch pie plate. Crimp edge as desired. Line unpricked pastry with a double thickness of foil. Bake in a 425° oven for 8 minutes. Remove foil. Bake for 4 to 5 minutes more, or until pastry is set and dry. Remove the piecrust from the oven. Reduce oven temperature to 375°.

2. Meanwhile, place the tomato slices on paper towels to absorb excess moisture. In a small skillet, melt butter over medium heat. Add onion. Cook until onion is tender but not brown, stirring occasionally.

3. In a medium bowl, whisk together eggs, half-and-half, flour, basil, salt, dry mustard and black pepper.

4. To assemble, sprinkle cheese onto bottom of the hot, baked pastry shell. Spoon onion mixture over cheese. Arrange tomato slices over cheese, overlapping slightly. Slowly pour egg mixture over tomatoes. Sprinkle paprika over egg mixture.

5. Bake, uncovered, for 35 to 40 minutes, or until egg mixture is set in center. If necessary, cover edge of pie with foil for the last 5 to 10 minutes of baking to prevent overbrowning. Let the quiche stand 10 minutes before serving. *Makes 6 servings.*

Nutrition facts per serving: 352 cal, 23 g fat, 146 mg chol, 426 mg sodium, 26 g carbo, 1 g fiber, 11 g pro.

AUTUMN

PUMPKIN CHEESECAKE WITH CARAMEL SWIRL

Page 93: A long line of loyal customers at Mooselips Java Joint in Seeley, Wisconsin, gives this local recipe a big thumbs up (and insist it's best served with a hot cup of house blend coffee). The dessert is creamy, cool and not overpowered by the pumpkin or spice, and the gingersnap cookie crumbs give this crust a pleasant kick. Quite simply, the pumpkin and caramel look and taste great together in this special-occasion recipe.
Prep: 25 minutes. Bake: 1 hour.
Cool: 2 hours. Chill: 4 hours

1 cup fine graham cracker crumbs (14 crackers)
1/2 cup fine gingersnap cookie crumbs (10 gingersnap cookies)
1/4 cup finely chopped walnuts

2 tablespoons granulated sugar
1/4 teaspoon ground ginger
1/2 cup butter, melted
3 8-ounce packages cream cheese, softened
3/4 cup granulated sugar
1/2 cup packed brown sugar
2 tablespoons cornstarch
1 teaspoon ground cinnamon
1 teaspoon vanilla
1/2 teaspoon ground nutmeg or ground allspice
1/8 teaspoon ground cloves (optional)
1 15-ounce can pumpkin
1 5-ounce can (2/3 cup) evaporated milk
2 eggs, lightly beaten
1 16-ounce carton dairy sour cream
1/3 cup granulated sugar
1 teaspoon vanilla
2 tablespoons caramel ice cream topping
Chocolate curls or chocolate leaves (optional)

1. For the cheesecake crust: In a medium mixing bowl, stir together the graham cracker crumbs, gingersnap crumbs, chopped walnuts, the 2 tablespoons granulated sugar and ground ginger. Stir in the melted butter. Press the crumb mixture onto the bottom and 2 inches up the sides of a 10-inch springform pan. Bake the crumb crust in a 375° oven for 5 minutes (do not allow crust to brown). Set the crust aside.

2. For the filling: In a large mixing bowl, beat cream cheese, the 3/4 cup granulated sugar, brown sugar, cornstarch, cinnamon, the 1 teaspoon vanilla, nutmeg and cloves (if you like) with an electric mixer until combined. Beat in the pumpkin and milk until the mixture is smooth. Stir in the eggs. Pour the pumpkin filling into the crust-lined springform pan. Place springform pan in a shallow baking pan. Bake the cheesecake in a 375° oven for 55 to 60 minutes, or until a 2 1/2-inch area around the outside edge appears set when gently shaken.

3. For topping: In a small bowl, stir together the sour cream, the 1/3 cup granulated sugar and the 1 teaspoon vanilla. Spread the mixture evenly over the top of the hot cheesecake. Drizzle the caramel topping over the sour cream mixture. Using the tip of a knife, carefully swirl the caramel topping. Return the cheesecake to the oven. Bake for 5 minutes more.

4. Cool the cheesecake in the springform pan on a wire rack for 15 minutes. Using a sharp knife, loosen the crust from sides of the pan. Cool the dessert on the wire rack for 30 minutes more. Remove the sides of the pan; cool cheesecake completely on rack. Cover and chill the dessert for at least 4 hours before serving. If you like, serve topped with chocolate curls or leaves. *Makes 14 to 16 servings.*

Nutrition facts per serving: 506 cal, 34 g fat, 118 mg chol, 307 mg sodium, 44 g carbo, 2 g fiber, 8 g pro.

HEARTY PORK AND ALE STEW

Page 95: This pork stew takes on an autumn orange from the russet-colored sweet potatoes. It celebrates the season with assorted root vegetables, apples and tomatoes simmered with melt-in-your-mouth pork sirloin.
Prep: 35 minutes. Cook: 35 minutes

2 tablespoons all-purpose flour
1/2 teaspoon crushed red pepper
1 pound boneless pork sirloin
2 cloves garlic, minced
1 tablespoon cooking oil
3 cups vegetable broth
1 12-ounce can beer or 1 1/2 cups vegetable broth
2 large sweet potatoes, peeled and cut into 1-inch cubes
3 medium parsnips, peeled and sliced 3/4 inch thick
1 medium onion, cut into thin wedges
2 tablespoons snipped fresh thyme or 1 1/2 teaspoons dried thyme, crushed
1 tablespoon brown sugar
1 tablespoon Dijon-style mustard
4 large plum tomatoes, coarsely chopped
2 small green apples, cored and cut into wedges

1. In a plastic bag, stir together the all-purpose flour and the crushed red pepper. Trim the fat from the pork sirloin. Cut the meat into 3/4-inch cubes. Add the meat cubes, a few at a time, to the flour mixture in the plastic bag, shaking to coat the meat.

2. In a 4-quart Dutch oven, cook the cubed pork and garlic in hot oil until the pork is browned. Stir in the 3 cups vegetable broth, beer, the cubed sweet potatoes, sliced parsnips, onion wedges, thyme, brown sugar and Dijon-style mustard.

3. Bring the stew to boiling; reduce heat. Cover and simmer the mixture for 30 minutes. Stir in the coarsely chopped tomatoes and apple wedges. Return to boiling; reduce heat. Cover and simmer for about 5 minutes more, or until meat, vegetables and apples are tender. *Makes 6 servings.*

Nutrition facts per serving: 288 cal, 7 g fat, 48 mg chol, 571 mg sodium, 36 g carbo, 6 g fiber, 20 g pro.

END OF THE SEASON CHERRY-LEMON PIE

Page 87: Cherry-picking ended in the summer, but this fruit's tart flavor feels right at home during the fall. The recipe is from the Tiemeyer family of south-central Indiana. Lemon peel adds a citrus accent to the filling. If you're a fancy pie maker, add a lattice top to this anytime favorite.
Prep: 25 minutes. Bake: 55 to 65 minutes

1¼ cups sugar
3 tablespoons quick-cooking tapioca
1 teaspoon finely shredded lemon peel
5 cups fresh or frozen unsweetened pitted tart red cherries
 Pastry for Double-Crust Pie (recipe follows)
1 slightly beaten egg white
1 tablespoon water
2 tablespoons butter, cut up
 Coarse sugar (optional)
 Vanilla ice cream (optional)

1. In a large mixing bowl, stir together the 1¼ cups sugar, tapioca and lemon peel. Add cherries. Gently toss until coated. Let mixture stand about 15 minutes, or until a syrup forms, stirring occasionally. (If using frozen cherries, let mixture stand about 45 minutes, or until fruit is partially thawed but still icy.)
2. Meanwhile, prepare the pastry. On a lightly floured surface, flatten one of the dough balls. Roll from center to edge into 12-inch circle. Wrap pastry circle around a rolling pin; unroll into a 9-inch pie plate.
3. In a small bowl, stir together egg white and water; brush some of the egg white mixture onto pastry in pie plate. Stir cherry mixture. Spoon cherry mixture into pastry-lined pie plate. Dot with butter. Trim pastry to edge of pie plate. Roll remaining dough to a 12-inch circle; cut slits in pastry. Place pastry over filling; trim ½ inch beyond edge of pie plate. Fold top pastry under edge of bottom pastry; crimp. Brush with additional egg white mixture; sprinkle with coarse sugar, if you like. Place pie on a baking sheet.
4. To prevent overbrowning, cover edge of pie with metal piecrust shield or foil. Bake in a 375° oven for 30 minutes (50 minutes for frozen fruit). Remove shield or foil. Bake for 25 to 35 minutes, or until center of filling is bubbly and top of pastry is golden. Cool on a wire rack. If you like, serve pie with ice cream. *Makes 8 servings.*
Pastry for Double-Crust Pie: In a large mixing bowl, stir together 2¼ cups flour and ¾ teaspoon salt. Using a pastry blender, cut in ⅔ cup shortening until pieces are pea-size. Sprinkle 8 to 10 tablespoons cold water (1 tablespoon at a time) over part of the mixture; gently toss with a fork. Push moistened dough to side of bowl. Repeat until all of the dough is moistened. Divide dough in half; form each half into a ball.

Note: For a decorative finish, cut any pastry dough scraps into decorative cutouts. Place on a baking sheet and bake in 375° oven for 5 to 8 minutes, or until golden brown. Use to decorate top of baked pie.
Note: For some almond flavor, sprinkle ½ cup chopped, toasted almonds into the bottom of the pastry just before adding the cherry mixture.

Nutrition facts per serving: 478 cal, 20 g fat, 8 mg chol, 258 mg sodium, 71 g carbo, 3 g fiber, 5 g pro.

SWEDISH RYE BREAD

Page 110: Raisins stud the slabs of rye bread served warm in the big, pine-paneled dining room looking out on Lake Superior at Minnesota's Lutsen Resort. This recipe is based on one that resort founder Anna Nelson brought with her from Sweden more than a century ago.
Prep: 40 minutes. Rise: 90 to 120 minutes.
Bake: 30 minutes

4 to 4½ cups all-purpose flour
2 packages active dry yeast
1½ cups water
⅓ cup packed brown sugar
¼ cup molasses
¼ cup shortening
1½ teaspoons salt
1 cup medium rye flour
1½ cups raisins

1. In a mixing bowl, combine 2 cups all-purpose flour and yeast; set aside.
2. In a saucepan, heat and stir water, sugar, molasses, shortening and salt until warm (120° to 130°) and shortening is almost melted. Add to flour mixture. Beat with an electric mixer 30 seconds. Beat on high speed 3 minutes, scraping down sides of bowl.
3. Using a spoon, stir in rye flour. Stir in raisins and as much remaining all-purpose flour as you can. Turn out onto a lightly floured surface. Knead in enough remaining all-purpose flour to make a moderately stiff dough that's smooth and elastic (6 to 8 minutes).
4. Shape into ball. Place in greased bowl; turn once to grease surface. Cover; let rise in warm place until doubled (45 to 60 minutes).
5. Lightly grease two 8x4x2-inch loaf pans or two baking sheets. Punch down dough. Turn out onto lightly floured surface. Divide into two portions. Cover; let rest 10 minutes.
6. Shape each portion into a loaf or a 6-inch round. Place in prepared pans or on baking sheets. (If you like, use a sharp knife to make ¼-inch-deep cuts in a crisscross design in the tops of the round loaves.) Cover and let rise until nearly doubled (45 to 60 minutes).
7. Bake in 350° oven 30 to 35 minutes, or until bread sounds hollow when lightly tapped. Remove from pan; cool on a wire rack.
Makes 2 loaves, 16 servings each.

Nutrition facts per serving: 113 cal, 2 g fat, 0 mg chol, 12 mg sodium, 22 g carbo, 1 g fiber, 2 g pro.

WINTER

FAIRY SANDWICH COOKIES

Page 125: These tender cookies taste wonderful filled with jam, preserves or even frosting.
Prep: 30 minutes. Chill: 1 hour.
Bake: 8 minutes/batch

⅔ cup unsalted butter, softened
½ cup sugar
¼ teaspoon salt
1 egg yolk
1 teaspoon vanilla
2 cups all-purpose flour
¼ cup apricot, peach, raspberry or cherry preserves
2 ounces bittersweet or semisweet chocolate, chopped
½ teaspoon shortening
2 ounces white chocolate baking squares or white baking bars, chopped
½ teaspoon shortening

1. In a large mixing bowl, beat butter with an electric mixer on medium to high speed for 30 seconds. Add sugar and salt. Beat until combined, scraping sides of bowl occasionally. Beat in egg yolk and vanilla until combined. Beat in as much of the flour as you can with the mixer. Stir in any remaining flour with a wooden spoon. Divide dough in half. Form into 2 flattened rounds. Wrap dough in plastic wrap. Chill in the refrigerator about 1 hour, or until easy to handle.
2. Roll dough between 2 sheets of waxed paper to a ¼-inch thickness. Remove top layer of waxed paper. Using a floured 2-inch fluted or plain round cookie cutter, cut out dough. Carefully peel cutouts off the bottom layer of waxed paper. Place cutouts 1 inch apart on an ungreased cookie sheet.
3. Bake the cookies in a 350° oven for 8 to 10 minutes, or until edges are firm and bottoms are very lightly browned. Cool them on cookie sheet for 2 minutes. Transfer cookies to a wire rack and let cool.
4. Up to 1 hour before serving, spread bottoms of half of the cookies with a rounded teaspoon of preserves. Top with remaining cookies, flat side down.
5. In a heavy small saucepan, melt bittersweet chocolate and the ½ teaspoon shortening over low heat, stirring constantly. Spoon melted chocolate mixture into a small, heavy, zip-top plastic bag; seal bag. Snip a tiny piece off a corner of the bag. Pipe on cookies to decorate as desired. Write holiday-related words or decorate with stars, Christmas trees and hearts. Let stand until set. Repeat with white chocolate and the ½ teaspoon shortening, using a second small, heavy, zip-top plastic bag. *Makes 14 sandwich cookies.*

Nutrition facts per serving: 240 cal, 13 g fat, 40 mg chol, 51 mg sodium, 29 g carbo, 1 g fiber, 3 g pro.

CHOCOLATE-RASPBERRY SOUFFLÉ

Page 128: Really a cross between a cake and a soufflé, these individual chocolate desserts are a fitting finale for any romantic dinner. Chef Steven Oakley has been known to serve the treats to his wife, Michele, at their Valentine's Day dinner. The Indianapolis chef from Oakleys Bistro completes the dessert with homemade ice cream and still more fresh raspberries on top.
Prep: 20 minutes. Bake: 12 minutes

¼ cup unsalted butter
2 ounces semisweet chocolate
1 egg
1 egg yolk
2 tablespoons brown sugar
2 teaspoons all-purpose flour
1 cup fresh raspberries
 Powdered sugar
 Sweetened whipped cream (optional)
 Fresh raspberries (optional)
 Sprigs of fresh mint (optional)

1. In a small saucepan, heat butter and chocolate until almost melted. Remove from heat and stir until smooth. Let the mixture cool at room temperature.
2. In a small mixing bowl, beat the egg, egg yolk and brown sugar with an electric mixer for 3 to 4 minutes, or until very light and a ribbon forms when you raise beaters. Beat in the chocolate mixture. Fold in the flour.
3. Divide the chocolate batter among four buttered 6-ounce custard cups. Sprinkle the 1 cup of fresh raspberries on top of the batter in the custard cups.
4. Bake the individual desserts in a 450° oven for 12 minutes. Sift some powdered sugar over the tops. Serve at once with sweetened whipped cream and garnish with additional berries and fresh mint sprigs, if you like.
Makes 4 servings.
Nutrition facts per serving: 248 cal, 19 g fat, 139 mg chol, 21 mg sodium, 17 g carbo, 3 g fiber, 4 g pro.

TORTA D'ALASSIO

Page 129: Glossy chocolate glaze encases moist, low flour chocolate cake in this decadent finale from Cucina Italian Restaurant located at the Shops at Woodlake in Kohler, Wisconsin. Top it with some caramelized sugar shards.
Prep: 20 minutes. Bake: 30 minutes.
Stand: 1½ hours. Cool: 2 hours

3 egg whites
3 egg yolks
½ cup unsalted butter
 Unsalted butter
1¼ cups whole hazelnuts (filberts), toasted,
 skins rubbed off*
8 ounces bittersweet chocolate, coarsely
 chopped
½ cup sugar

¼ cup sugar
¼ cup unbleached all-purpose flour or all-
 purpose flour
4 ounces bittersweet chocolate, coarsely
 chopped
½ cup unsalted butter
1 tablespoon honey
 Whipped cream (optional)
 Caramelized Sugar Shards (optional) (recipe
 follows)

1. Allow egg whites, egg yolks, and ½ cup butter to stand at room temperature for 30 minutes. Meanwhile, lightly grease bottom of a 9x1½-inch round cake pan with additional unsalted butter. Line the bottom of pan with parchment paper or waxed paper. Grease the paper and sides of the pan; set aside.
2. In a food processor bowl or blender container, place ¾ cup of the hazelnuts. Cover and process or blend until ground; set aside. Chop remaining ½ cup hazelnuts; set aside.
3. In a heavy small saucepan, heat the 8 ounces bittersweet chocolate over low heat, stirring constantly, until chocolate is melted and smooth; set aside.
4. For the cake: In a large mixing bowl, beat the ½ cup softened butter with an electric mixer on medium to high speed for 30 seconds. Gradually add the ½ cup sugar, half at a time, beating on medium speed until well-combined and scraping sides of bowl. Add egg yolks, 1 at time, beating well after each addition (about 1 minute total). Reduce the speed to low and beat in the melted chocolate and ground hazelnuts. Scrape the bowl as needed. Set aside.
5. Thoroughly wash beaters. In a separate large mixing bowl, beat egg whites on medium speed until soft peaks form (tips curl). Gradually add the ¼ cup sugar, 1 tablespoon at a time, beating until stiff peaks form (tips stand straight). Using a rubber spatula, fold half of the beaten egg whites into the chocolate mixture. Fold flour into chocolate mixture; fold the mixture into the remaining egg white mixture. Spread the cake batter into the prepared pan.
6. Bake in a 350° oven for 30 to 35 minutes, or until a wooden toothpick inserted near the center comes out clean and the cake is firm to the touch. Remove from the oven. Cool in the pan on a wire rack for 10 minutes. Loosen edges of cake with a spatula. Invert onto wire rack. Remove the pan. Cool cake thoroughly on wire rack.
7. For the glaze: In a heavy small saucepan, heat the 4 ounces chocolate, the ½ cup butter and honey over low heat, stirring constantly, until chocolate is melted and smooth. Place a sheet of waxed paper under the wire rack. Pour warm glaze over top of the cooled cake, allowing glaze to run down sides.
8. Transfer cake to a serving plate. With your fingertips, press chopped hazelnuts

onto the sides of the cake. Allow cake to stand until glaze is set (about 1 hour). Serve with whipped cream on the side and garnish with Caramelized Sugar Shards, if you like.
Makes 10 servings.
Caramelized Sugar Shards: Line a baking sheet with foil. Grease the foil; set aside. In an 8-inch heavy skillet, cook ½ cup sugar over medium-high heat until sugar begins to melt, shaking skillet occasionally to heat sugar evenly. Do not stir. Once the sugar starts to melt, reduce heat to low. Cook about 5 minutes more, or until all of the sugar is melted and golden, stirring as needed with a wooden spoon. Immediately drizzle melted sugar on prepared foil-lined sheet in a decorative fashion. Allow to set; break into shards.
***To toast hazelnuts:** Place the nuts in a shallow baking pan. Bake in a 350° oven about 10 minutes, or until toasted. Place the warm nuts in a clean kitchen towel. Rub the nuts with the towel to remove loose skins.
Nutrition facts per serving: 547 cal, 44 g fat, 119 mg chol, 24 mg sodium, 41 g carbo, 4 g fiber, 7 g pro.

CHOCOLATEY HOT CHOCOLATE

The coldest Midwest winter day wouldn't be complete without a cup of hot chocolate. This rich beverage for winter will warm you from the inside out. Try it with small scoops of ice cream to add flavor and cool it down. Or try it with a slice of quick bread or a cookie.
Start to finish: 25 minutes

3 cups whole milk
5 ounces bittersweet chocolate, chopped
2 tablespoons sugar
1 egg, slightly beaten
1 teaspoon vanilla
6 small scoops chocolate or vanilla ice cream
 (about ½ pint)
 Ground cinnamon

1. In a large saucepan, combine 1 cup of the milk, chocolate and sugar. Cook and stir over medium-low heat until chocolate is melted, whisking if necessary to make completely smooth. Gradually stir in the remaining 2 cups milk. Cook and stir over medium heat until milk mixture is very hot (temperature of mixture should be about 160°). Do not boil.
2. Gradually whisk about ½ cup of the hot milk mixture into egg; whisk egg mixture back into milk mixture in saucepan. Cook and stir for 2 minutes over low heat. Remove from heat and stir in vanilla. Beat the chocolate mixture with a rotary beater or blend with an immersion blender until it's very frothy and foamy.
3. Serve the cocoa in mugs with a scoop of ice cream in each. Sprinkle with cinnamon.
Makes 6 servings.
Nutrition facts per serving: 266 cal, 15 g fat, 55 mg chol, 83 mg sodium, 29 g carbo, 2 g fiber, 7 g pro.

INDEX *of the* HEARTLAND

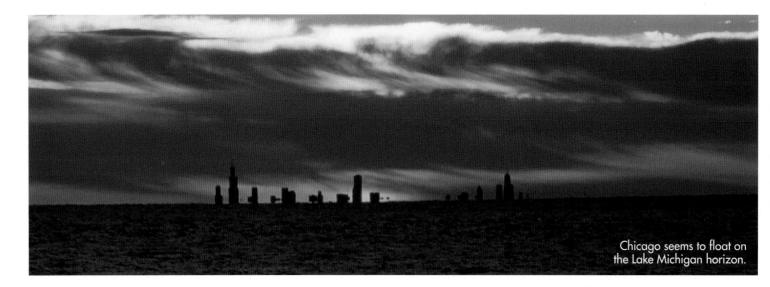

Chicago seems to float on the Lake Michigan horizon.

PHOTOGRAPHERS

EXPLORE *the* HEARTLAND

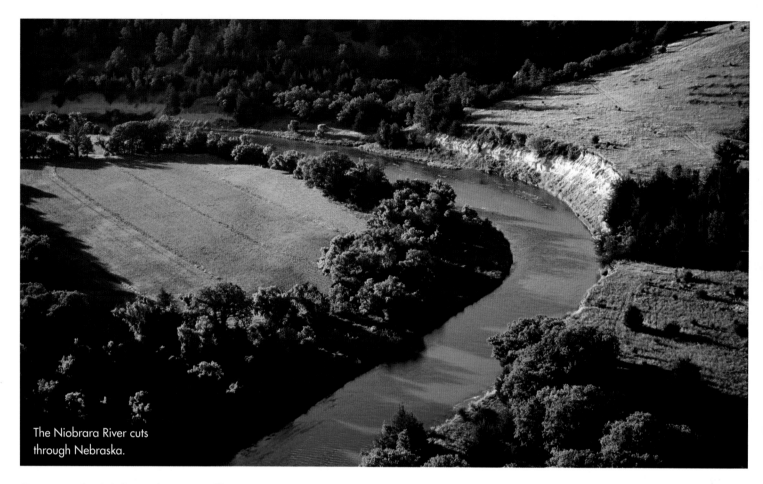

The Niobrara River cuts through Nebraska.

Discover the Midwest for yourself. Here are a few key resources to get you started on your adventures.

GENERAL

Midwest Living – (www.midwestliving.com)

Mississippi River Parkway Commission – (www. experiencemississippiriver.com)

National Park Service – (www.nps.gov)

National Scenic Byways – (800/429-9297; www. byways.org)

ILLINOIS

Illinois Bureau of Tourism – (800/226-6632; www. enjoyillinois.com)

Illinois Department of Natural Resources – (217/782-6752; www.dnr.state.il.us)

TOWNS AND CITIES

Chicago – (877/244-2246; www.877chicago.com)

Galena – (877/464-2536; www.galena.org)

Springfield – (800/545-7300; www.visit-springfield illinois.com)

DESTINATIONS

Illinois Amish Country – (800/722-6474; www. illinoisamishcountry.com)

Northern Illinois Tourism Development Office – (815/547-3740; www.visitnorthernillinois.com)

Shawnee Hills Wine Trail – (www.shawneewinetrail .com)

Tourism Bureau of Southwestern Illinois – (800/442-1488; www.thetourismbureau.org)

Western Illinois Tourism Development Office – (309/837-7460; www.visitwesternillinois.info)

INDIANA

Indiana Office of Tourism Development – (800/677-9800; www.enjoyindiana.com)

Indiana Department of Natural Resources – (877/463-6367; www.in.gov/dnr)

TOWNS AND CITIES

Brown County – (800/753-3255; www.brown county.com)

Indianapolis – (800/958-4639; www.indy.org)

South Bend – (800/519-0577; www.livethelegends .org)

DESTINATIONS

Indiana Dunes/Porter County – (800/283-8687; www.casualcoast.com)

Indiana Wine Trail – (888/776-4786; www. indianawinetrail.com)

Northern Indiana Amish Country – (574/262-8161; www.amishcountry.org)

IOWA

Iowa Tourism Office – (800/345-4692; www. traveliowa.com)

Iowa Department of Natural Resources – (515/281-5918; www.iowadnr.com)

TOWNS AND CITIES

Des Moines – (800/451-2625; www.seedesmoines .com)

Dubuque – (800/798-8844; www.travel dubuque.com)

Quad Cities/Mississippi Valley Welcome Center – (800/747-7800; www.visitquadcities.com)

DESTINATIONS

Amana Colonies – (800/579-2294; www.amana colonies.com)

Central Iowa Tourism Region – (800/285-5842; www.iowatourism.org)

Eastern Iowa Tourism Association – (800/891-3482; www.easterniowatourism.org)

Iowa Great Lakes – (800/270-2574; www.vacation okoboji.com)

KANSAS

Kansas Travel & Tourism Division – (800/252-6727; www.travelks.com)

Kansas Department of Wildlife and Parks – (620/672-5911; www.kdwp.state.ks.us)

TOWNS AND CITIES

Abilene – (800/569-5915; www.abilenekansas.org)

Kansas City, Kansas – (800/264-1563; www. visitthedot.com)

Lawrence – (888/529-5267; www.visit lawrence.com)

Topeka – (800/235-1030; www.topekacvb.org)

Wichita – (800/288-9424; www.visitwichita.com)

DESTINATIONS

Flint Hills National Wildlife Refuge – (620/392-5553; http://flinthills.fws.gov)

Quivira National Wildlife Refuge – (620/486-2393; www.fws.gov/quivira)

MICHIGAN

Travel Michigan – (888/784-7328; www.michigan .org)

Michigan Department of Natural Resources – (517/373-9900; www.michigan.gov/dnr)

TOWNS AND CITIES

Detroit – (800/338-7648; www.visitdetroit.com)

Frankenmuth – (800/386-8696; www.frankenmuth.org)

Grand Haven – (800/303-4094; www.grand havenchamber.org)

Grand Traverse Bay/Traverse City – (800/872-8377; www.mytraversecity.com)

Lansing – (888/252-6746; www.lansing.org)

DESTINATIONS

Harbor Country – (269/469-5409; www.harbor country.com)

Mackinac Island – (800/454-5227; www.mackinac island.org)

Sleeping Bear Dunes – (888/334-8499; www.sleeping beardunes.com)

Upper Peninsula – (800/562-7134; www.uptravel.com)

MINNESOTA

Minnesota Office of Tourism – (888/868-7476; www.exploreminnesota.com)

Minnesota Department of Natural Resources – (888/646-6367; www.dnr.state.mn.us)

TOWNS AND CITIES

Ely – (800/777-7281; www.ely.org)

Grand Marais – (888/922-5000; www.grandmarais.com)

Lanesboro – (800/944-2670; www.lanesboro.com)

Minneapolis – (888/676-6757; www.minneapolis.org)

Saint Paul – (800/627-6101; www.visitsaintpaul.com)

Winona – (800/657-4972; www.visitwinona.com)

DESTINATIONS

Brainerd Lakes – (800/450-2838; www.explore brainerdlakes.com)

Detroit Lakes – (800/542-3992; www.visitdetroit lakes.com)

Gunflint Trail – (800/338-6932; www.gunflint-trail.com)

Mall of America – (952/883-8800; www.mallof america.com)

Park Rapids Lakes Area – (800/247-0054; www.parkrapids.com)

MISSOURI

Missouri Division of Tourism – (800/810-5500; www.visitmo.com)

Missouri Department of Natural Resources – (800/334-6946; www.mostateparks.com)

TOWNS AND CITIES

Branson – (800/214-3661; www.explorebranson.com)

Hannibal – (573/221-2477; www.visithannibal.com)

Jefferson City – (800/769-4183; www.visitjeffersoncity.com)

Kansas City, Missouri – (800/767-7700; www.visitkc.com)

St. Louis – (800/916-8938; www.explorestlouis.com)

Ste. Genevieve – (800/373-7007; www.sainte genevieve.org)

DESTINATIONS

Wine Country/Hermann – (800/932-8687; www.hermannmo.info)

Katy Trail – (660/882-8196; www.bikekatytrail.com)

Lake of the Ozarks – (800/386-5253; www.funlake.com)

NEBRASKA

Nebraska Travel and Tourism – (877/632-7275; www.visitnebraska.org)

Nebraska Game and Parks Commission – (402/471-0641; www.ngpc.state.ne.us)

TOWNS AND CITIES

Lincoln – (800/423-8212; www.lincoln.org)

Nebraska City – (800/514-9113; www.nebraskacity.com)

Omaha – (866/937-6624; www.visitomaha.com)

DESTINATIONS

Lake McConaughy State Recreation Area – (800/658-4390; www.lakemcconaughy.com)

Niobrara River/Valentine – (800/658-4024; www.visitvalentine.com)

NORTH DAKOTA

North Dakota Tourism Division – (800/435-5663; www.ndtourism.com)

North Dakota Parks and Recreation Department – (701/328-5357; www.parkrec.nd.gov)

TOWNS AND CITIES

Bismarck – (800/767-3555; www.bismarck mandancvb.com)

Fargo – (800/235-7654; www.fargomoorhead.org)

Medora – (701/623-4910; www.medora.com)

DESTINATIONS

Sheyenne River Valley – (888/288-1891; www.hello valley.com)

Theodore Roosevelt National Park – (701/623-4466; www.nps.gov/thro)

OHIO

Ohio Division of Travel and Tourism – (800/282-5393; www.discoverohio.com)

Ohio Department of Natural Resources – (614/265-6561; www.ohiodnr.com/parks)

TOWNS AND CITIES

Cincinnati – (800/344-3445; www.cincinnatiusa.com)

Cleveland – (800/321-1004; www.travelcleveland.com)

Columbus – (800/354-2657; www.experience columbus.com)

Toledo – (800/243-4667; www.dotoledo.com)

Yellow Springs – (937/767-2686; www.yellow springsohio.org)

DESTINATIONS

Hocking Hills – (800/462-5464; www.1800hocking.com)

Lake Erie and Cedar Point – (800/255-3743; www.sanduskyohiocedarpoint.com)

Ohio Amish Country – (330/674-3975; www.visit amishcountry.com)

SOUTH DAKOTA

South Dakota Tourism – (800/732-5682; www.travelsd.com)

South Dakota Game, Fish, and Parks – (605/773-3391; www.sdgfp.info)

TOWNS AND CITIES

Pierre – (800/962-2034; www.pierre.org)

Sioux Falls – (800/333-2072; www.siouxfallscvb.com)

DESTINATIONS

Badlands National Park – (605/433-5361; www.nps.gov/badl)

Black Hills – (605/355-3600; www.blackhills badlands.com)

Crazy Horse Memorial – (605/673-4681; www.crazy horse.org)

Lake Oahe/Great Lakes of South Dakota – (888/386-4617; www.sdgreatlakes.org)

Mount Rushmore National Memorial – (605/574-2523; www.nps.gov/moru)

WISCONSIN

Wisconsin Department of Tourism – (800/432-8747; www.travelwisconsin.com)

Wisconsin Department of Natural Resources – (608/266-2181; www.dnr.state.wi.us)

TOWNS AND CITIES

Hayward – (800/724-2992; www.haywardarea chamber.com or www.haywardlakes.com)

Madison – (800/373-6376; www.visitmadison.com)

Milwaukee – (800/554-1448; www.visitmilwaukee.com)

Minocqua – (800/446-6784; www.minocqua.org)

DESTINATIONS

Apostle Islands National Park – (715/779-3397; www.nps.gov/apis)

Door County – (800/527-3529; www.doorcounty.com)

Lake Geneva – (800/345-1020; www.lakegenevawi.com)

Mineral Point – (888/764-6894; www.mineralpoint.com)

Wisconsin Dells – (800/223-3557; www.wisdells.com)

Books About the Midwest

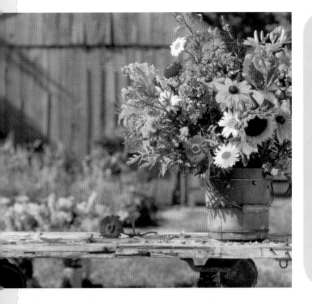

Best of the Midwest™

Join *Midwest Living*® magazine's founding editor, Dan Kaercher, as he revisits dozens of his favorite places across the Midwest—from hidden corners to vibrant cities—in this charming companion to the public television series. Includes full-color photos, complete travel information and recipes guaranteed to please the entire family!

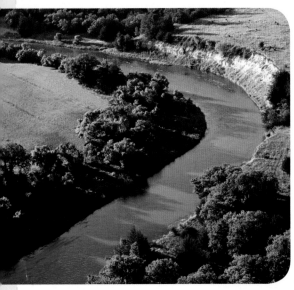

Parklands of the Midwest™

Discover the Midwest's unexpected and breathtaking natural treasures as Dan Kaercher takes you exploring through the region's most spectacular natural areas—stunning parks, scenic rivers and lakes, preserves teeming with wildlife and native plants, and other beautiful sites. This lavishly illustrated companion to the public television series includes travel information, recipes and so much more.

Taste of the Midwest™

Eat your way across the Heartland with Dan Kaercher as your guide, relishing the region's food culture and fantastic cuisine. Beautiful photographs and an engaging text are complemented by delicious regional recipes and insider information on fabulous food festivals and recommended mail-order sites, allowing you to create a memorable vacation—or meal—of your own.